Japanese Tattooing Now!

Memory and Transition

Classic Horimono to the new One Point style

Michael McCabe

Schiffer Publishing Ltd

4880 Lower Valley Road, Atglen, PA 19310

Dedication

This book is dedicated to my Mom in appreciation
for her ongoing encouragement of my work.

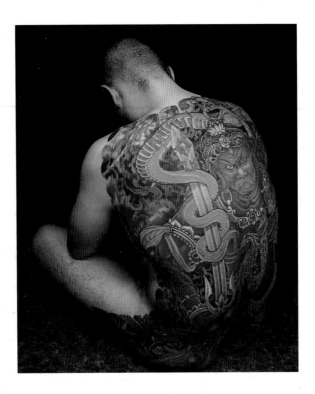

Designed by "Ellen J. Taltoan"
Type set in Van Dijk/Humanist521 BT

ISBN: 0-7643-2142-0
Printed in China

Published by Schiffer Publishing Ltd.
4880 Lower Valley Road
Atglen, PA 19310
Phone: (610) 593-1777; Fax: (610) 593-2002
E-mail: Info@schifferbooks.com

For the largest selection of fine reference books on this and
related subjects, please visit our web site at
www.schifferbooks.com
We are always looking for people to write books on new and
related subjects. If you have an idea for a book please contact
us at the above address.

This book may be purchased from the publisher.
Include $3.95 for shipping.
Please try your bookstore first.
You may write for a free catalog.

In Europe, Schiffer books are distributed by
Bushwood Books
6 Marksbury Ave.
Kew Gardens
Surrey TW9 4JF England
Phone: 44 (0) 20 8392-8585; Fax: 44 (0) 20 8392-9876
E-mail: info@bushwoodbooks.co.uk
Free postage in the U.K., Europe; air mail at cost.

Contents

Acknowledgments ... 4

Chapter One. Japanese Tattooing Today .. 6

Chapter Two. You Should Not Tattoo Ghosts on People: Sensei Horihide of Gifu 103

Chapter Three. Sensei Horitoshi and Tattoo Soul 118

Chapter Four. Sensei Horikoi—A Sense of Tradition and Respect 131

Chapter Five. Tokyo Shita-machi Culture and the Tattoos of Asakusa Horiyasu 140

Chapter Six. Looking Back Looking Forward: The Tattoos of Hori-Sho 151

Chapter Seven. Hori-Show Tattoos Tokyo ... 160

Chapter Eight. Sabado and Eccentric Super Tattoo 167

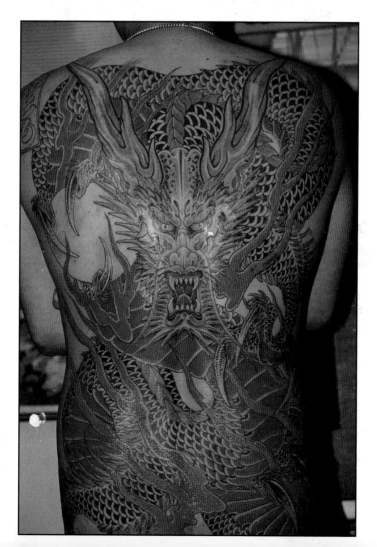

Acknowledgments

The world of Japanese tattoo is rarified and at times sequestered. This is changing rapidly today as Western stylistic options are being explored in Japan but a subtext of protection remains. Every culture has methods for addressing the issue of the outsider. I wish to thank Sensei Horihide, Sensei Horiyoshi III, Sensei Horitoshi I, Sensei Horiyasu, Sensei Horikoi, and Sensei Horiuno for their guidance. They each invited me into their private worlds and generously provided a very unique chance to begin to learn about their culture and art form.

I am indebted to all the tattoo people who contributed to this book for their generosity and openness. They permitted me to enter their lives and ask questions. I sincerely appreciate the opportunity to do so. Most cultures signify a mixture of declared and undeclared values, codes, and mores. Japanese culture represents an exaggerated complex of nuanced do's and don'ts that are very mysterious and intimidating. Language difficulty and misinterpretations abound. Without guidance, the outsider is very simply lost to the subtlety of what goes on. At some point it dawns on you that the only reason you are actually accomplishing anything is because people have extended themselves to you. They have taken the time to momentarily take you under their wing and point you in the right direction. This realization is humbling.

I would like to thank Masa Sakamoto of Three Tides Tattoo, Miho Kawasaki, Ryoichi Maeda, and Atsushi Takeuchi of *Burst Magazine*, Kawajiri, Hiro, and Yushi of Scratch Addiction, Kaori Hamada of Yokohama, Akie and Eri of Tokyo, Fumi of Kumamoto, Kyushu, KAZ of New York City, and Horiyu of 55 Tattoo in New York City for keeping an eye on me and making connections that would have otherwise been impossible.

My experiences in Japan have always been informed through the generosity of Don Ed Hardy and Francesca Passalacqua. I would also like to thank Kunihiro Shimada of Keibunsha Publishing for his help and generosity. Thank you to Loretta Leu and the Leu family for their encouragement and support of my writing. I also wish to express gratitude to Izumi Akiba for her constant assistance. She made difficult phone calls, translated continuously, and on one occasion got yelled at severely because of a misinterpretation between the languages that may have been my fault. As she held the phone receiver and took a lashing for me, the look on her face was not good. I felt so badly, I bought her some pretty pink flowers to apologize. As I presented the flowers, a smile broke across Izumi's face. She said, "Mike-san, these kind of flower people in Japan give somebody when they dead or dying…" She cracked up. I felt like an idiot. It was an important lesson in the mysterious layers of protocol and tradition completely lost to an outsider in Japan. It was also a poignant reminder about the endless accommodation Japanese people provide to visitors. Thank you to every one for your endless accommodation.

Finally, my deep appreciation to Yadi Tan for her care, encouragement, and support throughout the process of creating this book. Thank you Yadi.

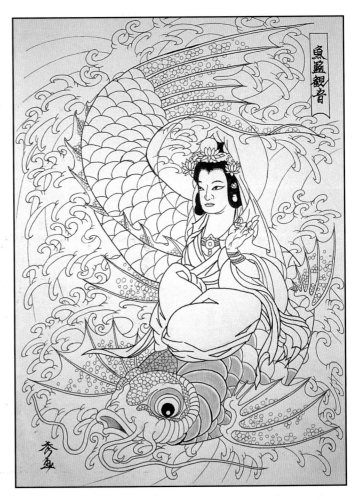

Painting by Sensei Horihide

4

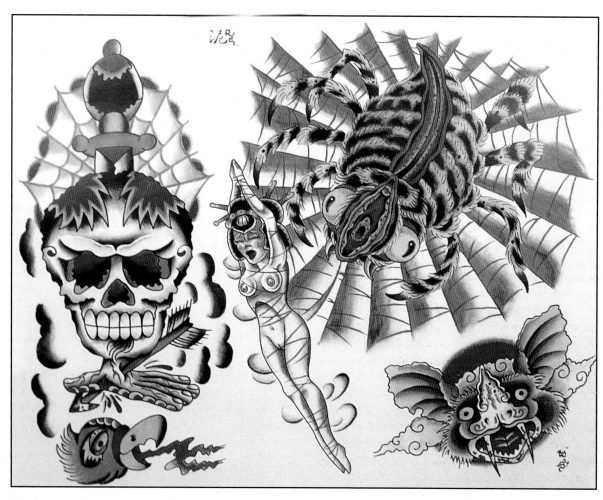

Flash sheet by Rei Mizushima, Ink Rat Tattoo, Tokyo

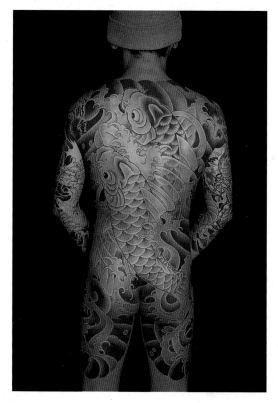

Tattoo by Tokyo Horishige on Gen Mukohyama,
Extreme Body Piercing, Harajuku, Tokyo

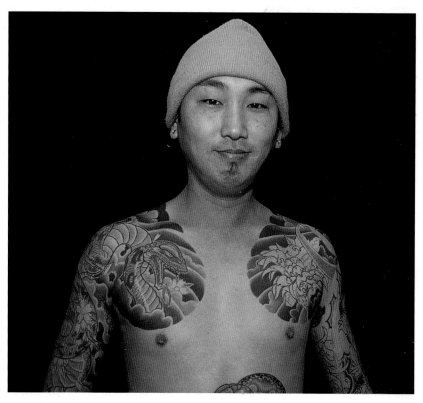

Tattoos by Tokyo Horiken on Gen Mukohyama,
Extreme Body Piercing, Harajuku, Tokyo

Chapter One
Japanese Tattooing Today

Toshio Shimada has a tattoo shop at the top of a narrow five-floor spiral staircase in the crazy Shibuya shopping district in Tokyo. The stairs wind past small Hip-Hop clothing boutiques while music videos blast from giant 100 foot square digital TV screens mounted on building walls just outside the windows. At the top of the stairs there are four young men and women looking through tattoo flash books, talking with Mica and Jeff Tam who work for Toshio. The customers are dressed like the young people in the videos—expensive jeans, some accessories around their necks and wrists, stylish sunglasses, a streaked crazy haircut, and tattoos. Everything in Shibuya is focused on youth culture and fashion. The styles are all from the USA and the look is urban and ethnic.

Trends move quickly through the youth culture in Japan. Twenty months ago it would have been rare to see visible tattoos on the street—particularly Western style tattoos. Traditionally in Japan, marking the body in any way is looked at with a skeptical eye. The animist belief system of Shintoism runs deep into the culture. It emphasizes purity, cleanliness, and respect of the body. Contradicting this, Japan has an elaborate sub-cultural history of hand-technique horimono tattooing dating back more than two-hundred years to the Ukiyo-e images of the Edo Floating World and later Meiji periods (1615-1868-1912). Full body tattoos depicting mythological heroes and animals framed by stylized wind or water motifs were worn originally by dandy Edo (now called Tokyo) laborers and firemen in the nineteenth century. Edo Floating World culture was characterized by a penchant for a pleasurable life emphasizing beautiful women, gallant men, fashion, and faddishness—impulses that continue to mold behavior among urban Japanese youth today.

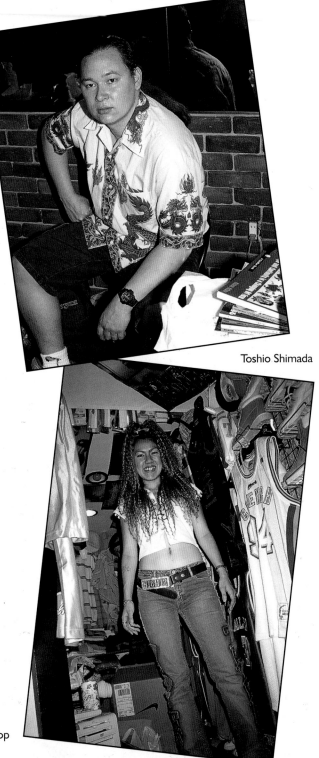

Toshio Shimada

Shibuya, Hip-Hop clothing shop

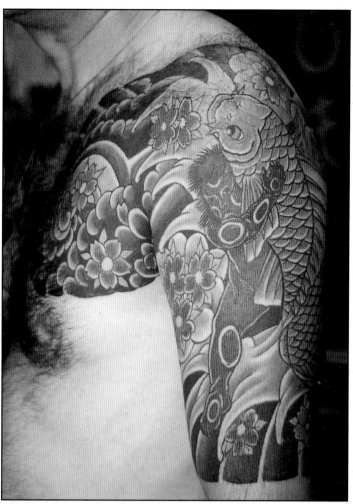

Tattoo by Toshio Shimada

Tattoo by Toshio Shimada

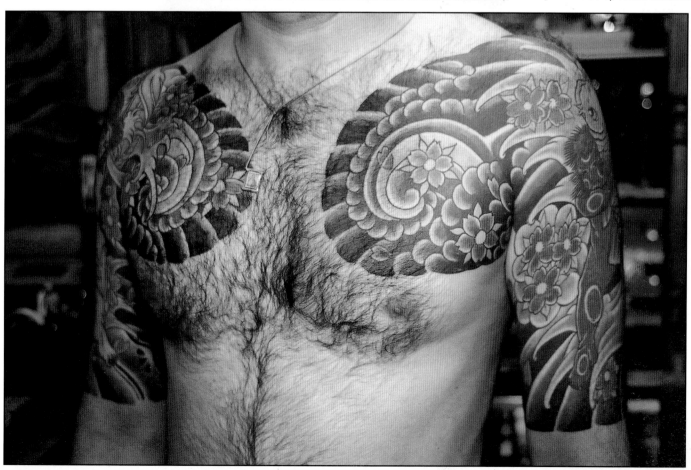

Shimada business card

Mica

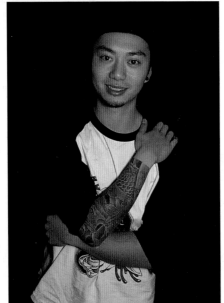

Jeff Tam

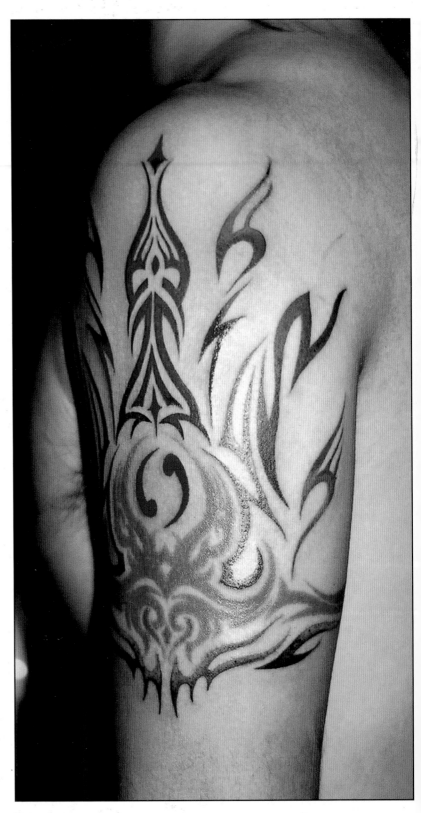

Tattoo by Mica

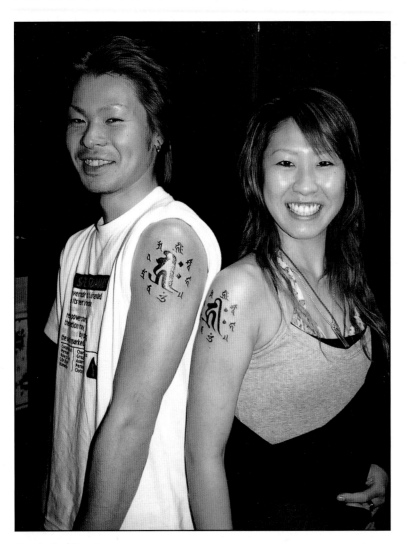

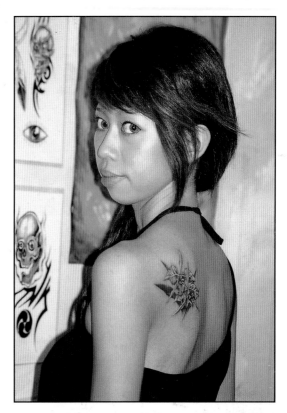

Tattoo by Mica

Tattoos by Mica

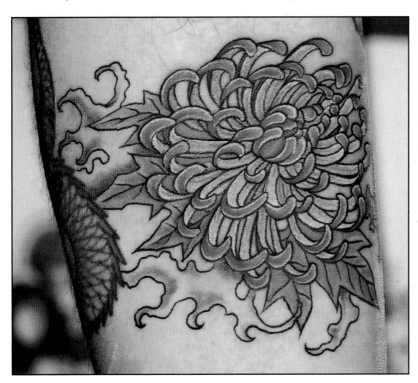

Tattoo by Mica

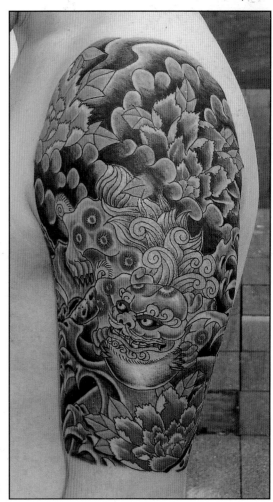

Tattoo by Jeff Tam

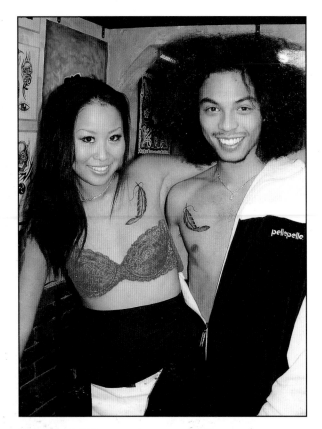

Tattoos by Jeff Tam

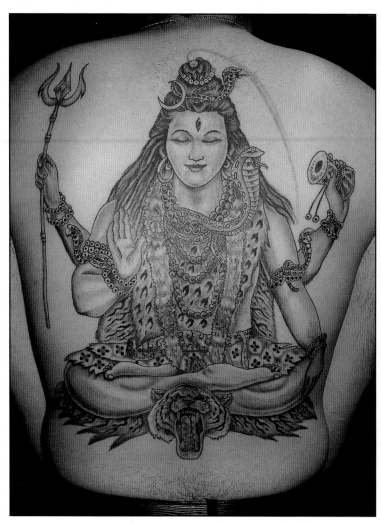

Tattoo by Jeff Tam

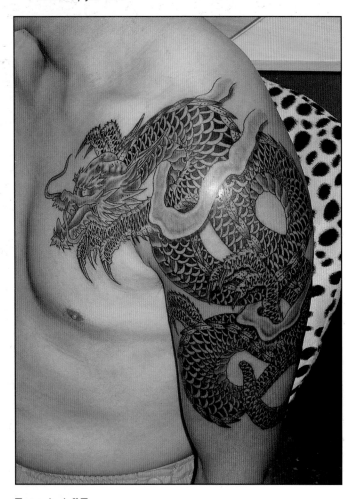

Tattoo by Jeff Tam

In recent history full body tattooing became the domain of Yakuza organized crime families. Big tattoos are macho and project traditional, neo-conservative Japanese images and values. Yakuza families are tattooed by their own tattooers in private studio settings. It is very low key and secretive. Each family has a crest design and many times family members have it tattooed on their chest to proclaim loyalty.

Traditional tattooing in Japan runs in family lineages. Through the master-apprentice system, tattooers and the people who are tattooed cluster into family associations and these connections are highly respected and honored. Once you are included into a family, you are a part of that family—exclusively. You don't wander around, you learn the working methods and aesthetics of your sensei (or master-teacher), and this becomes the foundation for both the people who get tattooed and tattoo apprentices who study under a sensei. Tattoos are not displayed and are reserved exclusively for the eyes of people in the family.

The process of acquiring and wearing a traditional, large-scale Japanese tattoo is seen as a social and political statement for people who have them. Life in Japan was permanently changed in 1854 when United States Navy's Commodore Matthew Perry steamed into Tokyo harbor with his black fleet; guns leveled at Edo castle. America forced Japan to sign the Kanagawa Treaty and open its doors to foreign markets and commerce. This put into motion a series of events that spelled the fall of the Tokugawa Shogunate in 1868 and the end of traditional Japan.

Until that point, Japan existed in a self sufficient, self-imposed isolation. In 1869 the lords or daimyo of the great Choshu, Hizen, Satsuma, and Tosa feudal clans that had controlled feudal Japan surrendered their fiefdoms to the Emperor. The 1871 Meiji Decree abolished all fiefs and created a new unified centralized government. Traditional values that included a system of chivalry based on virtues of rectitude, endurance, frugality, courage, politeness, truth, and loyalty known as Bushido were abandoned for a new system imposed by the interloping West. In time, nationalistic and neo-conservative minded Yakuza members turned to traditional tattoos and the ceremony surrounding them as metaphors that represented the idealized, historical values associated with old feudal Japan.

The young people flipping through the pages of Toshio's tattoo flash books are following the global tattoo trend at the same time that they are confronting and contradicting some of the basic values of their own culture. The Western style tattoo flash has little to do with the tattoo traditions of Japan and everything to do with a fascination with the West and global youth culture. The tattoos are tiny compared to the traditional, epic full body suits and are now referred to as "One Point" tattoos—they are only on *one point* of the body. Images run the spectrum from generic Tribal styles to nostalgic Americana. With the growth of enthusiasm about Western style tattooing among young Japanese, the practice has started to drop off with Yakuza devotees. Tattoos are losing their historical integrity and intimidating prowess. In the eyes of a growing number of Yakuza members, traditional significance has once again been diffused and polluted by Western influences.

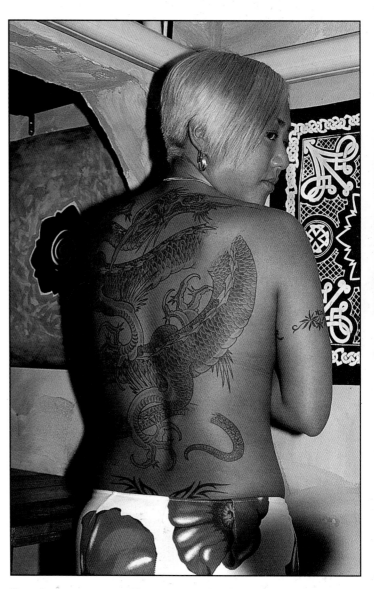

Shimada tattoo customer. Tattoo by Mike Ledger, Hawaii

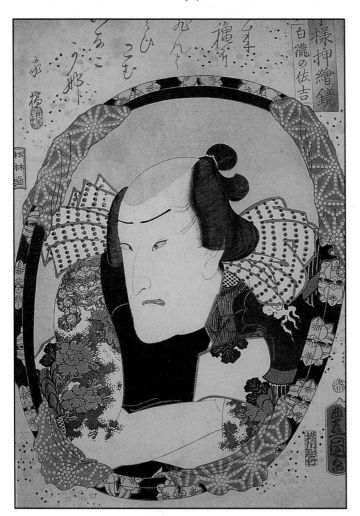

Ukiyo-e woodblock print by Toyokuni ca.1850

Shimada customers, Shibuya street flyer kids

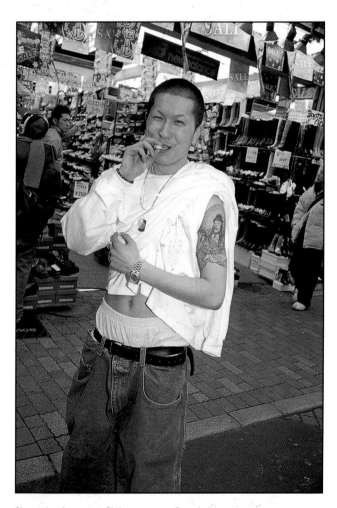

Shimada customer, Shibuya street flyer kid

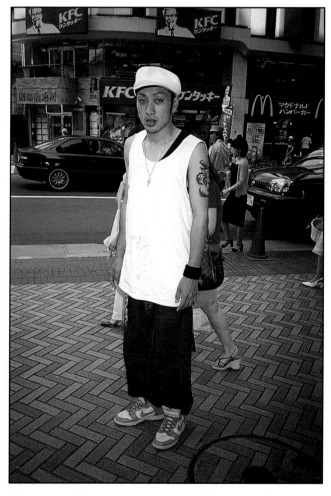

Shibuya flyer kid

In big cities like Tokyo and Osaka there are parallel tattoo cultures: The tattooers who have always been there are a part of the tradition and continue to specialize in classic images and techniques and the newcomer One Point tattooers exploring and fueling the trend. The traditionalists work in small studios located in anonymous apartment buildings. Without an introduction they remain a mystery. There might be a simple business card over a doorbell and that's it for advertising. They cater to a select clientele of insiders and their reputations are rarified and protected.

Contrasting this, Tokyo and Osaka now have dozens of Western style One Point tattooers working in open, street or upstairs shops. These shops have bold sidewalk signs and the artists openly advertise their location and abilities in the big Japanese tattoo magazines, *Tattoo Burst*, *Tattoo Tribal*, and *Tattoo Life*. These magazines have become very influential in promoting and mainstreaming the art form of tattooing in Japan. Young people look at these magazines, identify with the trendy images and lifestyles, and get tattooed. In the Tokyo youth districts of Shibuya and Harajuku or in Osaka's American Village area it has become common to see young people wearing Western, urban style clothing, flaunting their One Point tattoos, and appearing plugged in to something big, youthful, stylish, and powerful.

Shinjuku Park

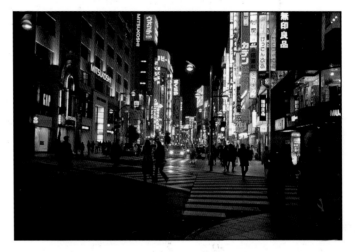

Shinjuku, Tokyo, at night

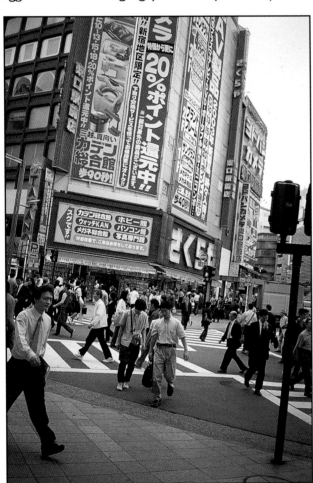

Shinjuku street

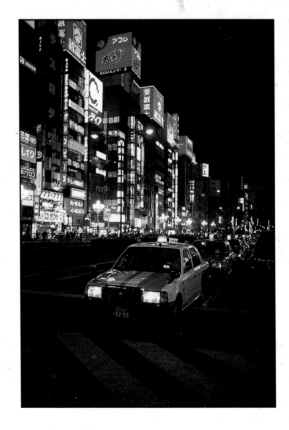

Shinjuku, Tokyo, at night

Toshio's perspective about the current upswing of tattoo interest in Japan is interesting. He is of Japanese decent but was born in Sao Paulo, Brazil, in the 1970s. His grandfather had migrated to Brazil from Japan and Toshio's father tattooed Western style in Brazil. Toshio learned the ropes about tattooing from his father when he was eleven years old. In 1994 Toshio moved to Japan to work in factories with other Brazilians. He speaks Japanese, English, and Portuguese and opened a tattoo shop in Guma-ku, Oizumi, Japan, where he developed a good reputation tattooing Western-style designs on Brazilians working in local auto assembly factories. He is both an insider and outsider to Japanese culture and can take a step back and reflect about the recent rise of One Point tattooing.

"This Westernizing process has changed everything about tattooing in Japan," Toshio explains. "The One Point style is all about the Western influence. I opened my shop in the Shibuya shopping district in 1998. The landlord charges me by the square meter for my space. Tokyo is about the space.

"A few years ago young people started to see tattoo magazines from America. They were impressed by the designs, the photos of American young people. These were strong pictures for some young Japanese. Many went to America to get tattoos. They came back with this new style. The influences from the West are powerful in a place like Japan. Young people are all Japanese. They live in their own world. They search for things. Japan is an island. On Saturdays in Shibuya there are tens of thousands of young people here. They look and they shop and they walk around. Like an ocean of young people. They look for new styles to buy. Everything is style for young people in places like Tokyo. Tattoo is new style.

"In old days in Japan the master was in charge of what was tattooed. Japanese people wanted to be tattooed by Japanese tattooers. The master system had a big influence over what was tattooed. When I came to Japan I tattooed outside that system. I am only half-Japanese. I experienced some discrimination. This has faded and will continue to fade as more One Point styles have influence. I tattooed what the customer wanted not what the master wanted but nobody knew what to get tattooed. There was no new pictures, no choice. Now there is more information."

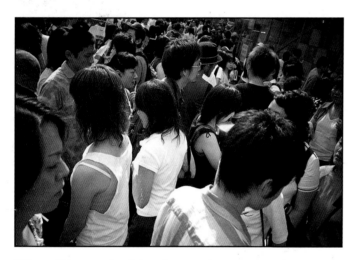

Shibuya, Tokyo, weekend shopping crowd

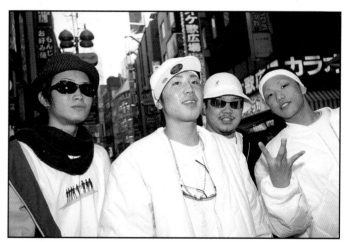

Shibuya, Tokyo, style kids

Shibuya, Tokyo, shopping

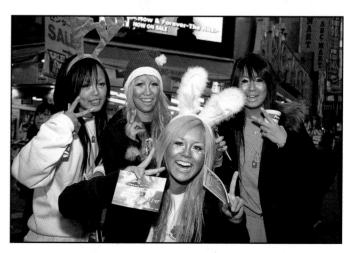

Ganguro Girls, Shibuya

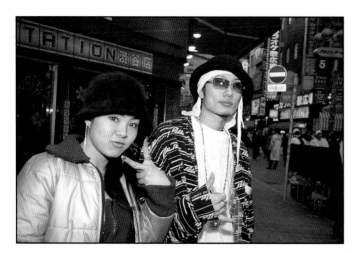

Shibuya, Tokyo, style kids

Yayogi Park kakkoii

Jeff Tam, who tattoos in Shibuya for Toshio, explains about the importance of presentation for many young people in Japan. "You know, the issue of presentation is so important here," he says. "Young girls don't like to go to emotional movies with their boyfriends. If they cry during the movie their eye make-up smudges and they get what they call raccoon eyes. They will not cry at the movie but later they will rent the video and watch it at home where they can cry in private and not worry about smudged make-up. Many young girls only put their make-up on in the anonymous setting of the subway. They will never see these people again and do not feel vulnerable or exposed. Tattooing has become a big presentation style too."

Shinjuku coffee shop kakkoii

Yayogi Park kakkoii

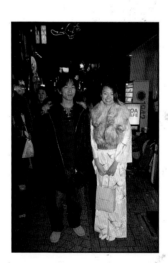

Harajuku kakkoii

Shinjuku coffee shop kakkoii

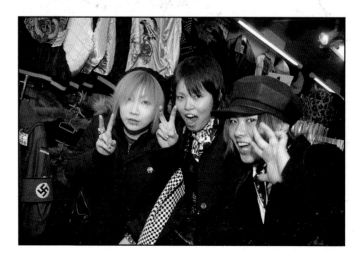

Harajuku kakkoii

Burst Magazine Senior Editor, Miho Kawasaki, Editor, Atsushi Takeuchi, and Editor and photographer, Ryoichi Maeda have chronicled the rapid rise of youth-based tattooing in Japan. Miho explains, "*Tattoo Burst* started in 1999 and was the first Japanese tattoo magazine. Now there are two new tattoo magazines in Japan: *Tattoo Tribal* and *Tattoo Life*. What has developed in Japan around tattooing is a way of life. For young people, particularly urban young people, style is a huge component of life. What music you listen to, what clothes you wear, how you shop, how you carry yourself on the street; it's all style. Street culture in Japanese cities is very important," she continues. "People live in tiny, confining apartments. During the warmer months, life unfolds outside on the street. Tattooing is seen as a new, vital aspect of street style. *Tattoo Burst* has been a big part of the growing popularity of tattooing in Japan. It has redefined, validated, and broadened tattooing away from strictly Japanese traditions. Tattooing is now seen by the young as a style they can explore to become hip and international."

Ryoichi Maeda has taken thousands of photographs for *Burst* and *Tattoo Burst* magazines of tattoo personalities and sponsored tattoo events. "There are now 400 or more shops in Japan," he says. "Different people in Japan use tattoos for different reasons. There are traditional connections to Yakuza families and there are new connections to young people One Point style and there is people called Chin-Pirra. This is street thug style for people who are not a part of a family or gang. They have Yakuza style tattoos to project this type of toughness. They use style to talk about their mentality about life—A Thug Life. This usefulness of tattoo style is interesting.

Vintage style

Vintage style

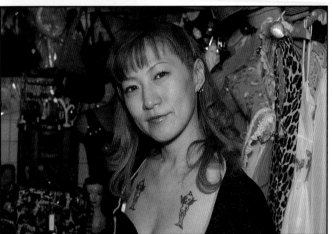

Burst Magazine staff

Harajuku Jack

Vintage style

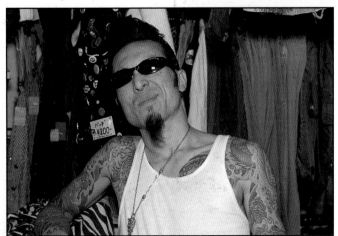

Shibuya Chin-Pirra

"The economy in Japan might have something to do with the current tattoo interest. At one point young people getting out of college were guaranteed a job for life," he says. "This is all gone now because of the bad economy here for almost fifteen years. Now young people struggle to find any job…. Some young people are now known as "Free-ta" kids. They live day to day and have little ambition to enter the corporate world. There is a perception among many young people that opportunity for them is limited."

Tattoo Events

A social life has evolved around contemporary, Japanese youth-based tattooing that includes what are called "Tattoo Events". Tattoo shops sponsor promotional parties at small nightclubs in an effort to create interest and stimulate business. Young urban people usually jump at the opportunity to get out of their cramped apartments, dress stylishly, and listen to some music.

Ink Rat customer. Tattoo by Rei Mizushima

Ink Rat customer

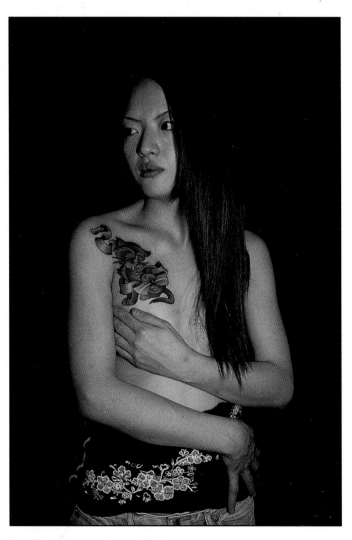

Cat Claw customer. Tattoo by Madoka

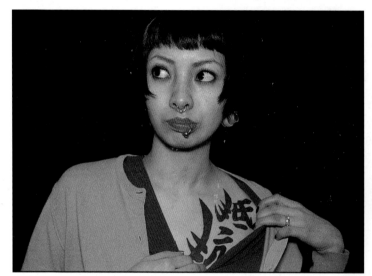

Ink Rat customer

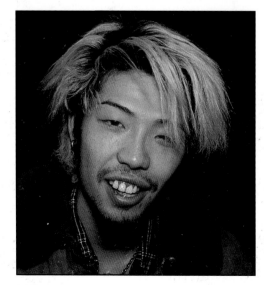

Ink Rat customer

Shinjuku coffee shop kakkoii

Young
Shinjuku
woman

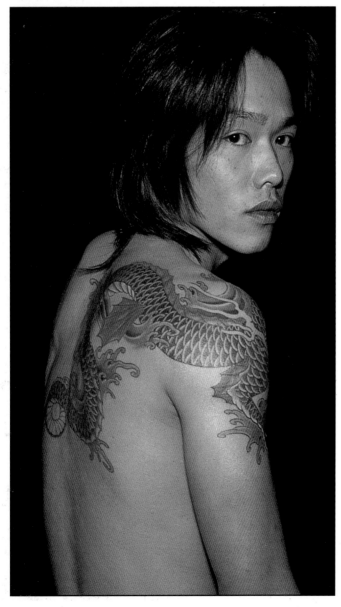

Tattoo by Toshikazu

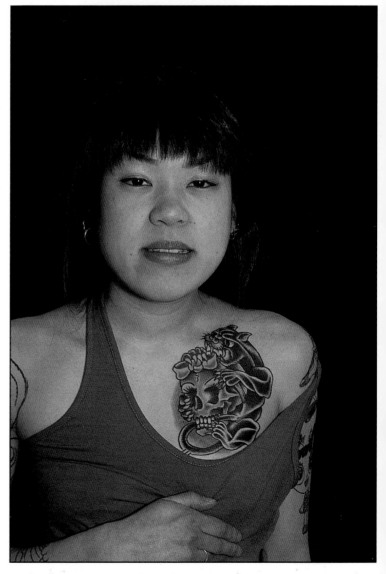

Ink Rat customer. Tattoo by Rei Mizushima

Ink Rat customer

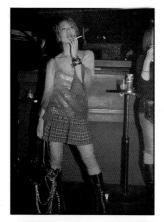

Spotlight Tattoo party

Spotlight Tattoo party

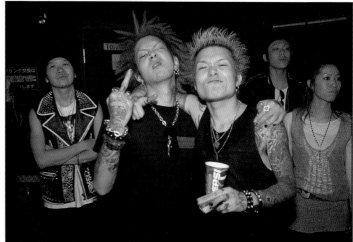

A recent Spotlight Tattoo Tokyo party was held in a medium-sized, split-level club called Marz in the Kabuki-Cho section of Shinjuku. It featured several hard-core bands, beer, and close to one hundred Spotlight customers. Spotlight is located in the Kitazawa section of Tokyo in a newly constructed shop. Shop owner Makoto Kato and a tattooer named Dai specialize in bold, Western One Point tattooing. Kato explains, "I opened the first Japan Spotlight tattoo almost ten years ago in Tokyo.

"There are similar looks to traditional American and traditional Japanese tattoos. They are both bold looks and the traditional colors are very similar. Both styles use a lot of red color. Images of snakes, dragon, tiger, flowers, it is all very similar. So when we put these styles together they look strong and good. These styles merge good. This is interesting I think. When I look at the old Ukiyo-e woodblock pictures of Hokusai and Kuniyoshi, I think the drawing style is very similar to old traditional American tattoo drawing. It is simple way to draw basic forms. You look at sideways pose of traditional koi and traditional Western panther, there are similarities. Cherry blossoms and Western roses, the visual themes are very direct. Panther to dragon to koi, very similar, direct style. At Spotlight we are always drawing and painting. This is very important to learn about how these designs work well."

Spotlight Tattoo party

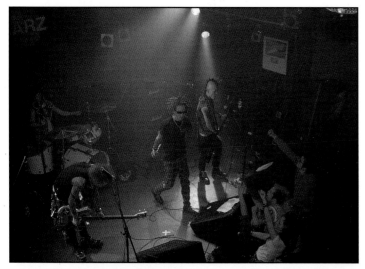

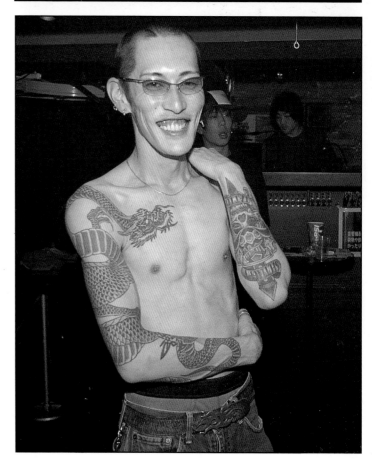

Spotlight Tattoo party

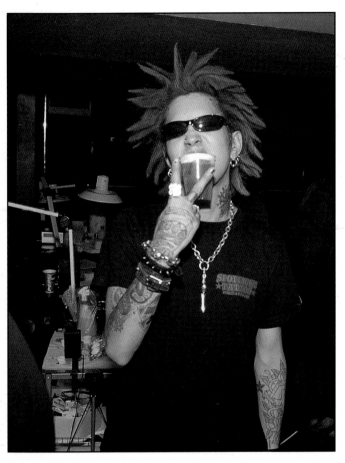

Spotlight Tattoo party

Spotlight Tattoo party

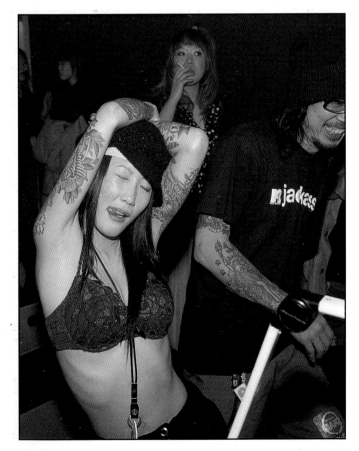

Spotlight Tattoo party

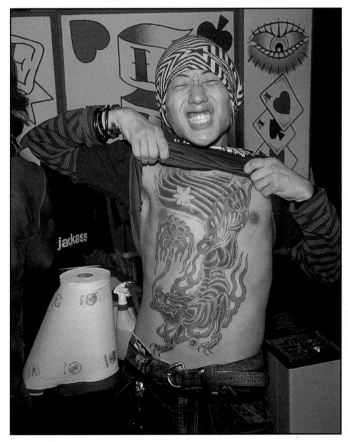

Spotlight Tattoo party

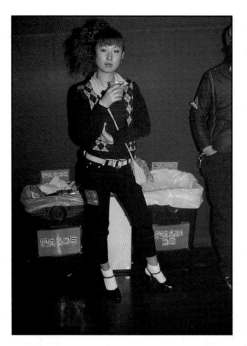

Spotlight Tattoo party

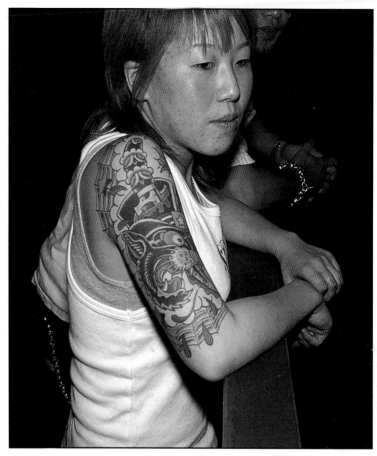

Spotlight Tattoo party

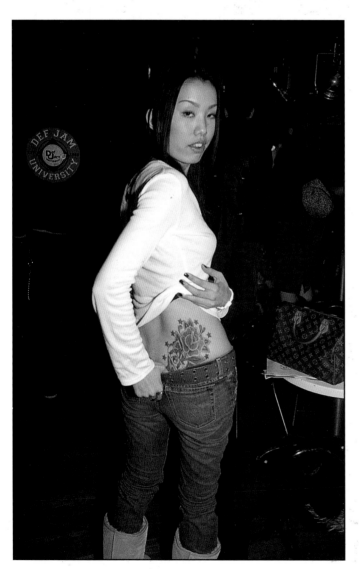

Spotlight Tattoo party

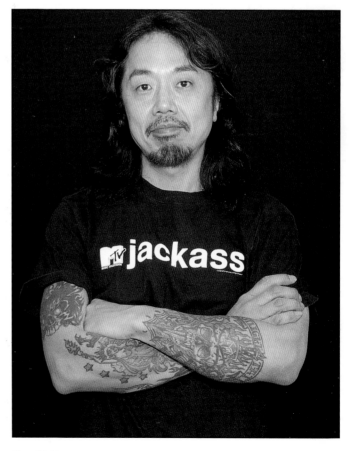

Kato Makoto

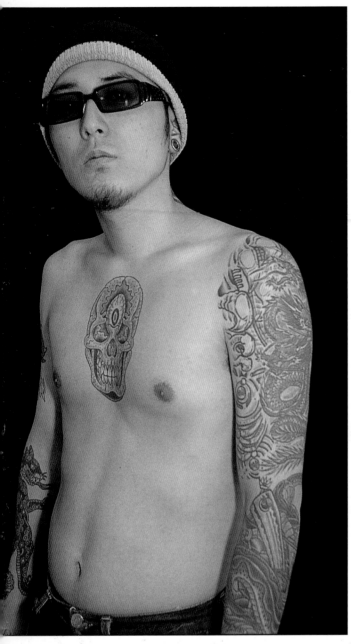

Dai

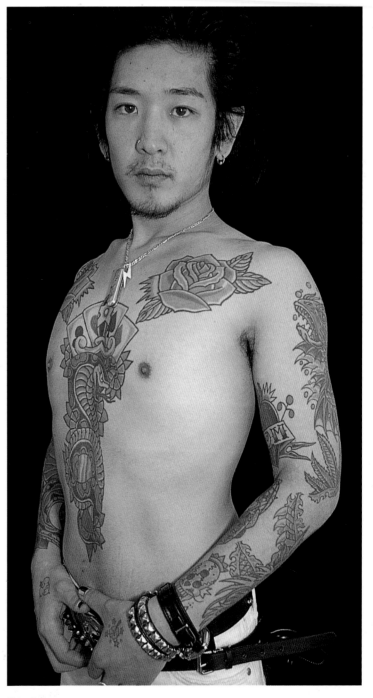

Shin Arai

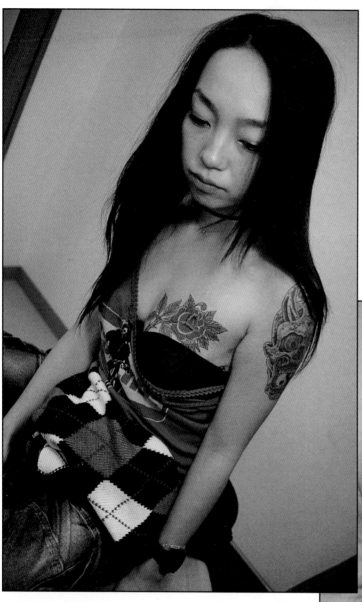

Tattoo by Kato

Tattoo by Kato

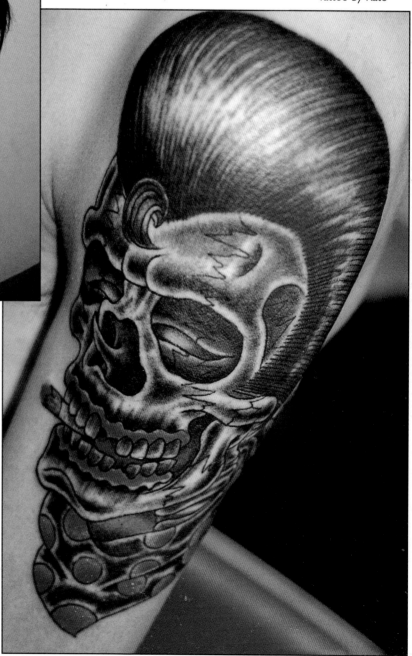

Tattoo by Kato

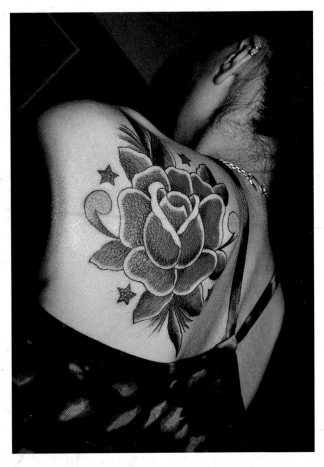

Tattoo by Kato

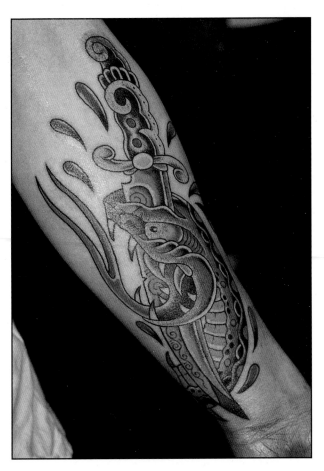

Tattoo by Dai

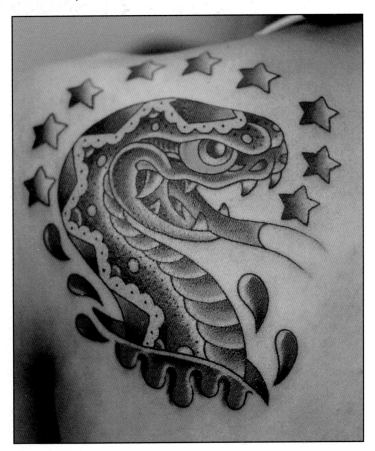

Tattoo by Dai

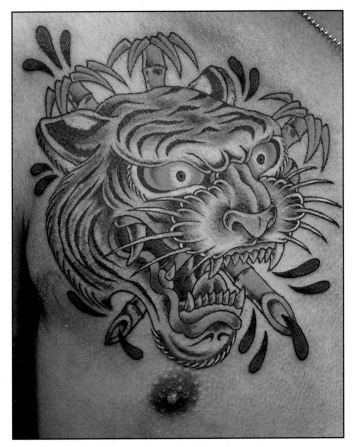

Tattoo by Dai

A second Tattoo Event sponsored by the skateboard fashion label Asian Wave is held at the trendy Club Wedge. There are several floors to the club and different groups of young people are attending different events. Each event has a different style theme, whether it is Punk Rock, or '50s Rock and Roll or Skate style. The fashion statements are specific.

A young tattooer named Toshikazu used to be a professional skateboarder and developed the Asian Wave label. He tattoos from a private studio located in the Mejiro section of Tokyo. As a young Tokyo person, he represents the cross over and intersection of youth, self-expression, style, and fashion. "At ten years old, I was a skateboarder," he says. "I started designing skateboard decks and other things related to skateboarding. I call my company Asian Wave. My father is a furniture maker and I used his workshop.

"My nick name is Black Fish. At eighteen years old I became a professional skateboarder. I was a competitor. In 1989 I was number one all Japan Championship Amateur Class. In 1990 I was sponsored by five or six skateboard companies. Most skateboarders were American style. I wanted to start a Japanese company. An original Japanese style skate company. My skateboard style is surf style—like water. I flow like water. I go to skate park and I like to just continuously skate. No stopping. Like water. I tattooed myself when I was thirteen years old. I wanted to be a tattoo artist since I was a young man."

Toshikazu describes the intersection of different styles and ambitions in his life as a young, urban Japanese person. His experiences describe a broader cultural theme and process effecting young people in Japan. "There are all different styles now among Japanese youth," he says. "Skateboarding is very popular now among young people. I think that skateboarding and tattoo are my life. Like a coin with two sides. My life is skateboarder on one side and tattooing on the other.

"In the United States many professional skateboarders make tattoos. Now in Japan I might be the only professional skateboarder who is tattoo artist. I respect the old Japanese style but I want to change a little to make it more myself. Old style Japanese uses the same images and design motifs. This is good. I wonder about making changes. Making it more a personal artistic expression. I have great respect for tattoo artists Horitaku and Hori-Show.

"I look at tattoo magazines sometimes but I like Japanese art and old Japanese artists like Kawanabe Kyosia for demons and Ekin for crazy faces. Soga Shomaku looks crazy but I like this style. I enjoy crazy expressive faces. I might be skateboarder but I know about my culture and history.

"I tattoo now for thirteen years. Every day I study and draw on my own. I study my method every day. I have tremendous respect for older tattoo artists. This is a part of being Japanese—to respect what has been. To respect the past. There is no conflict with the past and present. There is a seamlessness. Even if it is One Point tattoo. The respect goes through time. There are no divisions."

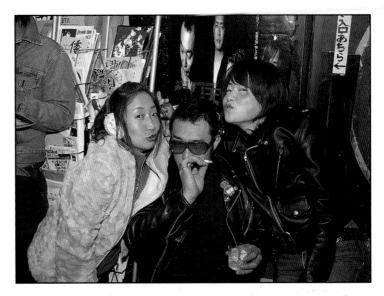
Asian Wave party

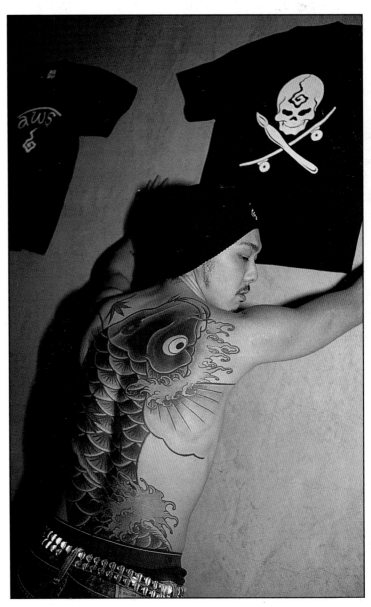
Tattoo on Toshikazu by Tokyo Horitaku

Asian Wave party

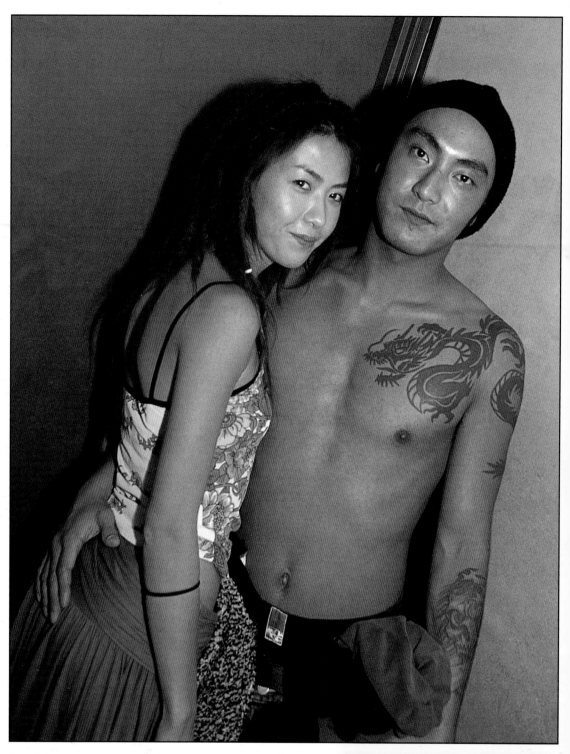

Asian Wave party

Toshikazu

Asian Wave party

Tattoo by Toshikazu

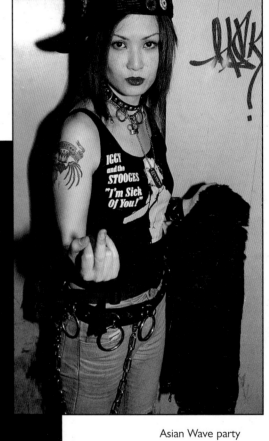

Asian Wave party

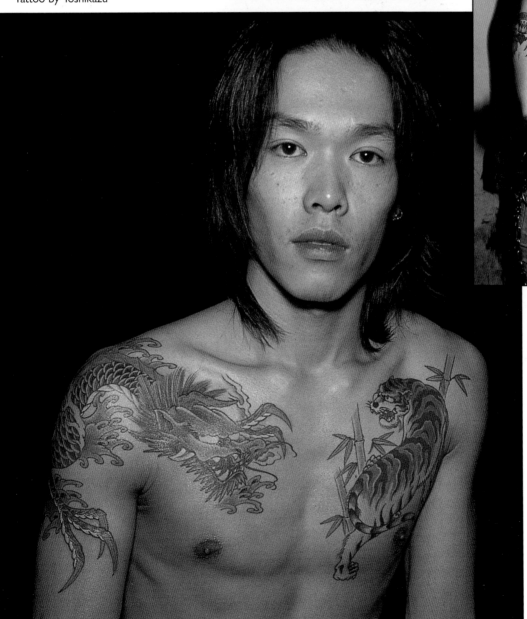

Scratch Addiction

Teenybopper girls who stroll Takeshita Street in the Harajuku district stretch the limits of Japan's healthy respect for the past. They slide along carrying a half dozen shopping bags over their tiny wrists. Marketing research companies are known to give young women in Harajuku 100,000 Yen ($100US) and then check out the crazy stuff that they buy.

A Harajuku girl is standing in the middle of Scratch Addiction Tattoo eyeballing the flash. She has dark eye makeup, a dozen pieces of metal sticking out of her face, fake bandages wrapped around her arms and legs, and is wearing a black ensemble of tattered jeans and a see-through fishnet top. That's Harajuku in a nutshell. Scratch Addiction was opened by Kawajiri in 1997 and was the first real street shop in Tokyo. The original tattooers to work at Scratch Addiction: Horijin, Kagetora, Horiken, Yushi, Washo, and Horikado charted a new direction for tattooing in Japan.

Harajuku girl.

"Horijin and Yushi opened a tattoo bar in a different section of Tokyo in 1996," Kawajiri explains. "I felt it was better to open a shop and it was important to open in the Harajuku section. When we first opened there was a mixture of reactions but gradually the interest increased and slowly tattooing became more popular. This is the first example of this style shop; we specialize in Western style tattooing. It is out of respect for the old traditional Japanese style and artists. I never crossed that line. I organized the shop to be accepting and inviting, to be normal. I hired a shop girl, Satsuki, someone to be soft and inviting. This was a first, to create an inviting atmosphere.

"It took six months or a year," Kawajiri continues. "And everything took off. Tattoo magazines from the West could be found in record shops. Punk bands like Rancid were heavily tattooed. The word on the street combined all these pop culture influences together to create a new trend."

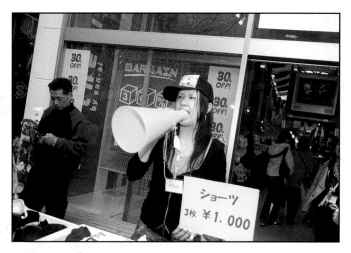

Takeshita Street, Harajuku

Harajuku girls

Harajuku Goth girl

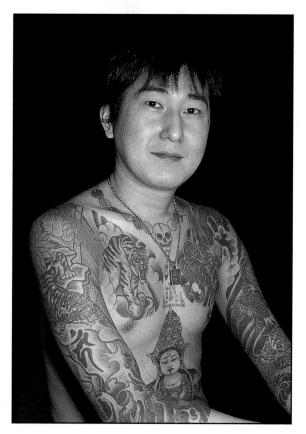

Kawajiri

Yushi

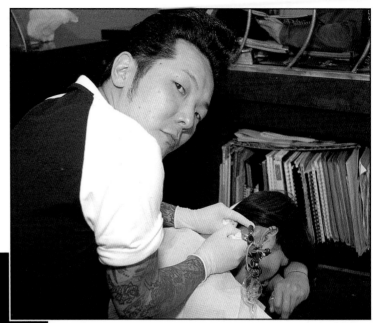

Yushi

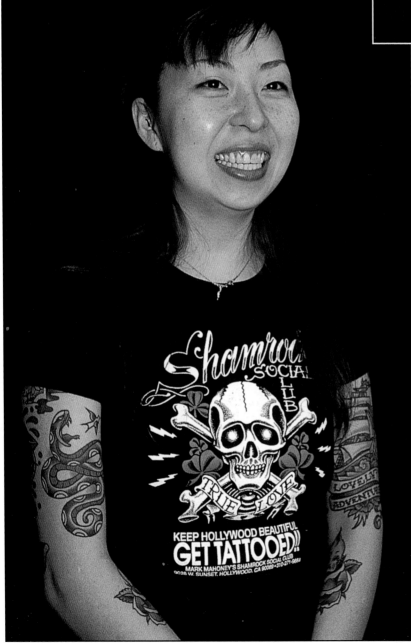

Satsuki

Kenya

Scratch Addiction has had a big influence on the face of tattooing in Japan. As a walk-in shop this has changed the way people think about tattoos. There are no associations with gangs or organized crime—just tattoos. When a customer walks into Scratch Addiction, they leave those associations behind. The shop welcomes tattooers from outside Japan. Mike Wilson, Freddy Corbin, Juan Puente, Charlie Roberts, Pantung, Marcos Fernandez, and Ron Ackers have all worked at the shop over the years.

Mike Wilson visits the shop from Jacksonville, Florida. He has been traveling to Japan for six years and first started tattooing here privately. Now that the scene has opened up, he enjoys the standard street shop environment at Scratch Addiction.

"There are always three artists working at the shop," Mike says. "Fuji and Yushi work all the time and Hiro splits his time here and in Jacksonville. There is a long list of visiting artists. Language is always a problem for visiting artists from the West. We made a cheat sheet and keep it tacked to the wall: Come here—kocchi kite, Sit down—swate, What? nani, Where? doko, OK? daijobu, Stop moving—ugokanaide. Without that list there is no real communication. It is challenging.

"The world media has created this new environment in Japan," Mike explains. "It is all youth based, people are being hooked up through the sharing of images. Tattoos become passports in this new world. Having tattoos today opens doors for you. This is all just starting in a place like Tokyo. Just having tattoos today is what's important in terms of creating connections between people. As tattoos become completely popular this will change. The only constant thing in a place like Tokyo is change."

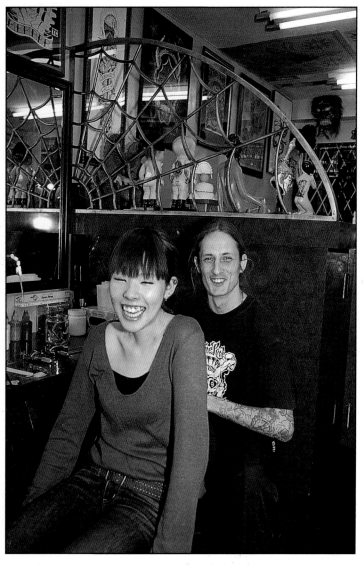

Pantung

Marcos Fernandez

Hiro is twenty-nine years old and tattooed for the first time at fourteen when he was in reform school. He met Bob Roberts in Tokyo and worked on the street as his flyer guy when Bob was in town. Then one day in 1992 he gathered together some of his best paintings, flew to California, found Roberts at Spotlight in L. A., and asked for an apprenticeship. He studied with Roberts for a while. He continues to be associated with Ray Giambroni of Classic Tattoo in Orange County. He moved back to Tokyo and pitched a little semi-pro baseball until he broke his arm throwing a slider. The arm has healed and he now dedicates himself entirely to his tattooing.

"There is a cultural process going on everywhere," Hiro says. "People like to experience other people's cultures. After the War in Japan the culture went two ways. There were some people who saw the United States as the new power, the new thing to identify with. Anything from America was seen as powerful. Then there is the other part of the culture, which identifies with Japanese culture. There is no concern with the West. It is seen as a bad influence.

"Tokyo is a very stylish place. This goes back into Japanese history, the late Tokugawa period and the Floating World. It was called Ike-teru: To be cool and stylish. People in Tokyo are living the same style life. It is new but same belief. Tokyo style is separated into different tastes," Hiro continues. "People in their late twenties and thirties want to identify with something. Something like Rock-A-Billy or Punk but always something. How you look, what music you listen to, these are important. Everything must be cool. Kakkoii! The concept is a part of life. Without this, there in no life!

"Life is fast in places like Tokyo," Hiro continues. "Fads develop quickly. Television stars, music stars come and go very quickly. They are at the top and then totally disappear. Life comes and goes. It's just what happens."

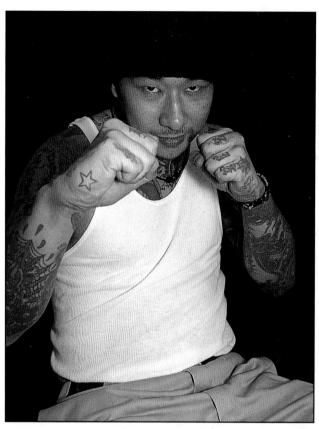

Hiro

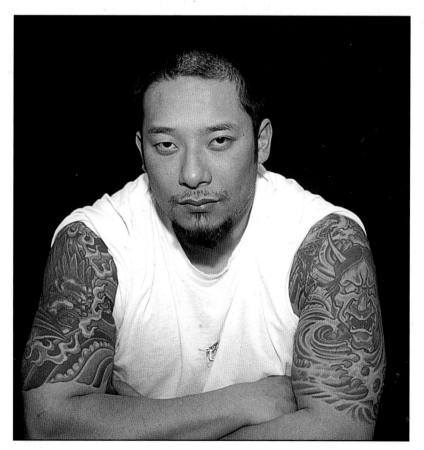

Scratch Addiction customer

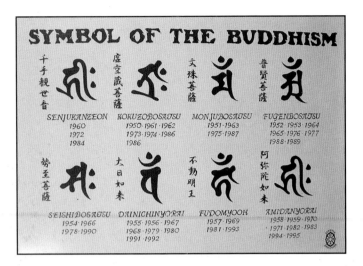

Bonji flash sheet by Satsuki

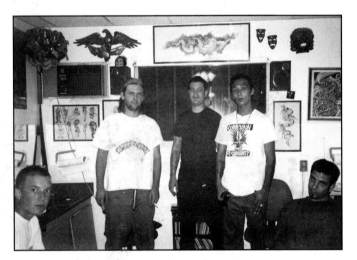

Scratch Addiction 1994. Hiro (R) with Charlie Roberts and Joe Vegas

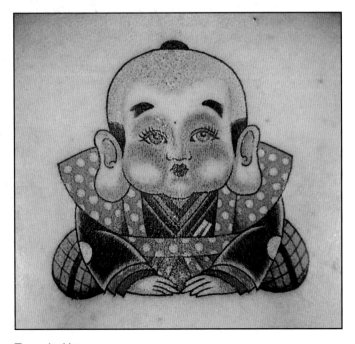

Tattoo by Hiro

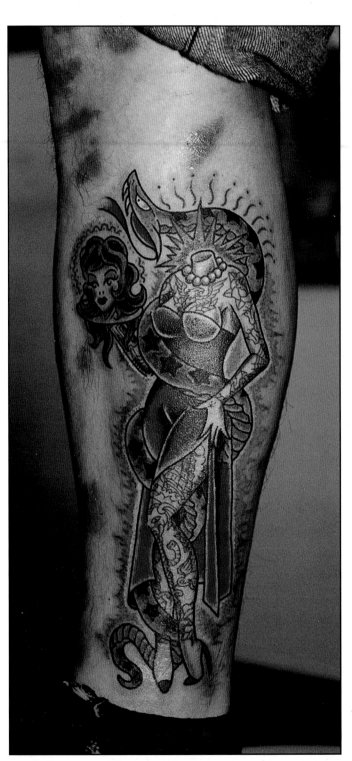

Tattoo by Hiro

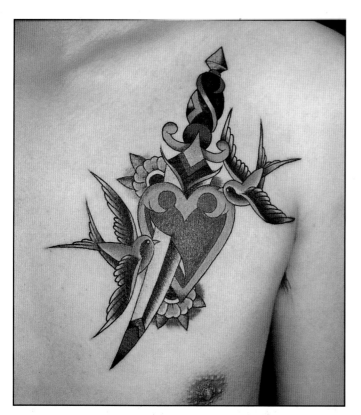

Tattoo by Hiro

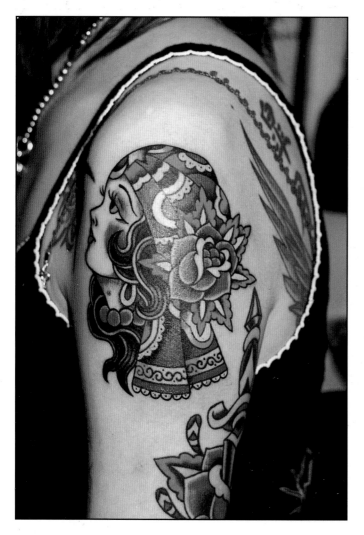

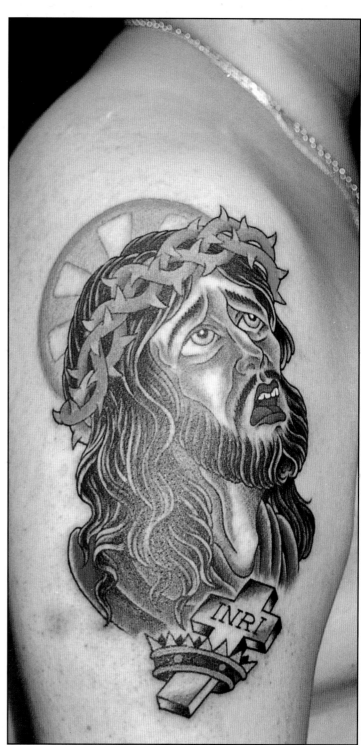

Tattoo by Hiro

Tattoo by Hiro

Tattoo by Yushi

Tattoo by Yushi

Tattoo by Yushi

SCRATCH ADDICTION
1-7-5 B1 JINGUMAE SHIBUYA-KU TOKYO JAPAN 150-0001
TEL 03-5411-1228 FAX 03-3746-9943

Scratch Addiction business card

Shibuya Horimasa

The Shibuya section of Tokyo is known for its trendy shops and trendy people. Horimasa's small apartment-like tattoo setting is a ten-minute walk from the Harajuku, Yamanote Line subway station. The sidewalks are overrun with a mix of younger and middle-aged people who all seem to be in a rush, like they are running from a fire. This is the typical Tokyo pace.

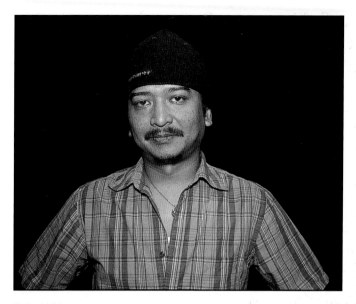

Shibuya Horimasa

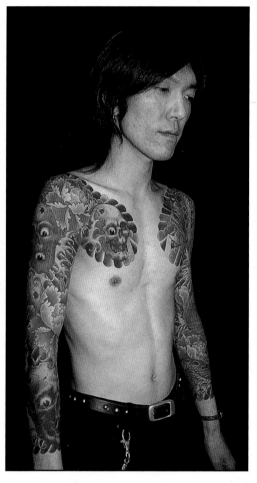

Tattoos by Shibuya Horimasa

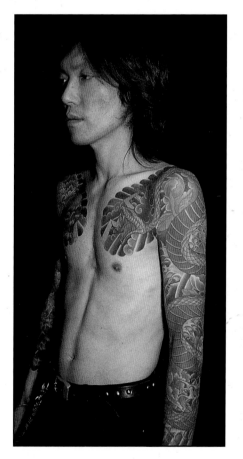

Tattoos by Shibuya Horimasa

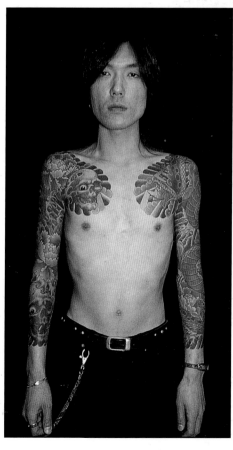

Tattoos by Shibuya Horimasa

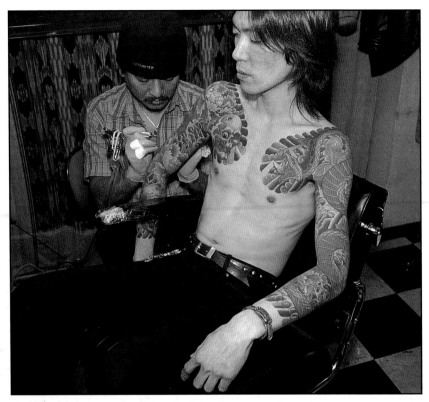

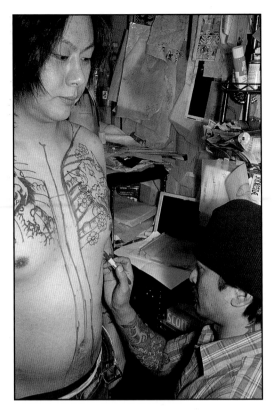

Shibuya Horimasa

Shibuya Horimasa

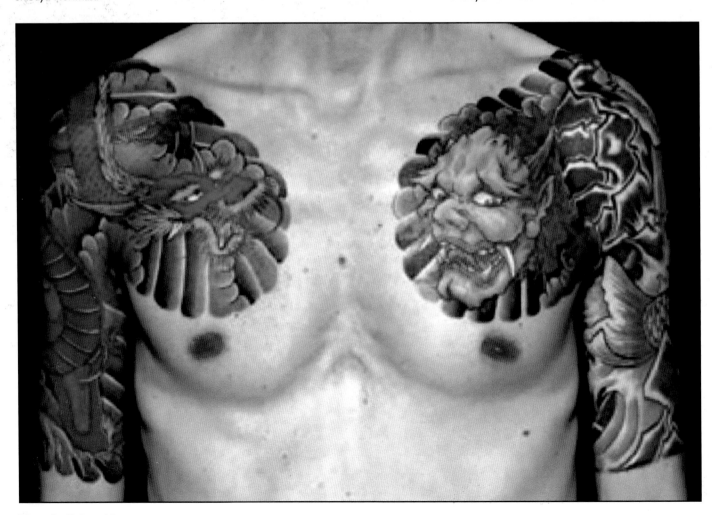

Tattoo by Shibuya Horimasa

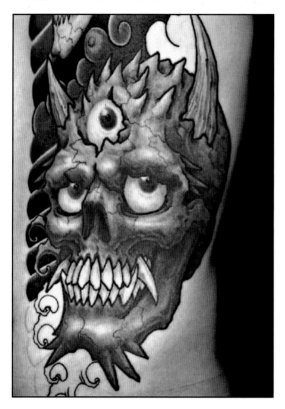

Tattoo by Shibuya Horimasa

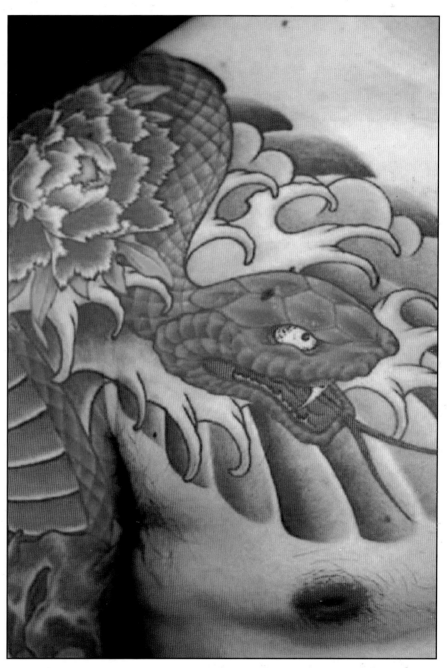

Tattoo by Shibuya Horimasa

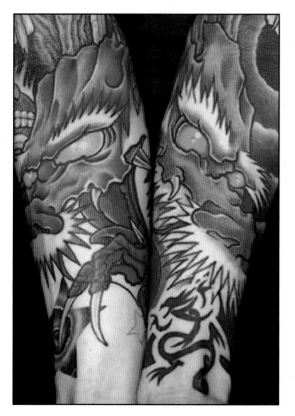

Tattoo by Shibuya Horimasa

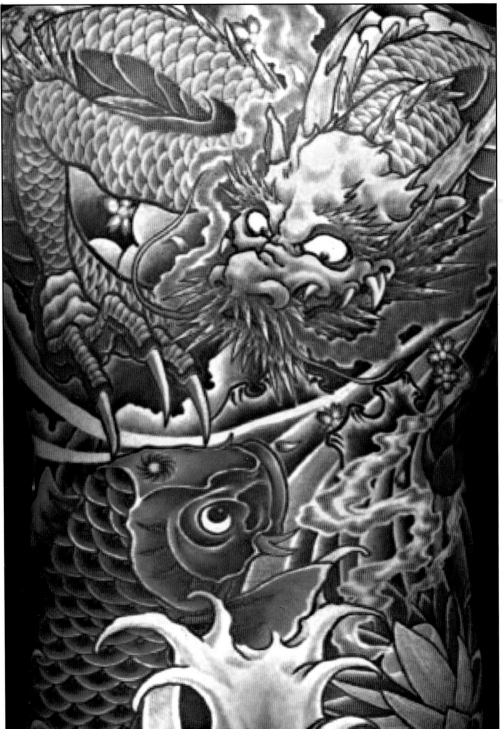

Tattoo by Shibuya Horimasa

椿五六突

Shibuya Horimasa name card

Shibuya Horimasa Shop card

Horimasa has traveled to Europe and the West a few times. He is influenced by the Asian Fusion look and has worked with European tattooers Filip Leu and Luke Atkinson who both had an early hand in developing the style.

"I've been tattooing for fourteen years," Horimasa says. "I always tattoo in Tokyo. My first studio was near my current location for three years. Then one year at a different shop with a Tokyo tattooer named Hideo Uchiyama. I started tattooing One Point style for four years but I always respected the Japanese style. It has had such a big impact on me as a tattoo artist. The images of the skull and dragon always seemed very strong to me but I wanted to maybe change them a little. Image of skull is old in Japanese art— the dark, macabre, and weird is a tradition, especially in period of Ukiyo Floating World and Ukiyo-e art. Utagawa Yoshiiku, Utagawa Kuniyoshi, and Shunkosai Hokuei make many image of skull and ghost and weird things. These pictures were favorite of many Japanese people; they help people to think about different kinds of life.

"Japanese people still believe in all these spirits. Maybe not as strong in city like in the country life but people do believe. There is spirit world called Yomi-no-kuni. This is underground world of dead people but not necessarily a bad place, just the place where dead people go. If they behave well they can go to other places too.

"At the end of every year, Japanese people have a ritual of cleaning called Susuharai. Everybody sweeps out and clean their house or apartment or business. They clean all the objects in the place. Everybody believes that this helps to discourage negative things and bad spirits from getting too deep or getting too powerful. Around New Years time when you walk down the street, everybody outside sweeping and cleaning and arranging things. This is important thing to do to make your life better.

"With my tattoos, I wanted to make new version of these old image, I wanted to keep the traditional Japanese background the same. A good combination I think. I experimented with this idea for a while but during the past three or four years I have really discovered how to combine the styles. I think when you combine the styles is where the real strength is. I like to learn the old stories about the old traditions. I really work at learning the stories and feel that this is what gives me strength as an artist. The story of the Earth Spider, the spirit of Tamichi and the Great Snake, the Lantern Ghost of Oiwa."

Like many tattoo artists in Japan, Horimasa turns to traditional cultural history for his foundation. He is making changes but does not stray too far from the fundamental significance. He understands that without the historical strength, he is only making hollow pretty pictures.

"In the future I plan to study traditional tebori styles. I feel that the use and knowledge of traditional styles is what makes a tattoo Japanese. Not necessarily the technique…. However, I feel that once I learn and practice tebori this will change my mind. Then maybe doing this traditional technique will influence me. Then I may become more of a traditionalist.

"I respect many different tattoo artists. I worked with Tokyo Horitoku and he taught me drawing. He tattoos using traditional tebori style. I respect him like my sensei. I also respect Sensei Horitoshi. I also respect younger tattoo artists, Yokohama Hori-Shige and Sabado. I studied fourteen years ago in 1989 with Hideo Uchiyama. He helped me a lot. It is interesting to me to see the different styles of tattoo now in Japan. They all exist together and there is respect for each I think."

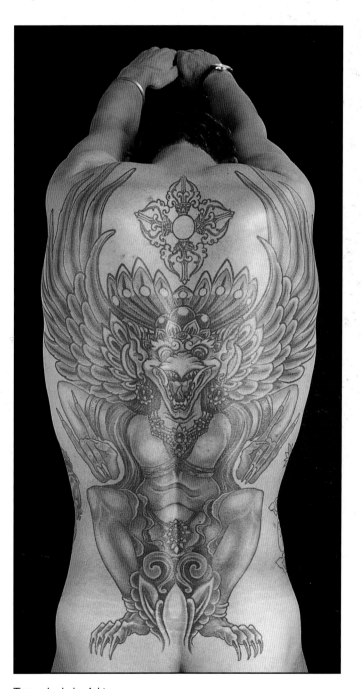

Tattoo by Luke Atkinson

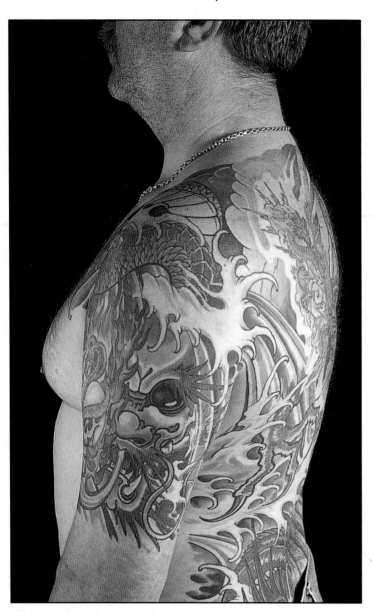

Tattoo by Luke Atkinson

Luke Atkinson with Sensei Horiyoshi III, 1999

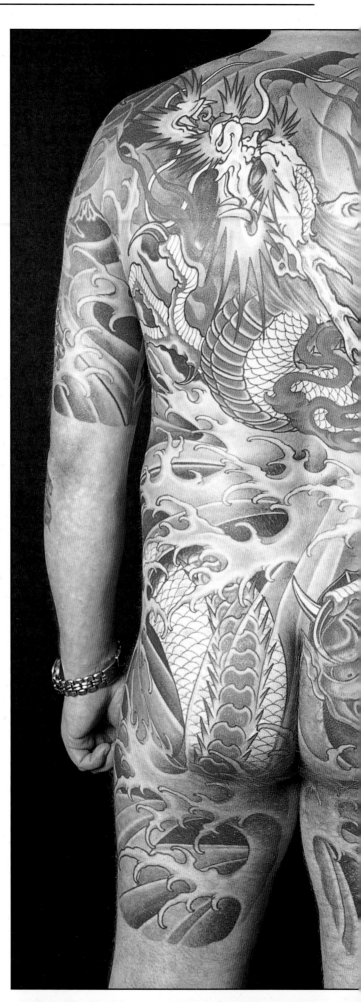

Tattoo by Luke Atkinson

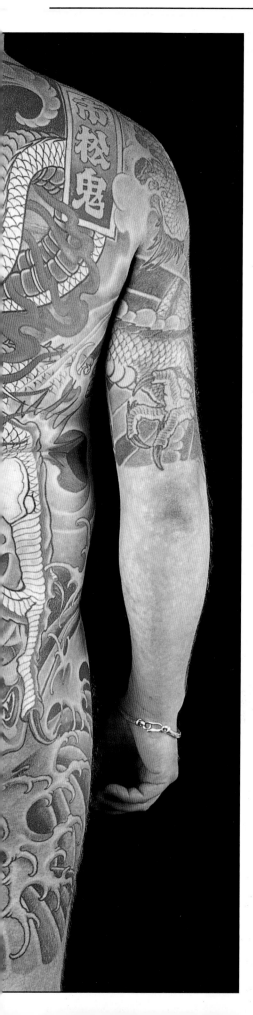

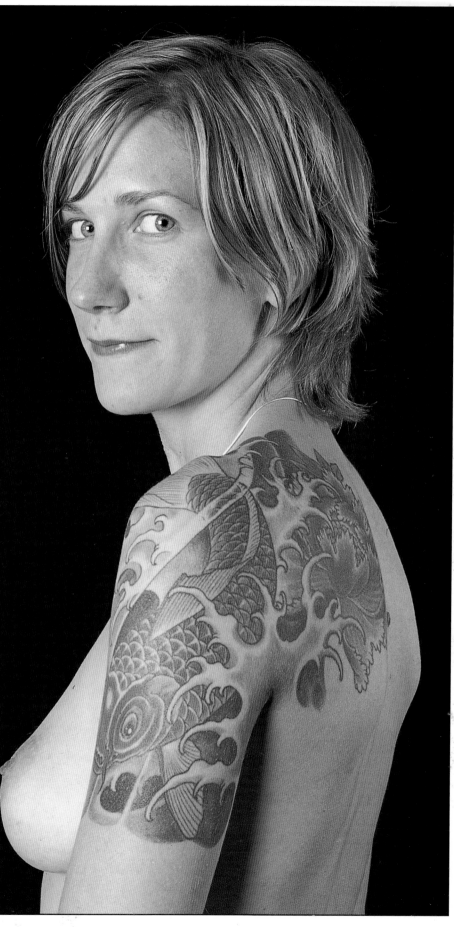

Tattoo by Luke Atkinson

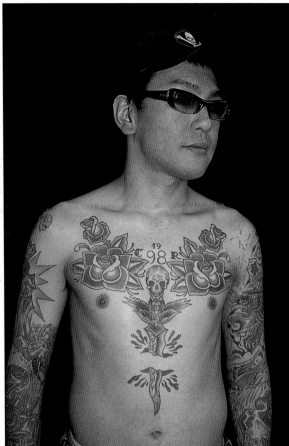

Rei Mizushima

Ink Rat Tattoo

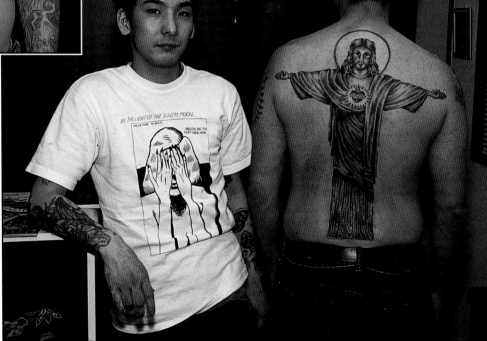

Hata Ryosuke with Christ tattoo

Ink Rat Tattoo

Ink Rat Tattoo is located on the second floor of a small, modern, brick building in the Kouenji, Suginami-ku section of Tokyo. A neon sign glows "Ink Rat" in the window. Shop owner Rei Mizushima tells me that a lot of Rock-A-Billy, Hard Core, and Ska musicians live in this section of Tokyo and that it is a hip place. The tattoo studio is very comfortable and stylish, with display cases full of American Hot Rod artifacts. The shop stereo is softly playing *The Space Mon-* *keys vs. Godzilla* in the background. Rei's girlfriend Izumi speaks English pretty well and helps with the back and forth between the languages. A second artist, Hata Ryosuke, is preparing a customer for some big work on his back. The tattoo is not a typical Japanese style dragon or protective Buddhist deity but a beautifully rendered black and gray image of Jesus Christ.

"There is total assimilation with tattoos now," Izumi says, translating for Rei and Hata as they point at the image of Christ. "This new tattoo is bigger than Japan. Just like the music. Everything is international now for the young. There are no seams in life anymore—Culture is seamless.

"I am thirty years old," Izumi continues. "There is new generation now in Japan. People under thirty may not remember the culture directly after the War. No food, no housing, much difficulty. Young kids have no knowledge of this difficulty. They only know the unconditional abundance of the New World culture. Young Japanese kids see life as limitless abundance. American Style tattoos become symbols of this abundance.

"The term Cool, 'Kakkoii' is used by young people in Japan to refer to Western symbols: whether it is music or style or tattoos or street culture. Southern California Chollo or New York City Gangster. These styles are idolized by many young Japanese kids, the 'Thug Life'. It is thrilling and dangerous. It is reaction to the safety of Japanese society."

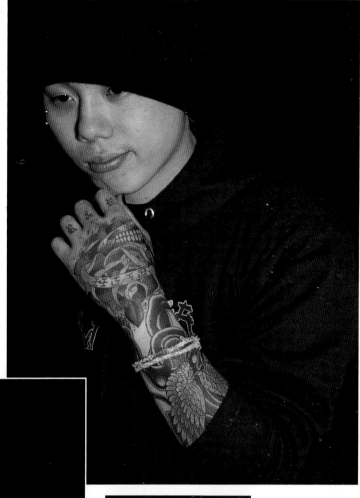

Tattoo by Rei

Hata
Ryosuke

Tattoo by Rei

Ink Rat customer

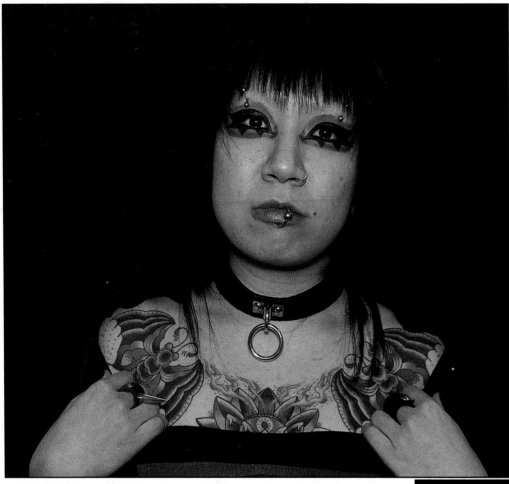

Tattoo by Rei

Rei has been exploring the American traditional tattoo style with his work. He is fascinated with the old American images as historical artifacts. "I enjoy tattooing the American traditional style and Japanese style because they both have meaning," he says. "These are old design that have history. I like to mix these and try to create a new style. I like Sailor Jerry Style; it is a happy style. It looks simple but it is not too simple. I find American style interesting just as American tattoo people find Japanese style interesting. I finally understand why I like American traditional style. There is a bold line, simple color and shading. This is similar to traditional Japanese style. I can mix the styles easily.

"For example, the Hula Girl image has similar power to Japanese image of Hannya. They are both cultural icons that have gone through time and kept their power. I study old stories associated with traditional Japanese tattoos. I also have interest in American culture. It is important to create a balance always.

"Since I was young I have an interest in America. When I was teenager, American products started to enter my life. In the 1970s, movies, music, and style came from America. These things had never been seen before in Japan so an interest developed. There was a theme of cultural freedom mixed with exotic material.

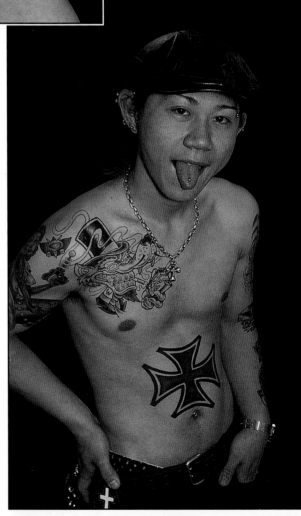

Ink Rat customer

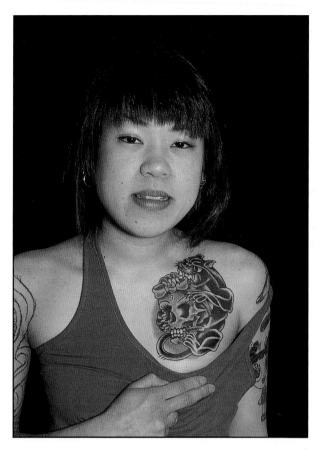

Kyoto Girl, Tattoo by Rei

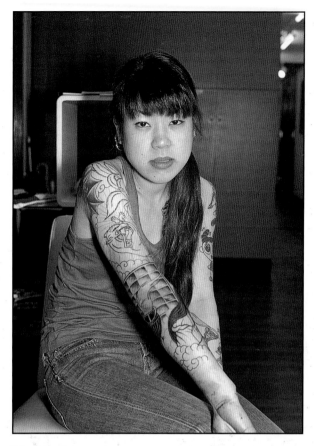

Tattoo by Rei

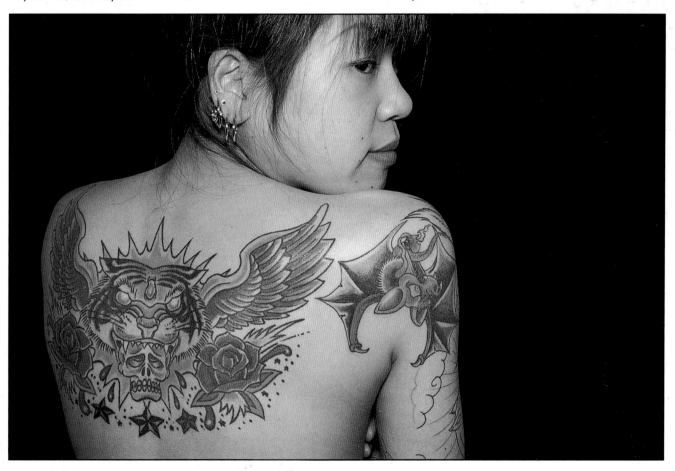

Tattoo by Rei

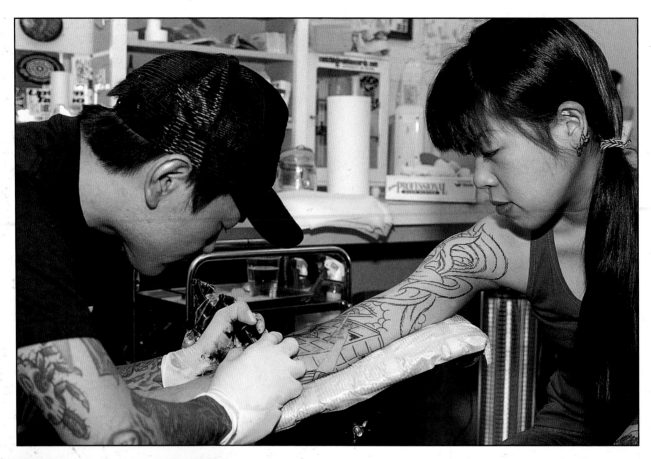

Rei tattooing

"Young people today in Japan," Rei continues. "Maybe their parents are also young. Maybe they do not know the traditions as much. Maybe the old culture is fading a little. If this is happening, I feel a sadness. Young people see the West as excitement. It is a combination of two forces. A fading of traditions and a flood of new things from the West. A trendyness from the West. Trendyness is an old thing in Japan from days of Edo.

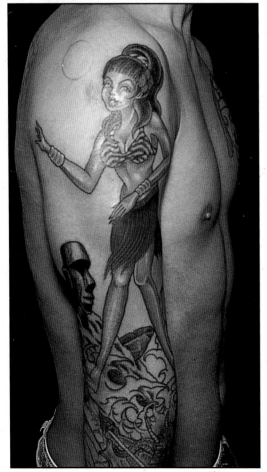

Hula Girl by Rei

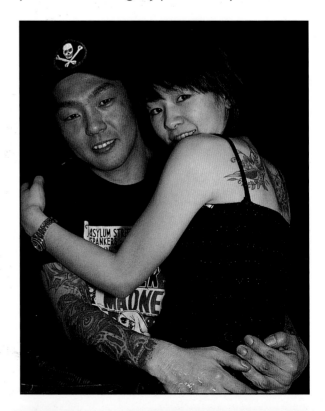

Rei and Izumi

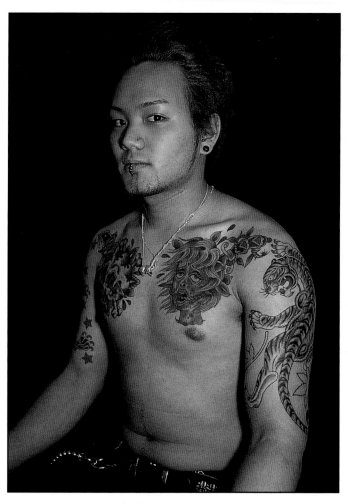

Ink Rat customer

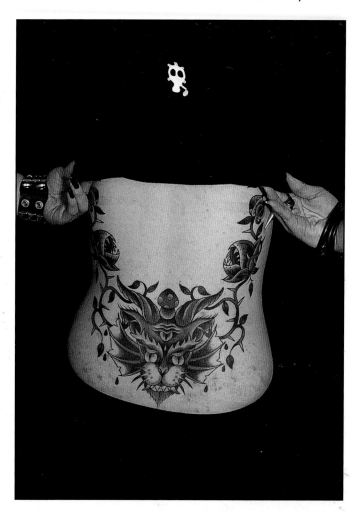

Tattoo by Rei

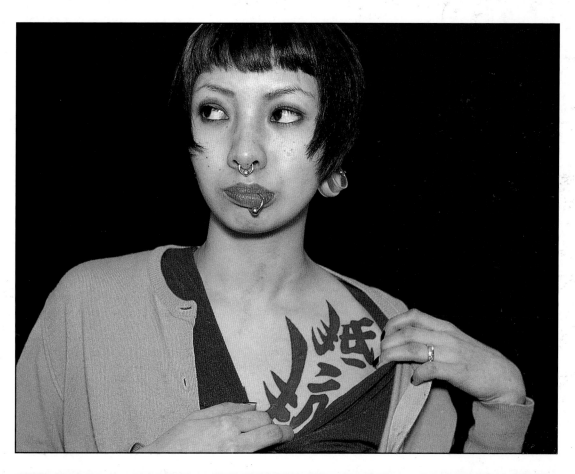

Ink Rat customer

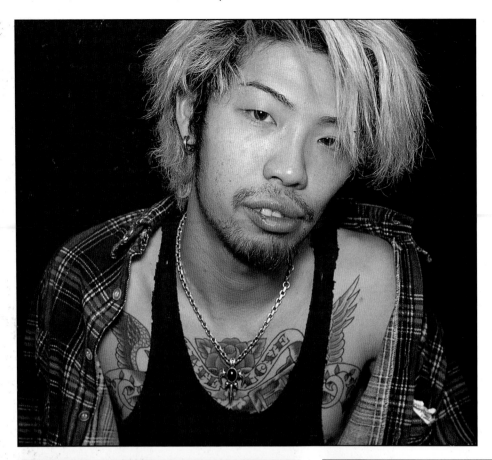

Ink Rat customer

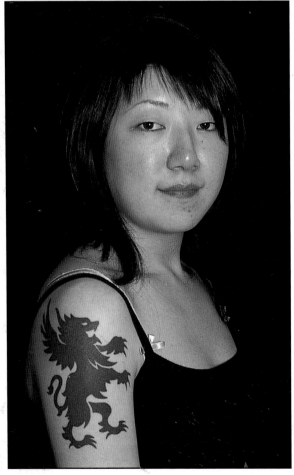

Ink Rat customer

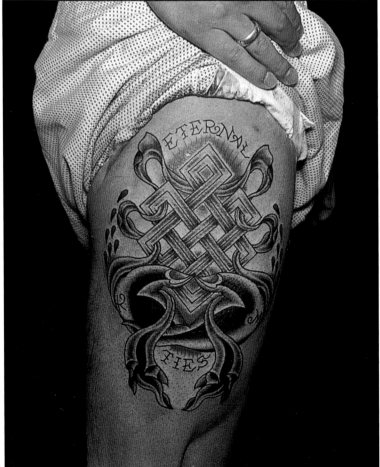

Tattoo by Hata

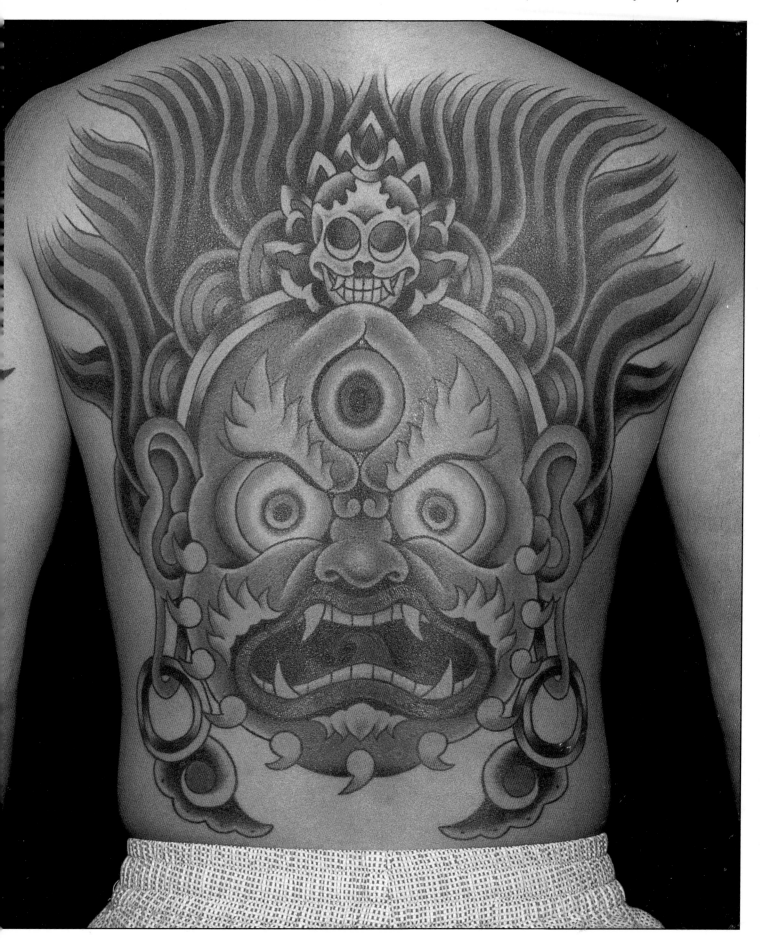

Tattoo by Hata

"There is something in Japan called 'Ime-chan'—Image Change," Rei says. "Many young people change their look. They always go through different looks. For young people in a place like Tokyo, the trends keep changing. For many young people this is life. People in Japan like to keep ex- ploring the change. Trendyness is a part of Japanese culture. Tattoo might be a part of this. There are trends in tattoos. Tattoo artists know about these trends and explore them. Customers maybe don't know but they follow these trends."

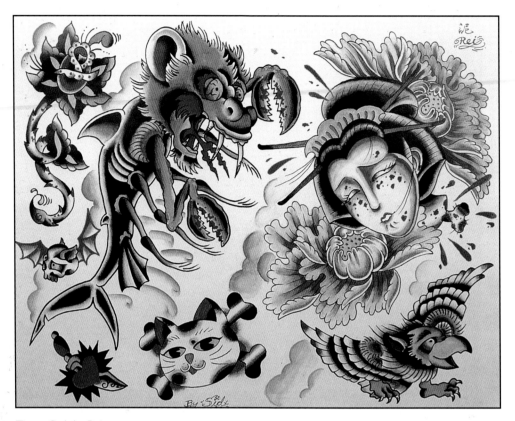

Tattoo flash by Rei

Tattoo flash by Rei

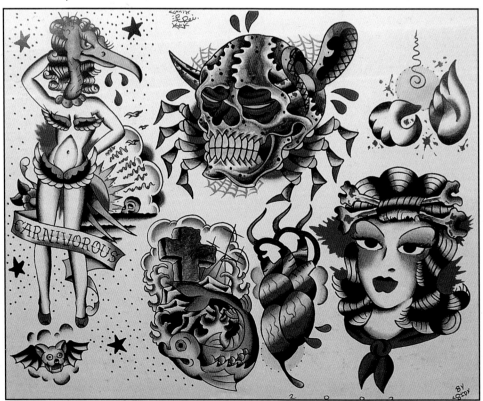

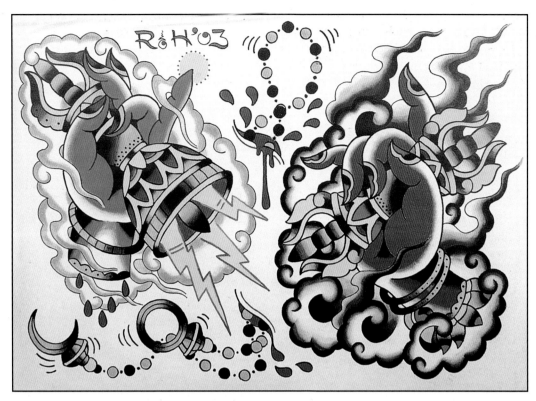

Tattoo flash by Hata

Tattoo by Hata

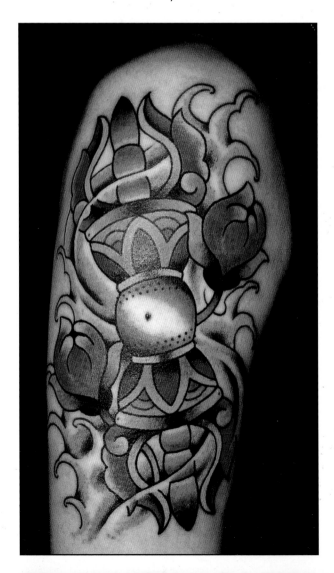

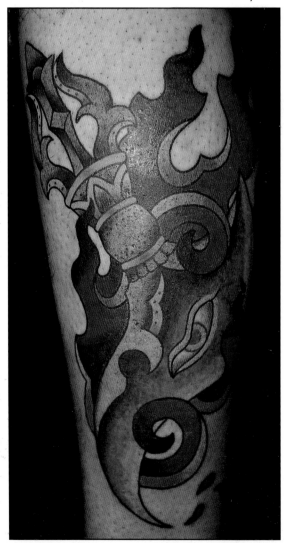

Tattoo
by Hata

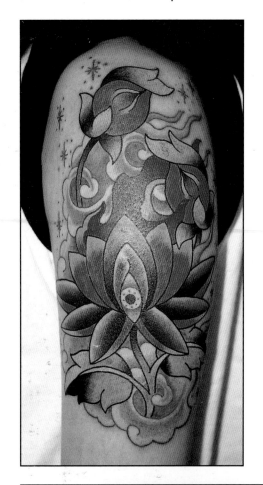

Tattoo by Hata

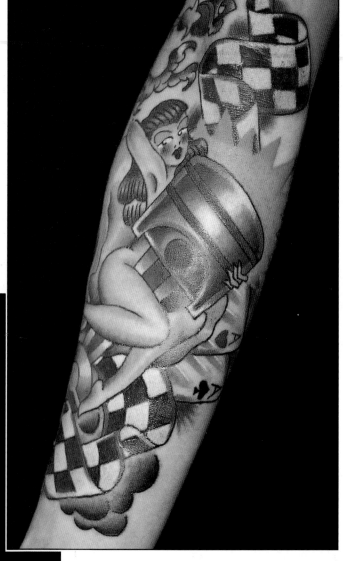

Tattoo by Rei

Tattoo by Rei

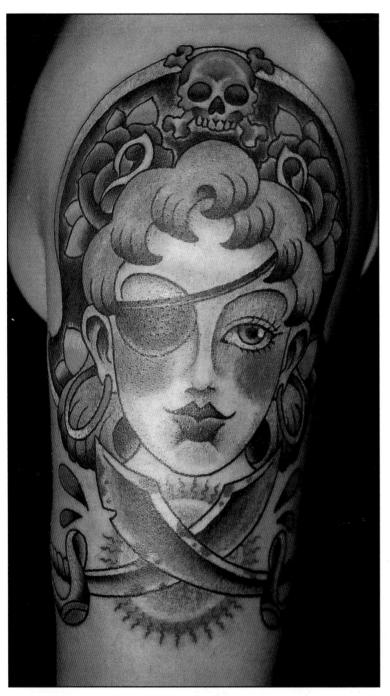

Tattoo by Rei

Ink Rat business card

Ink Rat business card

Kouenji Image-Change

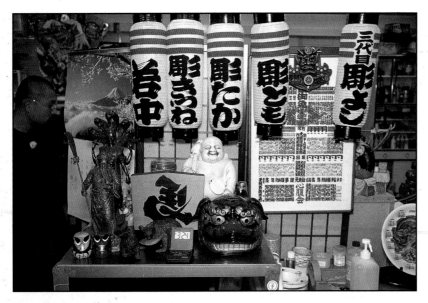

Name lanterns in Sensei Horiyoshi's Noge studio.

Yokohama

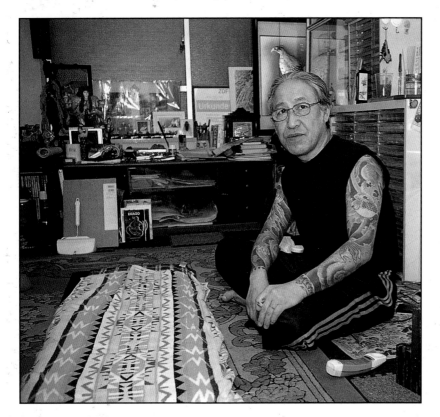

Sensei Horiyoshi III

Horiyoshi III

There are five paper lanterns hanging in the center area of Sensei Horiyoshi's downtown Yokohama studio located in the Noge neighborhood. The top of each lantern has three bold red stripes that symbolize the Horiyoshi III family. Each lantern represents a member of this family: The first lantern on the right is for Sensei Horiyoshi, then Horitomo who works at this Yokohama studio, Horitaka of State of Grace Tattoo in California, Horikitsune or Alex Reinke of Holy Fox Tattoo Studio in Germany, and finally an unnamed lantern reserved for a new member.

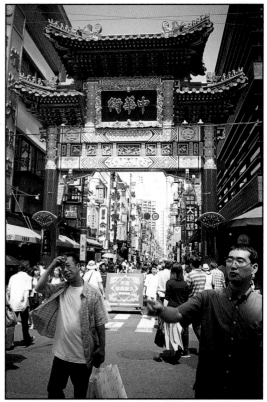

Yokohama

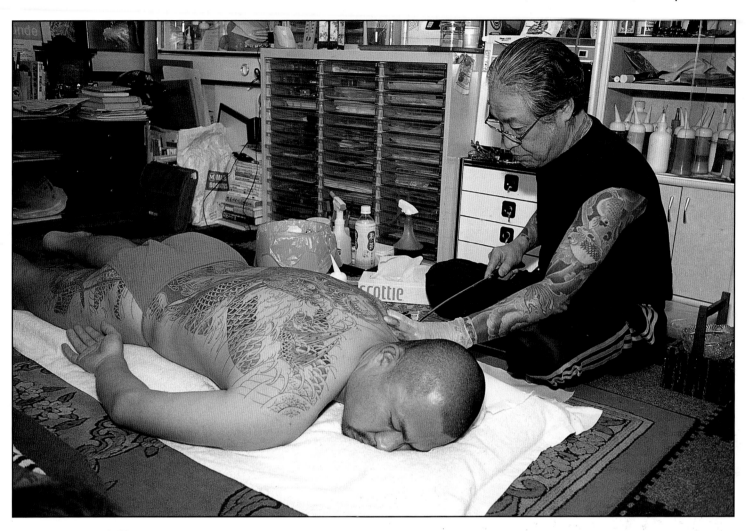

Sensei Horiyoshi III

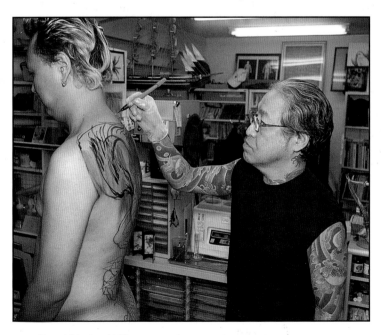

Sensei Horiyoshi III

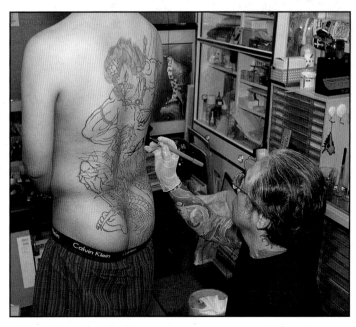

Sensei Horiyoshi III

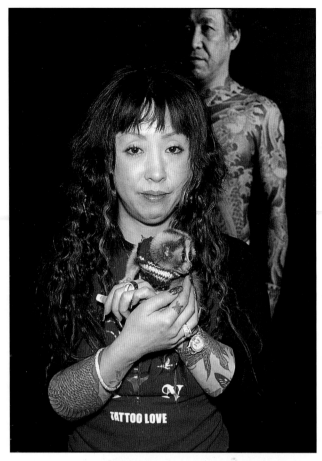

Mayumi Nakano

Kazuyoshi
Nakano,
Horiyoshi IV

Sensei Horiyoshi III is one of the most celebrated tattooers in the world. He works from his exclusive hilltop studio in Yokohama and also the more open Noge studio with a young artist named Horitomo, who has tattooed for ten years but recently apprenticed with Horiyoshi for two years. He was given his tattoo name by Horiyoshi at the completion of his apprenticeship. A third artist, named Horiken, tattoos at Studio Shin, upstairs from The Horiyoshi III Tattoo museum that is managed by Sensei Horiyoshi's wife Mayumi. Horiken apprenticed for eight years with Sensei Horiyoshi and now focuses on an international mix of designs.

Sensei Horiyoshi has tremendous historical knowledge about the art form of tattooing in Japan. His perspective on the current dynamic here is very important. "One Point tattooing is OK but it is finished just one time," he says. "Small designs added together create a different look. This is not necessarily a bad look, but some people want the traditional Japanese style tattoo.

"Maybe young Japanese start with One Point tattoo and then they might eventually become interested in Japanese style," Horiyoshi continues. "One Point may lead them to Japanese style again. The thing about One Point style is that it is the same everywhere. One Point tattooing now becoming popular in Taiwan, Korea too. Many shops in Soul. Maybe this is military influence but also just the interest of the young people wanting to be tattooed. Wherever you go it is the same.

"Because One Point style is mostly for young people. Maybe they do not think about the big picture. They act a little impulsive and are covering their bodies with One Point designs. Maybe there is regret for some. Now I start to see people that want to cover One Point tattoos with large body tattoos. My apprentice Horitomo started as One Point tattooer but now is doing traditional Japanese tattooing.

Horiken

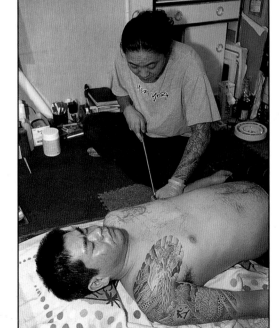

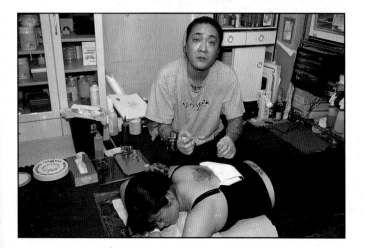

Horiken

"There is a sense of responsibility that comes with doing traditional Japanese tattoos. The knowledge of the history, the images, the stories. To get a traditional style tattoo is connected to the depth of the culture but the culture is so dense and the requirements are intense. Young people may be attempting to escape from this. They may be turning to One Point tattoos as a sense of release and liberation. There are many dedicated One Point tattooers too. It is just a different style."

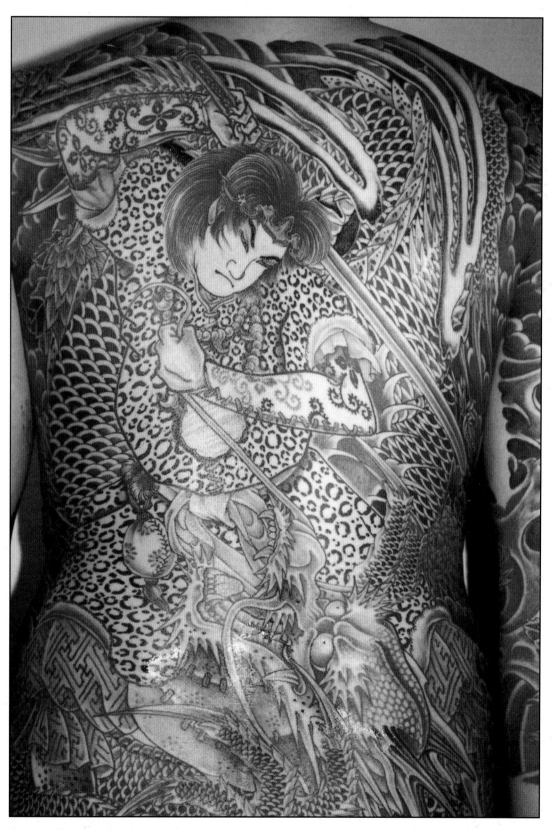

Tattoo by Sensei Horiyoshi III

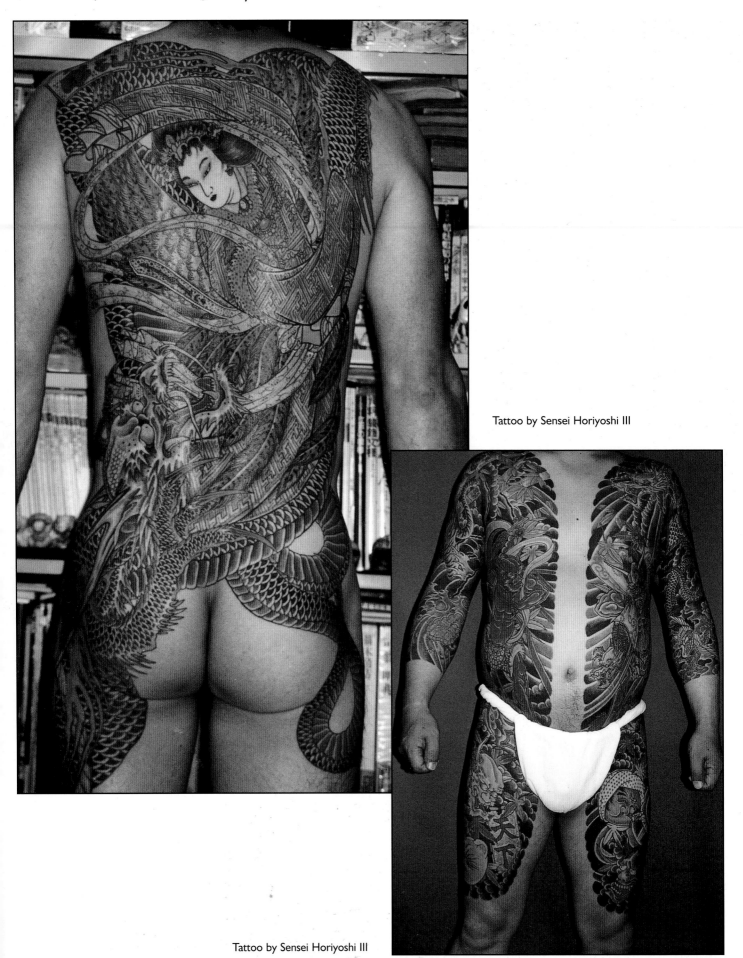

Tattoo by Sensei Horiyoshi III

Tattoo by Sensei Horiyoshi III

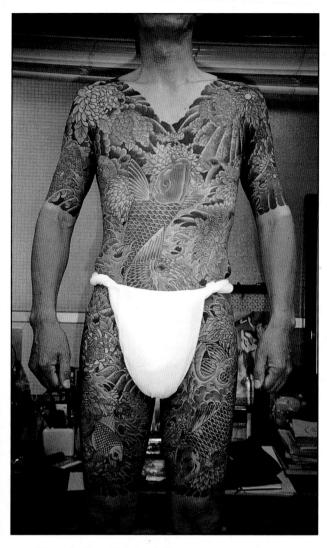

Tattoo by Sensei Horiyoshi III

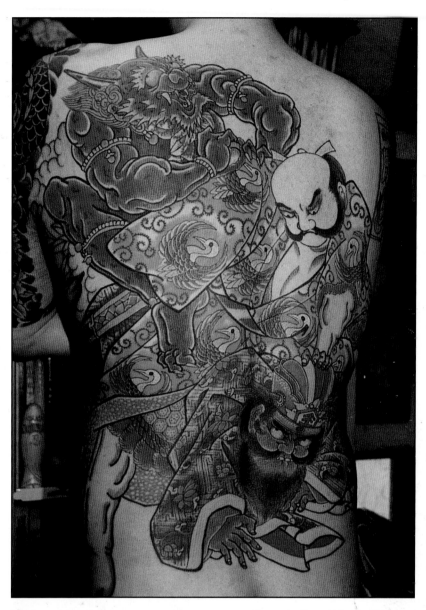

Tattoo by Sensei Horiyoshi III

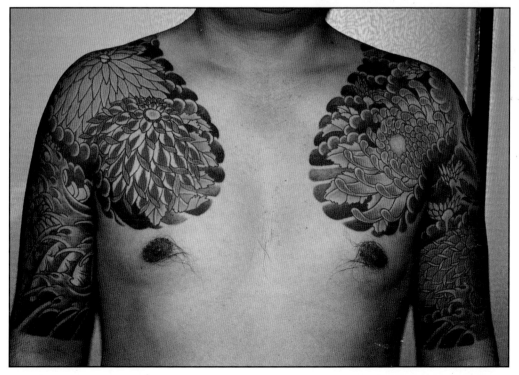

Tattoo by Sensei Horiyoshi III

Sensei Horiyoshi is tattooing a young man from America of Japanese descent named Maron with a traditional full body tattoo. Maron has rearranged his life and stays in Japan for extended periods to be tattooed by Horiyoshi. "I first learned of Sensei Horiyoshi's work two years ago at Ed Hardy's Tattoo City shop in San Francisco," Maron says. "For me, Horiyoshi's artwork is the best. His style represents Japanese tattooing for me. I wrote to Sensei asking to meet with him. I wanted to get a back piece. I was very nervous and excited to meet with Sensei. I talked with him about what I should put on my back. Sensei chose the Water General for my back and the Fire General for my front. Sensei saw that I had a balance developing on my body. I have dragons on my arms and carp on my legs.

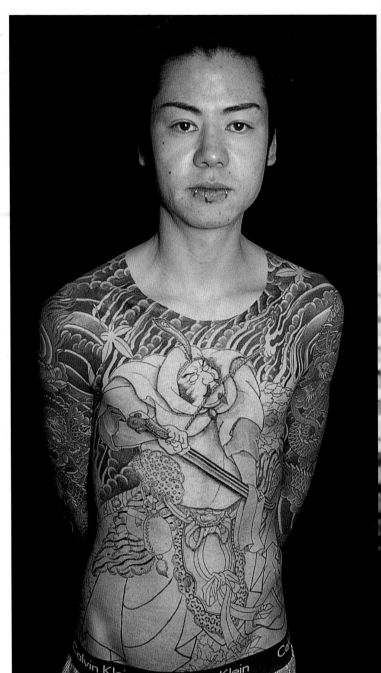

Maron

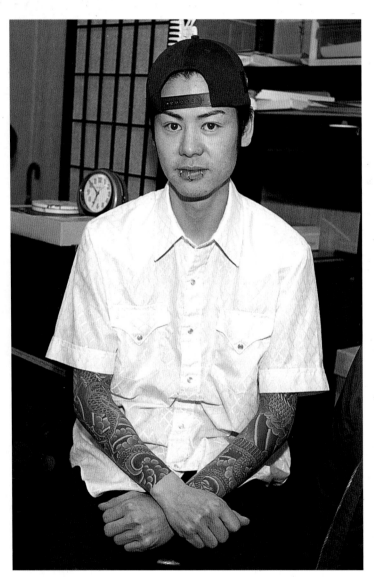

Maron

"I am interested in the cultural traditions. A tattoo is forever. It is a painful process that takes time. I think you should have a sense of devotion about this. Many young people everywhere see tattoos as fashion. One Point style tattoos have different motivations. For me a sense of cultural connection and cultural commitment is important. I travel three hours each way every day to get tattooed by Sensei Horiyoshi. I am committed to this experience."

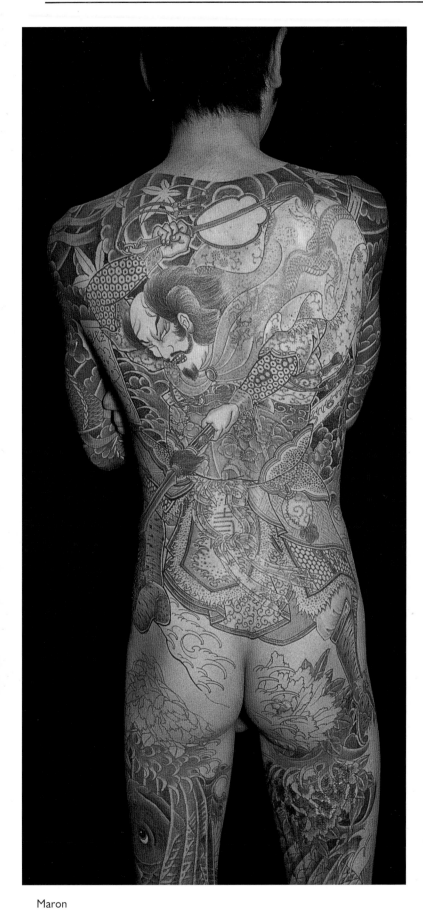

Maron

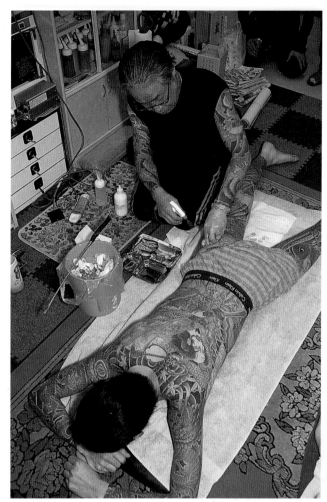

Sensei Horiyoshi tattooing Maron

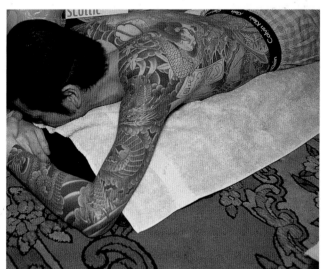

Maron

Horitomo works at Sensei Horiyoshi's Noge street studio. He was known as Washo when he started tattooing One Point style with a tattooer named Sabado in Nagoya and then at Three Tides in Osaka. He reassessed his direction as an artist and returned to the traditional style with Sensei Horiyoshi III.

"I started tattooing ten years ago." Horitomo says. "I never studied art in school. I was always pretty good at art. I first learn tattoo from Sabado. It look interesting as an art form. There never used to be any One Point shops or One point tattooers. I remember I saw Ed Hardy book that showed Sensei Horiyoshi's tattoo work. In the early days, traditional tattoos were mostly Yakuza. I felt intimidated by this. I did not feel comfortable approaching traditional style. When I first want to learn from Sensei Horiyoshi I feel intimidated. I was not comfortable approaching traditional style. After five or six years of tattooing I decide that Japanese traditional style is better style. I studied with Sensei for two years.

"I realize that collecting tattoos from different artists was too much—a confused look. I think it is better to have work from same artist. It looks more unified. Many Japanese customers are attracted to Western images, like Jesus Christ. They do not really understand the meaning. It is OK for young people to get Western One Point tattoos. It just reflects the global process. It is what is happening now.

Customer of Horitomo

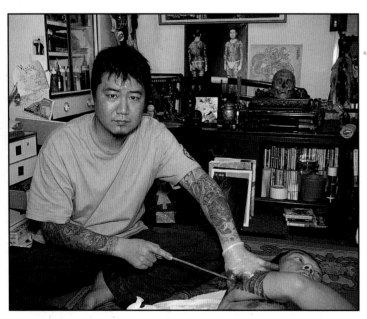

Horitomo

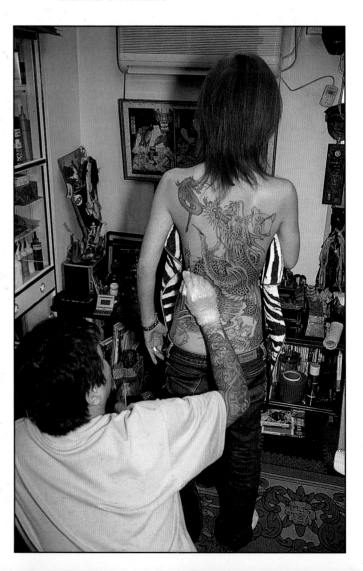

Horitomo and customer

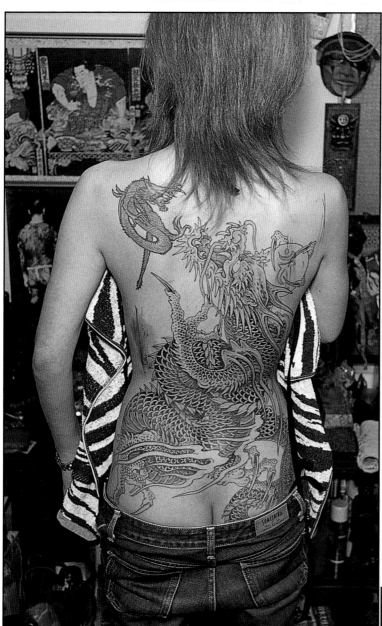

Horitomo customer

Horitomo and Sensei
Horiyoshi III customers

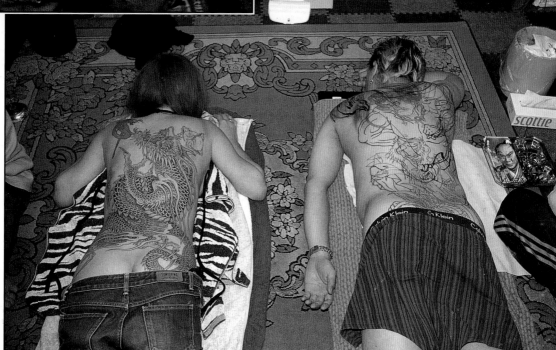

"I decide to do Japanese style. For example, if I draw a Jesus Christ I do not understand. There is no real connection. I am just drawing a picture. This experience is not too deep. When I draw a Japanese design it is a part of me and my culture. I decided that this is more fulfilling."

Horitomo works between the worlds of tradition and global interest. As a young person himself, he has experienced the powerful influence of the Western world in his own life. He has taken a step back however and reflected about what truly interests him as an artist and he feels resolved about his decision to explore the traditional Japanese design base. "I do not feel it is correct to tell people not to get One Point tattoos. They can do whatever they want. I felt this way at one time too!

"I was brought up next to the ocean and noticed the tattoos on the guys that surfed. I thought that the tattoos looked cool! I found Sabado and got tattooed by him. I was a surfer kid and liked to ride the big waves during the seasonal typhoon. One day the water was very high so I went out in it. It was very powerful and I fell off a really big wave and came down hard on my board. I got my teeth knocked out when my head hit the board. I stopped surfing after that. Six months later I asked Sabado for an apprenticeship. I asked him about the possibility to learn tattooing.

"I looked at many books and practiced my drawing. I taught myself how to draw. I looked at many books about traditional forms and learned how to tattoo."

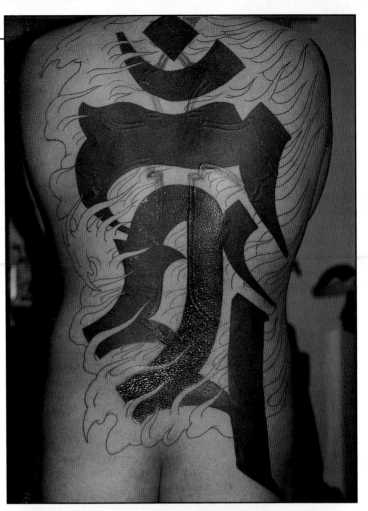

Above right:
West to East cover-up tattoo by Horitomo

Right:
West to East cover-up tattoo by Horitomo

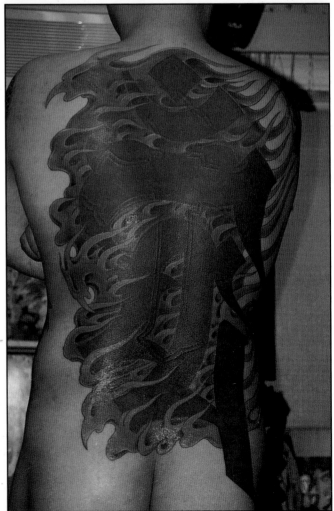

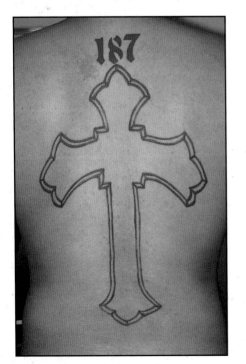

West to East cover-up tattoo by Horitomo

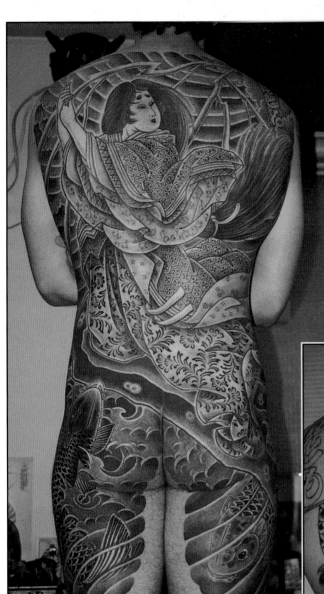

Tattoo by Horitomo

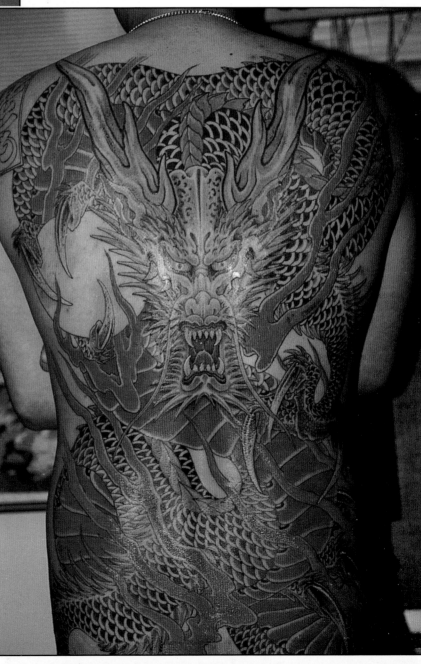

Tattoo by Horitomo

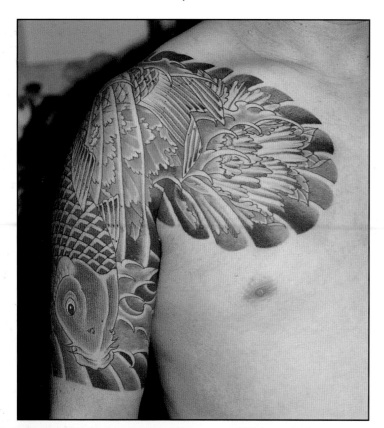

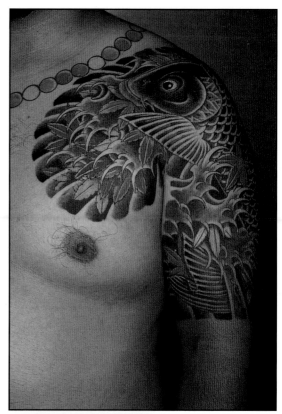

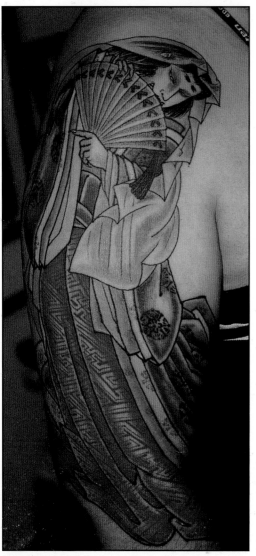

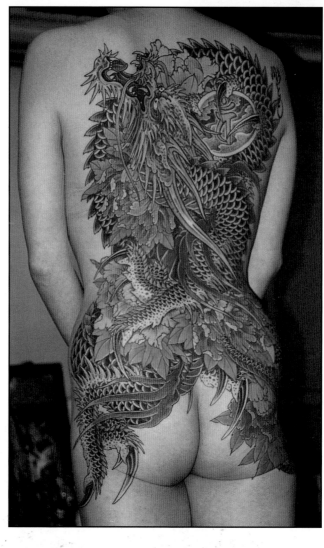

Top left:
Tattoo by Horitomo

Bottom left:
Tattoo by Horitomo

Top right:
Tattoo by Horitomo

Left:
Tattoo by Horitomo

Cat Claw Tattoo

Kyoto is a deep place. Old Japanese culture is revered and the pace is very slow compared to Tokyo. Cat Claw Tattoo has two shops in the old section of the city, which is characterized by small traditional wood frame houses lining narrow, calm streets. There is a palpable air of sophistication here. The esthetic quality of Japanese life reveals itself at every turn. During the hot summer months, air conditioned taxicabs pick up women wearing kimonos for reduced or no fares. The traditionally dressed women project a good image for the taxi companies. When the American hamburger chain McDonald's came to town, the city of Kyoto demanded that the bright, garish trademark colors of red and yellow be changed to subdued brown and pleasing amber.

Kyoto Street

Kyoto temple

Kyoto street, Gion district

Kyoto woman

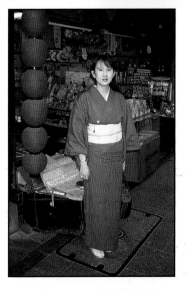

Kyoto woman

A young woman named Madoka tattoos at one shop with co-worker Hiro. Cat Claw owner Horinao tattoos down the street at the other shop with a young tattooer named Ai, a piercer named Bin, and a talented young woman named Kuma, who is the shop assistant.

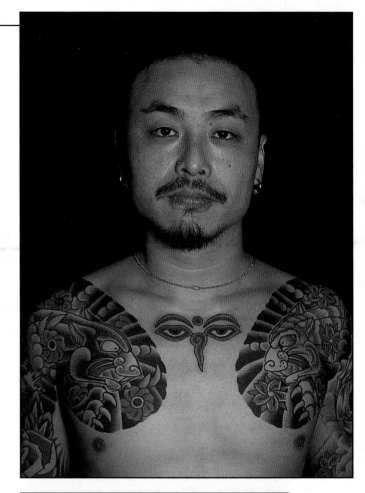

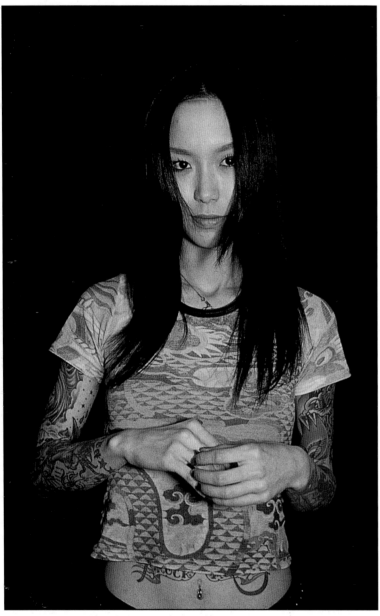

Madoka

Above right:
Hiro

Right:
Horinao

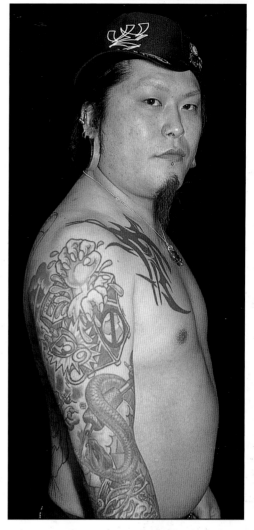

Bin

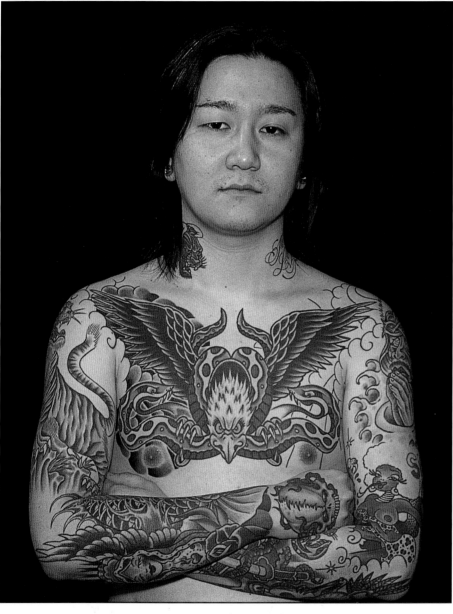

Ai

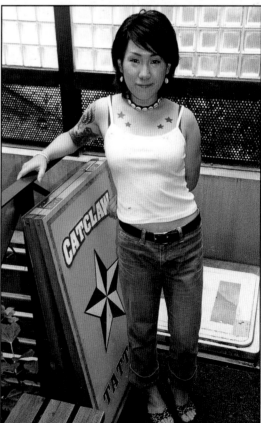

Shop manager Kuma

Madoka

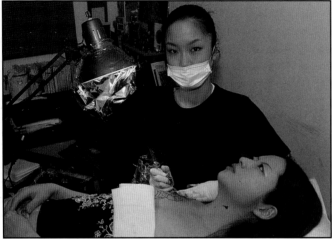

Madoka and Cat Claw customer

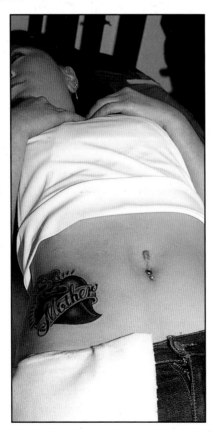

Cat Claw customer,
tattoo by Horinao

"There are very few female tattoo artists in Japan, maybe ten," Madoka says as she tattoos a young woman. The woman sits like a stone—no complaints; she looks like she's sleeping. "I think this will change but it take time. Women treated different in Japan than USA. They number two. My customer is getting a tattoo in very painful area but she is not complaining," Madoka continues. "Women in Japan develop a resiliency. It is old Japanese way. For many young women in Japan, tattoos give an outlet, something they can use to look strong."

Cat Claw is an open street shop but has a calm and quiet sense about it. Customers walk in calmly and are greeted with respect and interest. There are several portfolio books of the Cat Claw artists and visiting Western artists like Permanent Mark, Mr. Cartoon, and Joe Vegas.

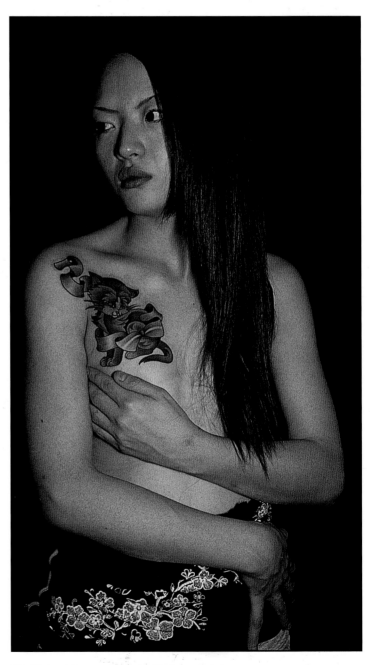

Cat Claw customer, tattoo by Madoka

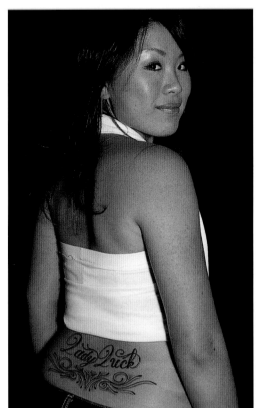

Cat Claw customer, tattoo by Horinao

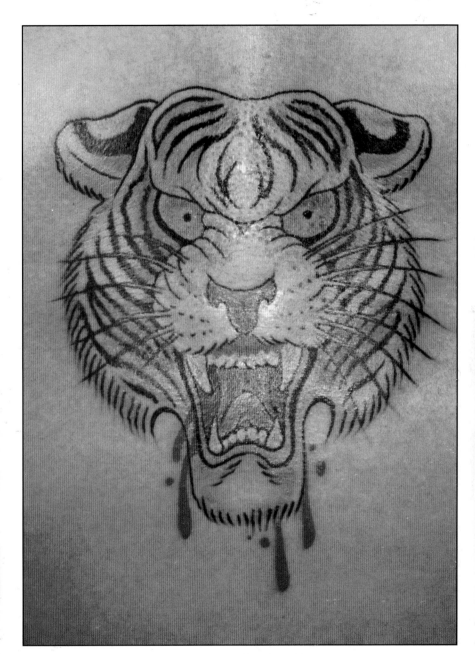

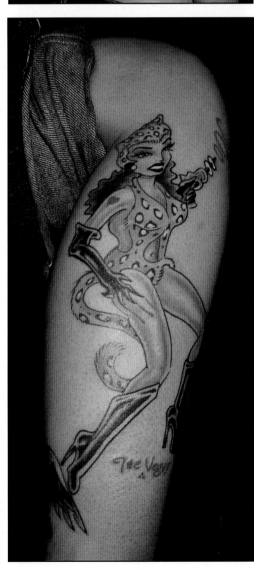

Tattoo by Joe Vegas

Tattoo by Joe Vegas

"First time I see American traditional style on paper, I like it but I do not understand it. Then I see it on skin and I understand. It is powerful like Japanese traditional style. I think this traditional style projects strength, especially in the skin. Somehow, seeing designs like Sailor Jerry on the skin, the power came through. I get tattoo from Horinao in 1996, then I apprentice with him. Now I am tattoo artist, it makes me feel complete as an artist. Tattooing makes me feel strong and relaxed.

"I remember, I had tattoo magazines in my home when I was young. My parents were very worried … I liked to hang out at tattoo studios, it changed the way I feel about life. A long time ago before I was tattoo artist I had opinions about tattooing. Now I am a tattoo artist; my thoughts have changed. For me, drawing is like breathing, you just keep drawing."

Tattoo by Horinao

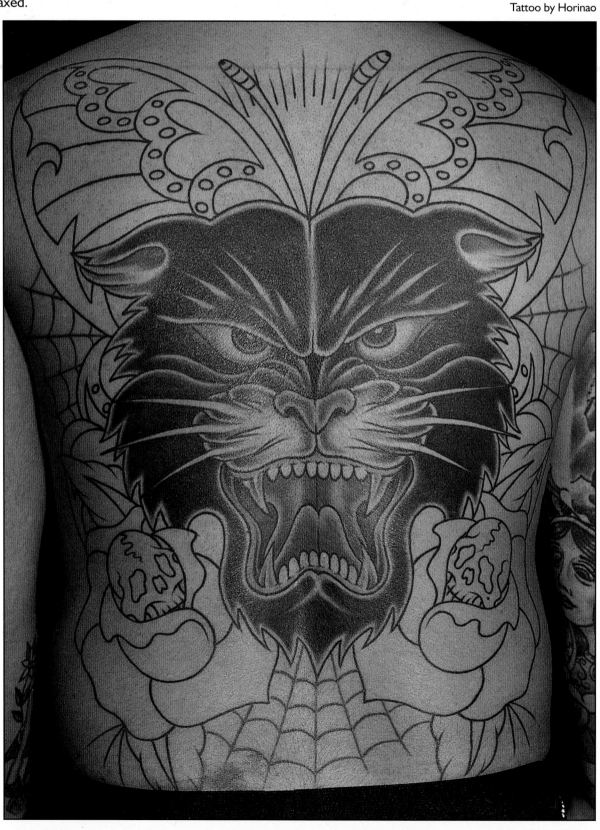

Artwork by Madoka

Artwork by Madoka

Artwork by Madoka

Life in Japan is a completely esthetic experience. It is an old culture that has been continuously refined for more than a thousand years. Traditional Japanese tattoo designs have been distilled into powerful stylistic messages. There are similarities between powerful Japanese and American tattoo iconography. Over the years the designs were both refined into economic and potent message systems. Madoka and Horinao both feel that one reason young Japanese people are intrigued with traditional American designs is that they are intuitively sensitive to the process of historically refined messages.

"In old times life in Japan was full of messages," Madoka says. "This is Japanese way. When Geisha carry fan she always put a few drops of her favorite perfume on fan. Then when she use fan, her favorite scent is all around her. People remember her scent, they remember her. This is a mes-

sage. Today at antique shop, you pick up old fan and you can smell the delicate scent of old times. This is very beautiful. This is very Japanese. There are different kimono lengths that tell people message. When woman wear long kimono this means she is not married. If she wears a shorter kimono this mean she has husband. People look, they know meaning. In old time if a woman wore her hair in elaborate style, this meant she was single. If she wore hair simple, pulled back tight style this meant she was married. Geisha would have black on teeth if they were married, white teeth if single. This was message. I think young people today do same thing with Western style tattoos. These are messages that tell things about young people.

"Sometimes when customers from other parts of Japan come to Cat Claw, they notice Kyoto language different. There was time not long ago when Japan had different style of language in different areas, different style tattoos."

Kyoto street

Kyoto temple

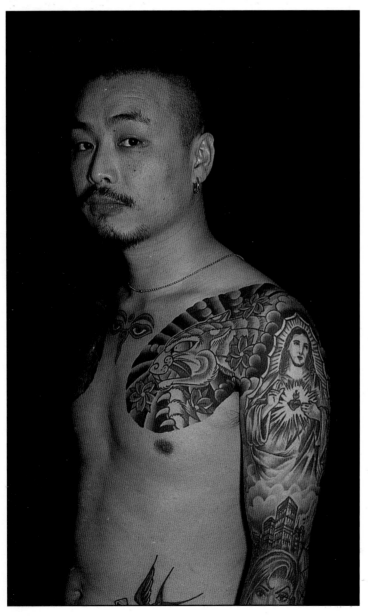

Hiro

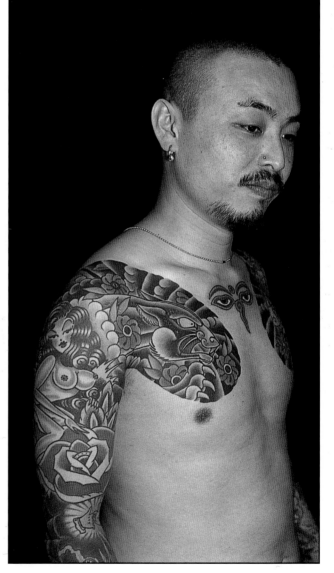

Hiro

Madoka has an evolved opinion about her culture, young Japanese adults, and the powerful impulses that motivate some to stretch out and experiment with their sense of self. "Ever since I was a young girl," Madoka reflects, "I have been fascinated with the USA—Sun, road, car, women, music. The American image. Many Japanese young people are preoccupied with American culture. It is culture of possibility and freedom. I think tattoos have become a part of this fascination.

"I think people in Japan like to play with cultural form. It is almost like a game. We have been collecting these forms for a long time, from China, Korea ... America. We make them our own but we collect. I think this fascination is a part of being Japanese. I think this goes together with style. Japanese people like to play with form and style. These are a kind of message too. This gets complicated.

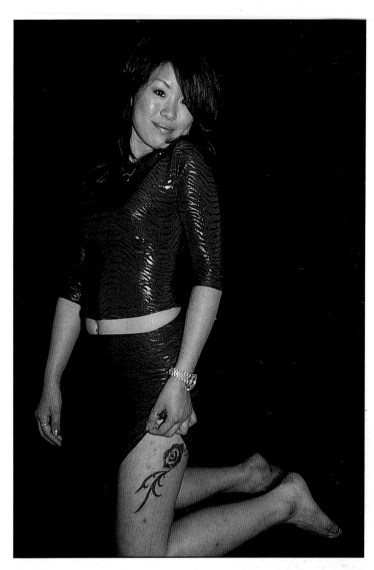

Cat Claw customer

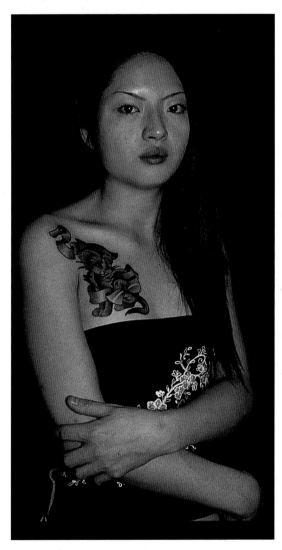

Cat Claw customer, tattoo by Madoka

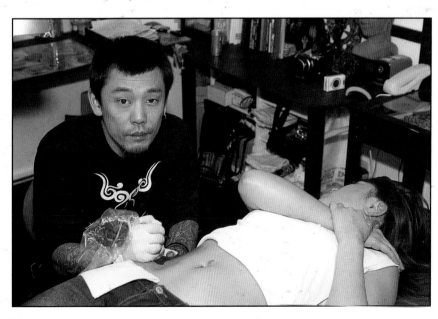

Horinao

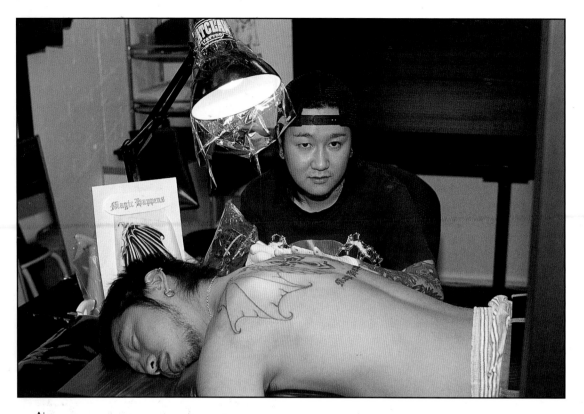

Ai

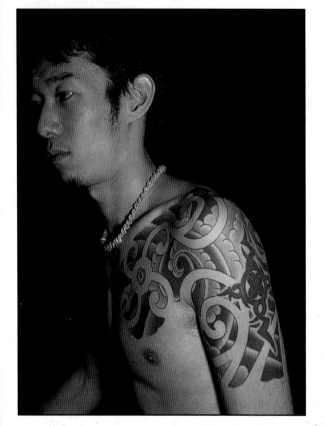

Cat Claw customer, tattoo by Hiro

Cat Claw customer, tattoo by Hiro

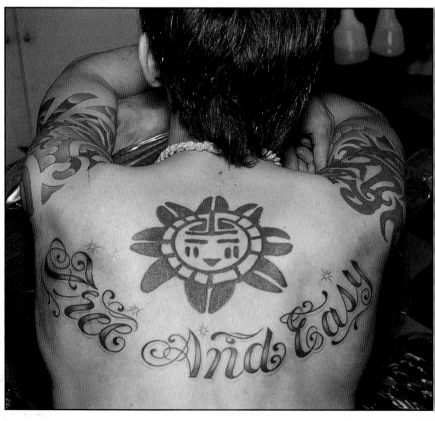

Cat Claw customer, tattoo by Hiro

"I think Japanese like to live with form and style. Like girls that walk with pigeon toes. They do not do this because they have problem with legs. This is psychological style. Like burikko cutesy baby talk. This is style statement: a look, a style way to attract. Japan is animation mind. Anime is aspect of young people's mind—comic mind. Some of these girls walk like the comic. It looks vulnerable. This is style performance. Tattoos are the same. They are style performance too."

Tattoo by Madoka

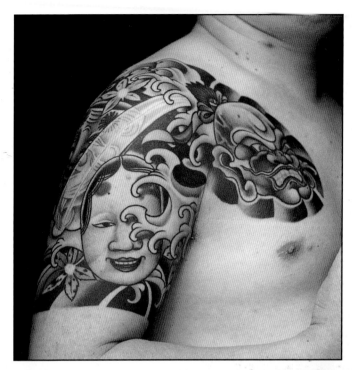

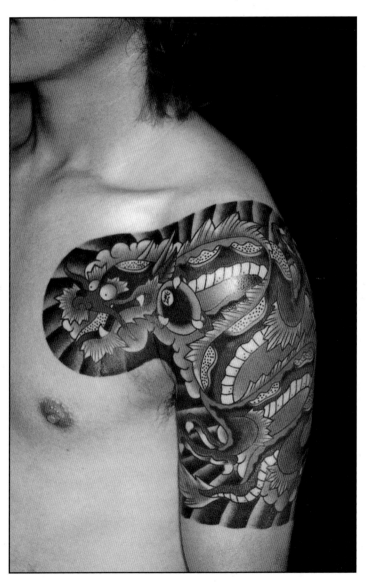

Tattoo by Madoka

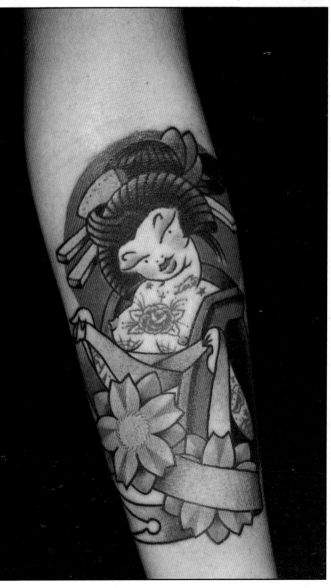

Tattoo by Madoka

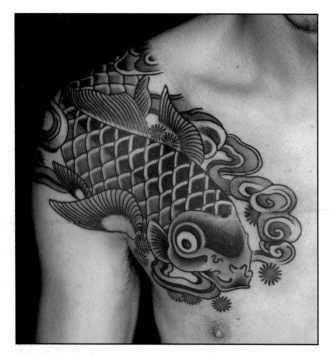

Tattoo by Madoka

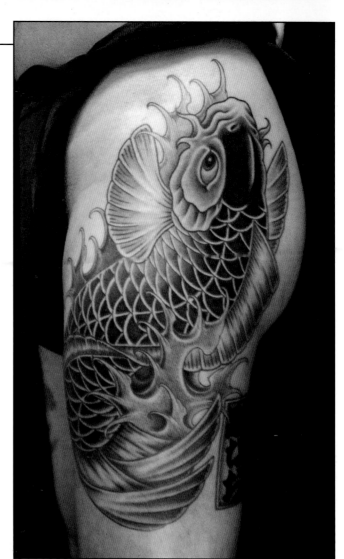

Tattoo by Horinao

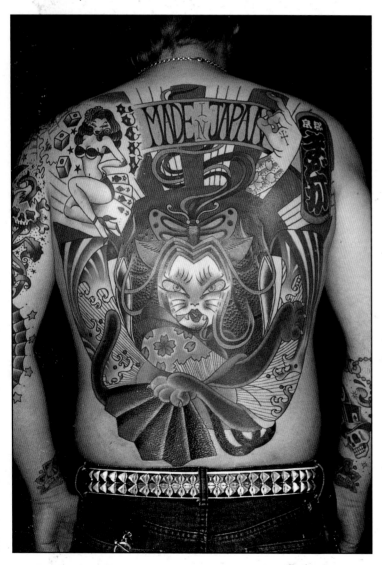

Tattoo by Madoka

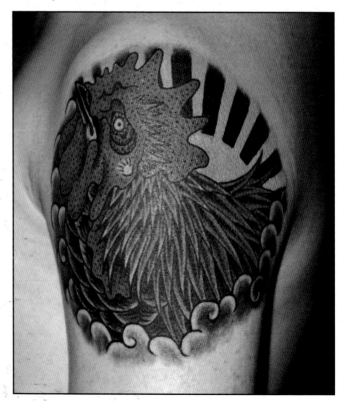

Tattoo by Horinao

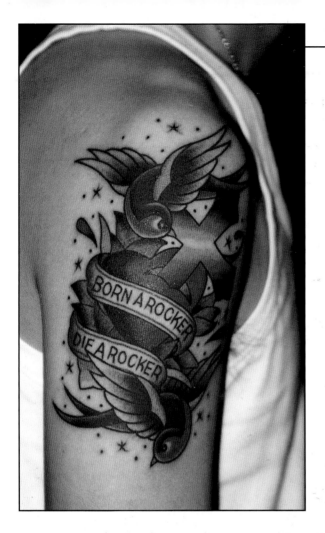

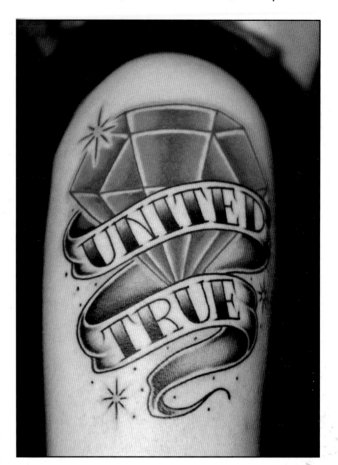

Tattoo by
Horinao

Tattoo by Horinao

Tattoo by Hiro

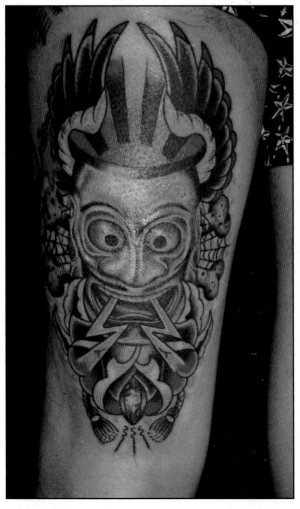

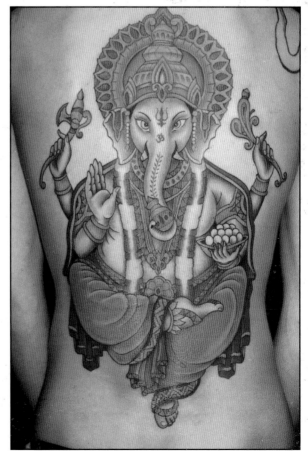

Tattoo by
Horinao

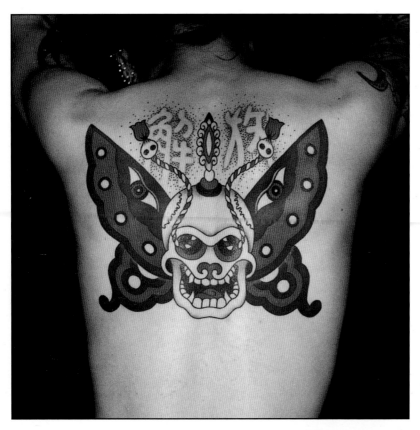

Tattoo by Hiro

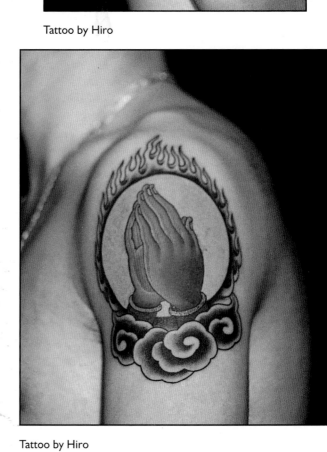

Tattoo by Hiro

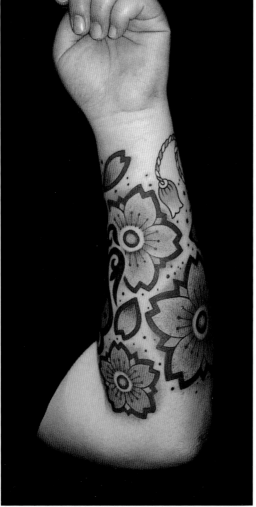

Tattoo by Hiro

Tattoo by Hiro

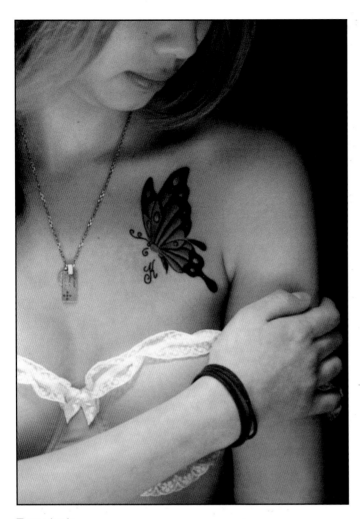

Tattoo by Ai

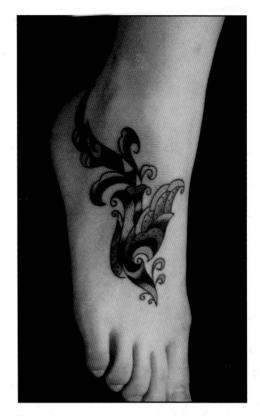

Tattoo by Ai

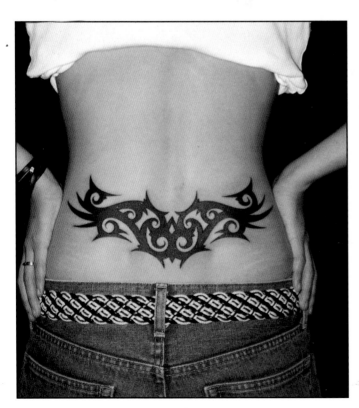

Tattoo by Ai

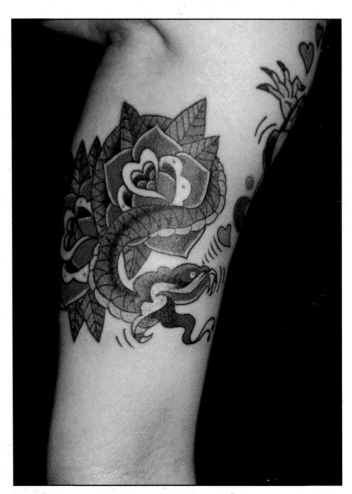

Tattoo by Ai

At the second Cat Claw shop Horinao says, "Our shops have very good reputations. Customers travel to Cat Claw from all over Japan and all over world. I name Cat Claw after a rare plant that grows in Amazon called Cat Claw. The plant has medicinal power. I see plant power and power of being tattooed is similar. Having a tattoo can help you too.

"I get my first tattoo traditional, tebori style. I find it interesting and start to teach myself. I start tattooing 1993 tebori style and then I change to machine. Everyone at Cat Claw like family. At the end of day, we get together to have dinner. We have a good, creative time here."

Hiro's business card

Horinao's business card

Madoka's business card

Ai's business card

Three Tides Tattoo

IMasa Sakamoto's Three Tides Tattoo is located in the trendy Minamihorie neighborhood near Osaka's American Village youth and shopping district. There are hundreds of young stylish people wandering the streets shopping. It seems that everyone is wearing a snappy hat of some kind.

"Osaka is all about presentation," Masa explains. "This is the first custom tattoo shop in Osaka. It took a long time for people to get used to the idea of custom tattoos. Horitomo was a part of this shop when he was called Washo, then he went to study with Sensei Horiyoshi. He did a lot of very good, One Point style tattoos here that helped to build this shop's reputation. I invite a lot of tattooers to visit from all over the world: Chris Trevino, Adam Barton, Tim Lehi, Chris Garver, Grime, Amanda Toy, Civ, Charlie Roberts, Mr. Cartoon, and Jason Kundell. I show Osaka customers the work of talented tattooers to expose them to new possibilities. I like to talk with the customers to see what they are looking for and then match them with a tattooer. People know that I am connected to the best artists."

Osaka street

Osaka street

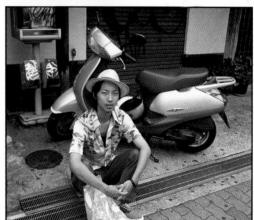

Osaka style

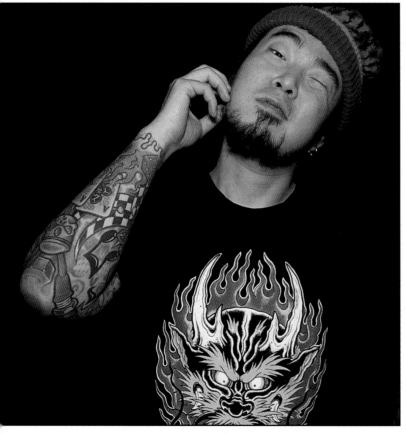

Masa Sakamoto

Three Tides Tattoo store front

Chris Trevino visits from the United States periodically for a few weeks at a time. He has built up solid followings in Osaka. He has a shop in Austin, Texas, and has been tattooing in Japan for several years. He concentrates on tattooing large, elegant, traditional Japanese body suits. His views about Japanese tattooing are informed by his personal experiences. "The depth of traditional Japanese tattooing is limitless," he says. "Many of the young are sidestepping the depth at this point and going for the new One Point style. There is a new process going on here. It is international in scope and has a lot to do with consumerism. I call it the Commercial Soul. I think it is a part of a process. Eventually things will work themselves through. These customers are young. I am fortunate to have a good following here and work on young people who continue to explore the old styles."

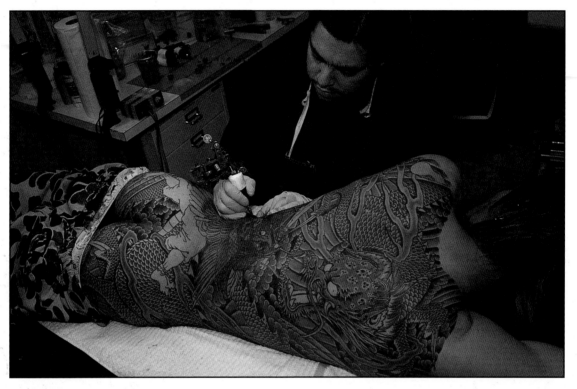

Chris Trevino working at Three Tides

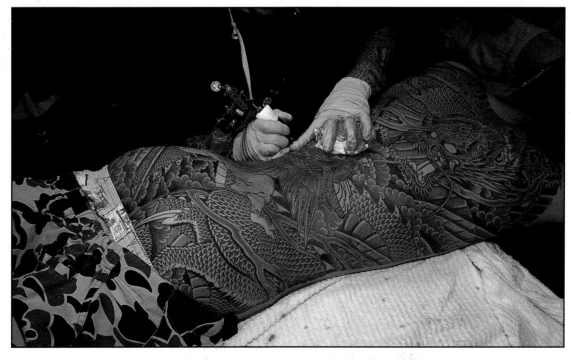

Chris Trevino tattooing

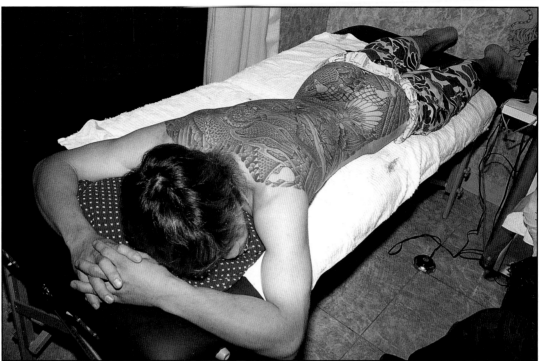

Chris Trevino customer

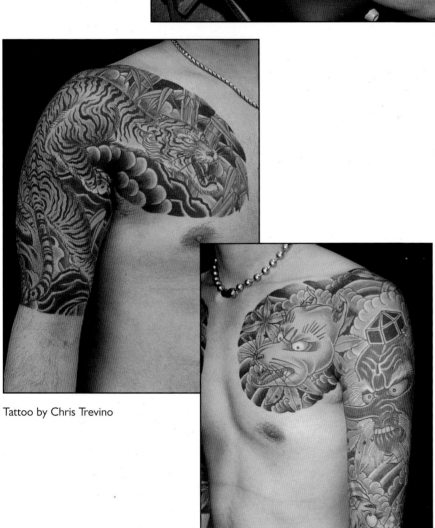

Tattoo by Chris Trevino

Tattoo by Chris Trevino

Tattoo by Chris Trevino

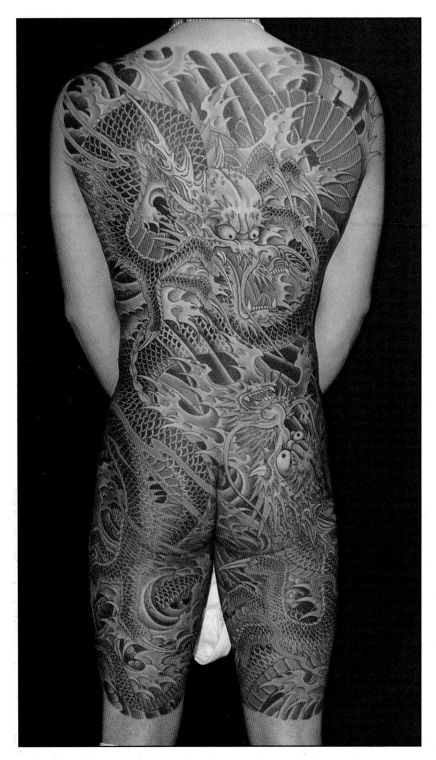

Tattoo by Chris Trevino

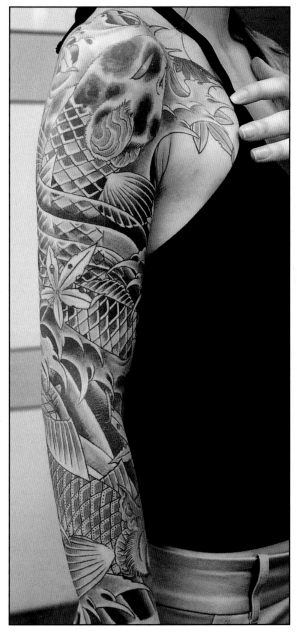

Tattoo by Chris Trevino

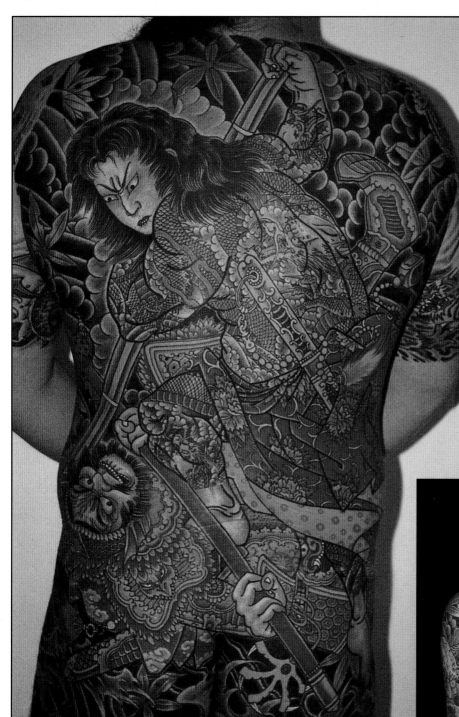

Tattoo by Chris Trevino

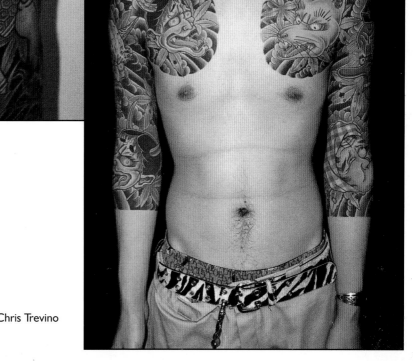

Tattoo by Chris Trevino

Adam Barton also has a solid following in Osaka. He has tattooed for several years and started working in Osaka in 2002. He was tattooed by Mike Shwaggart of Point Pleasant, New Jersey, Scott Harrison of New York City, and Chris Chisholm of Newburg, New York, early in his career and these influences have stayed with him. He has a background in graffiti art and his tattoo artwork was featured recently in the *New School Collective* book. He credits New School Tattoo in San Jose, California, for their encouragement and help.

"Adrian Lee opened the door in Osaka for other guys from New School," Adam explains. "I first came to Japan in 2002 as a part of a big body suit tattoo drawing show. The show was really well accepted and got things going here. People saw the art in that show and it got them thinking. The art was very new looking to young people here. They had never seen images like that.

"I am always impressed with traditional American designs and I like to tattoo in that style. It is strong stuff and the look has influenced me a lot. I think one reason the young people here in Japan like it is the strength they feel from it."

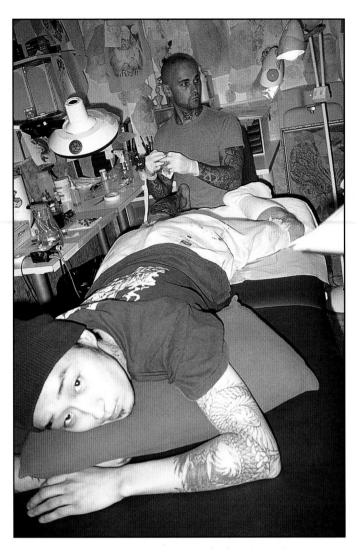

Adam Barton tattooing

Adam Barton on Osaka street

Adam Barton on Osaka street

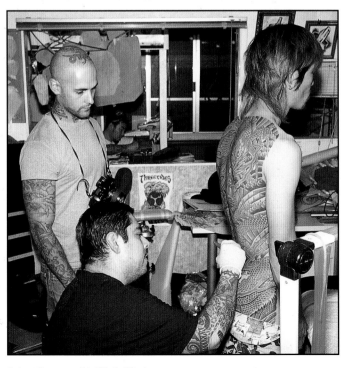

Adam Barton with Chris Trevino

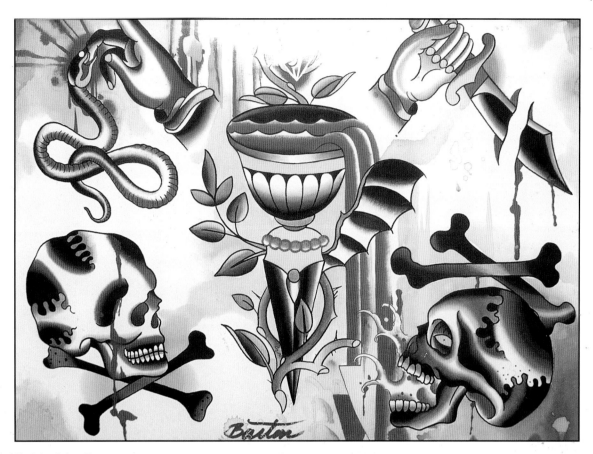

Flash by Adam Barton

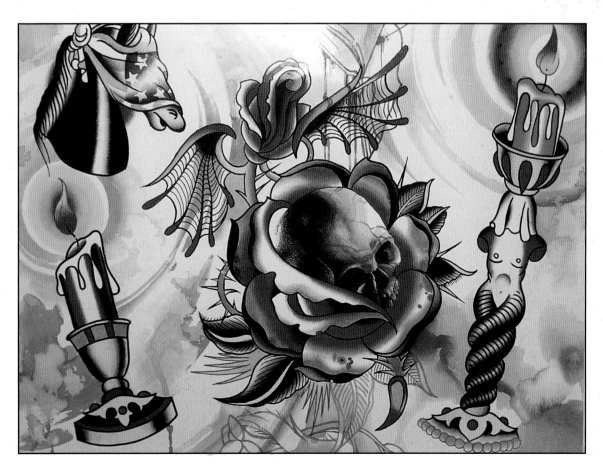

Flash by Adam Barton

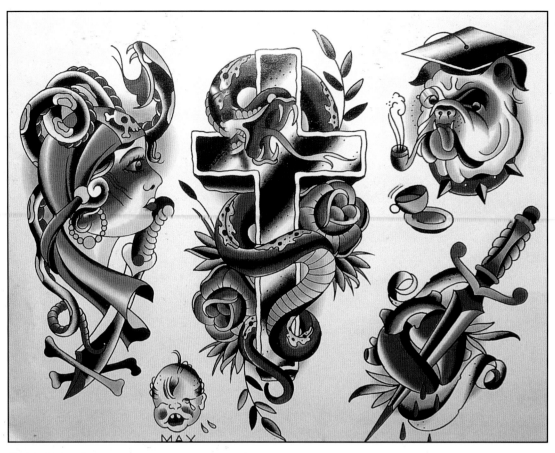

Flash by Adam Barton

Masa reflects on the city of Osaka. It is a bustling, dynamic, modern town but is Japan's number two city. The tastes are a bit provincial compared to the extreme cosmopolitanism of Tokyo.

"Osaka tattoo is different," he says. "Traditional tattoo is from Edo period. At that time, Tokyo was central. Maybe this is one reason Tokyo has so many traditional tattoo artists. It is central.

"Osaka is number two city but it is still a bit traditional compared to Tokyo. For example, during the big holiday season, a city like Tokyo sees a huge exodus of people going back to their family homes. In Osaka you don't see this. This is still the center of family life.

Tattooer Tsukasa

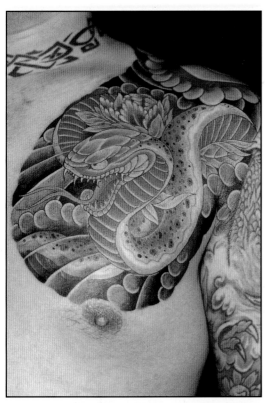

Tattoo by
Tsukasa

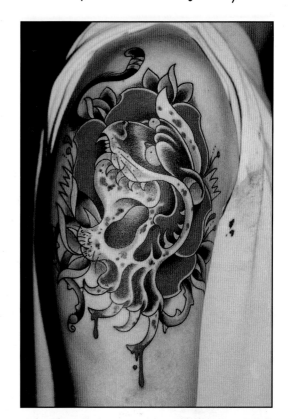

Tattoo by
Tsukasa

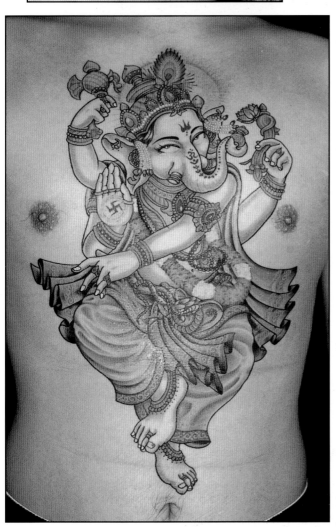

Tattoo by Tsukasa

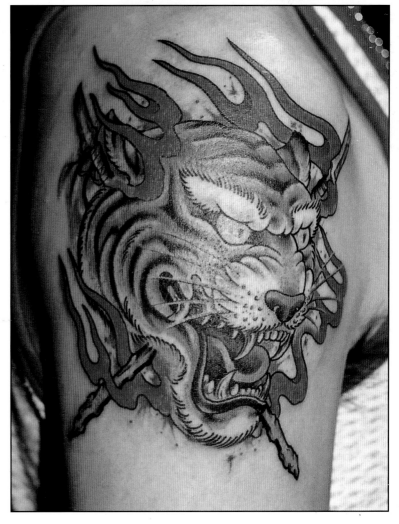

Tattoo by Tsukasa

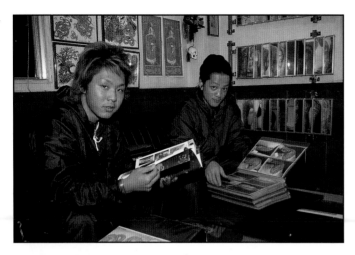

Three Tides customers

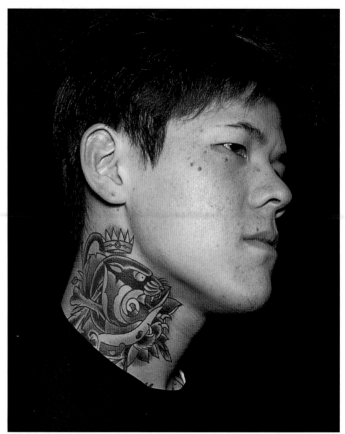

Three Tides customer, tattoo by Paco

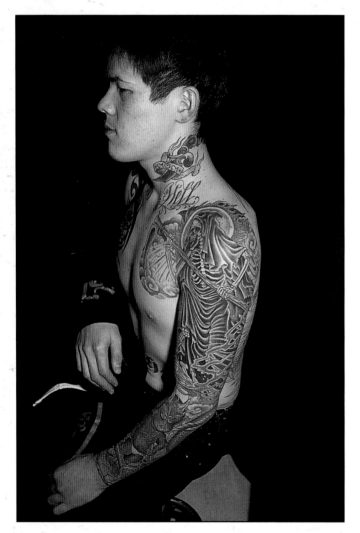

Three Tides customer, sleeve by Chris Trevino

"Japanese culture brings in other culture. This is a part of being Japanese. Today, youth culture embrace Western and particularly USA culture. Young people feel confined to their island. They look to the outside world and this makes them feel larger. They become more involved in terms of their identity. Scale of Japan is smaller. The size of the country has a lot to do with the perspective of the people.

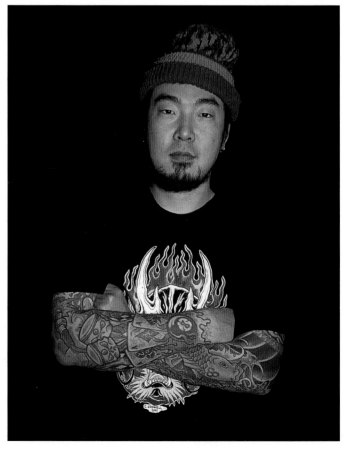

Masa Sakamoto

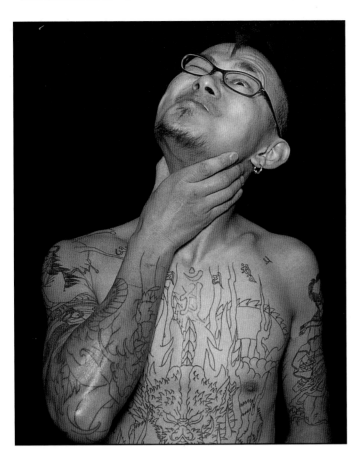

Shop assistant

Tattooer Mutsuo

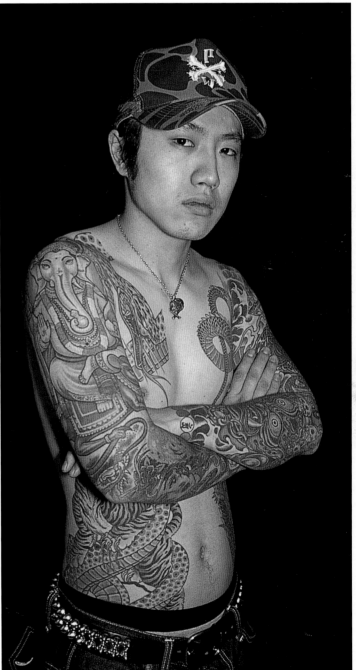

"Young people are changing now in Japan. There was a time when all young people would understand the three Japanese alphabets; the old Kanji characters from China, Hiragana, and Katakana. This is difficult, so now many young Japanese people no longer study to learn the alphabets. This is example of change in life. People no longer have time or effort to study the alphabets. It is a lot of work. Tattoo is an example of change too but different. Young people make time and effort to get tattoos because it is happening now. This is important to young Japanese."

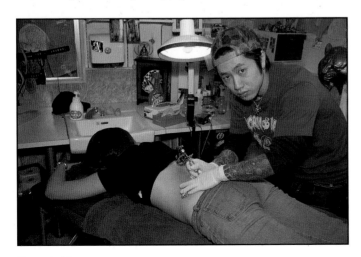

Tattooer Mutsuo

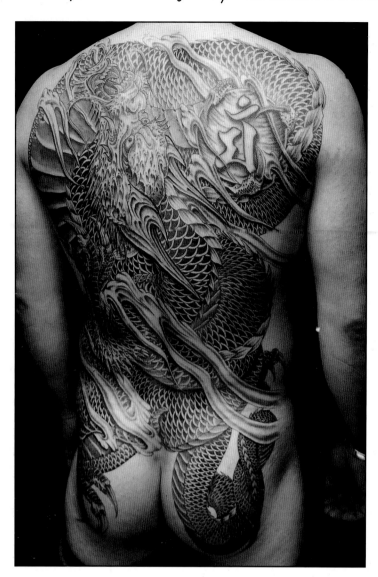

Tattoo by Mutsuo

Tattoo by Mutsuo

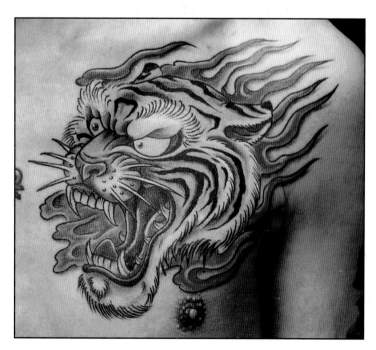

Tattoo by Mutsuo

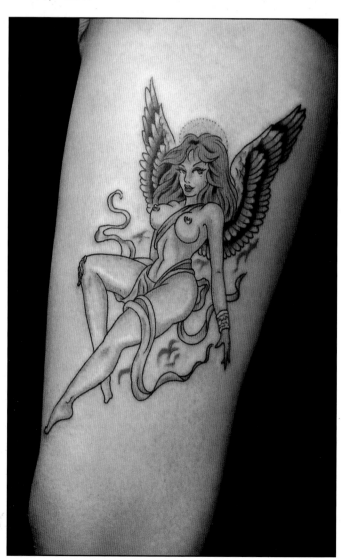

Tattoo by Mutsuo

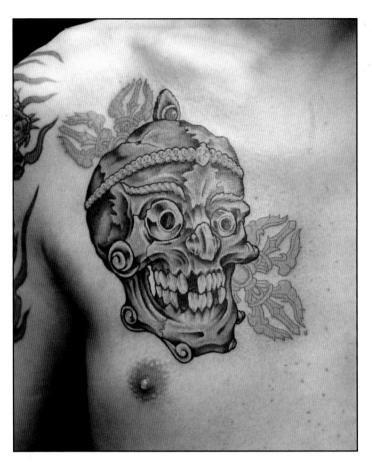

Tattoo by Mutsuo

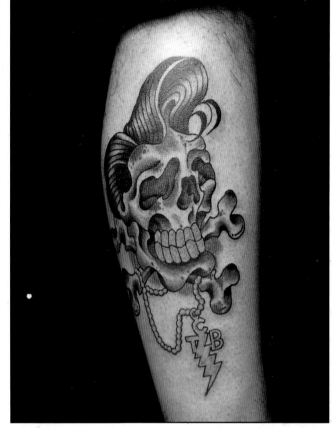

Tattoo by Mutsuo

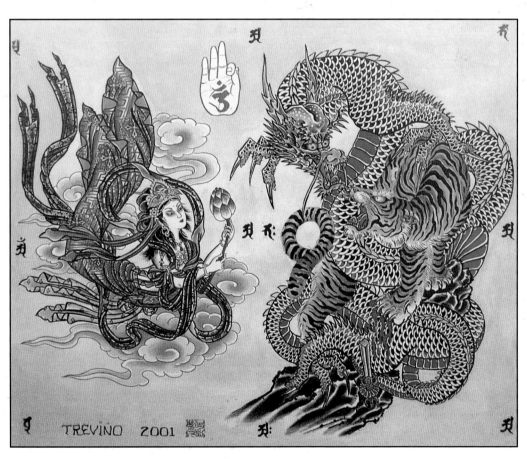

Flash by Chris Trevino

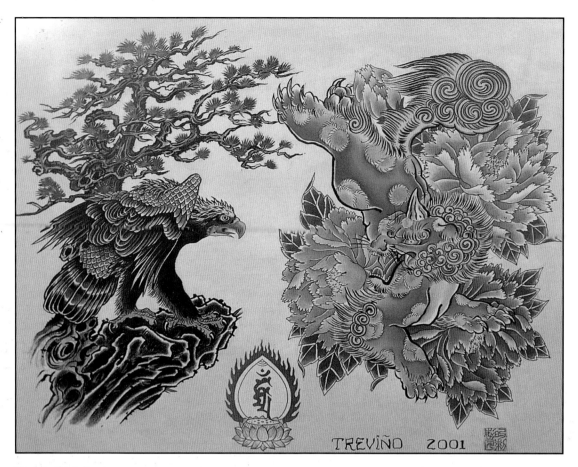

Flash by Chris Trevino

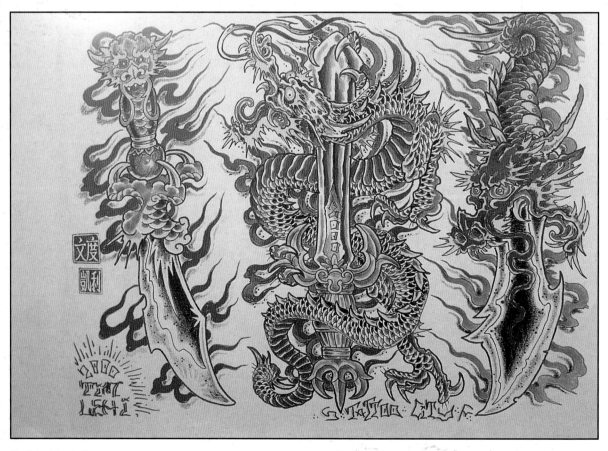

Flash by Tim Lehi

Shige and Yellow Blaze of Yokohama

Shige started to tattoo in 1993 and explored the art form on his own for the most part. He had a friend who was also interested in tattooing and they both practiced and experimented on each other. He has always been interested in the power of images and from an early age he taught himself how to draw. Both his mother and grandmother were talented artists who encouraged him to work hard at his drawing and he has been greatly influenced by their interest and support.

As a young man he was aware of tattooing in Japan but at that point the art was clouded by its associations with the Yakuza. He was not necessarily drawn to the classic tattoo styles worn by Yakuza members and had more of a curiosity about the examples of Western tattooing that he had seen from time to time in Western magazines. He was a Harley Davidson mechanic for ten years and became aware of Western biker style tattoos after looking at biker magazines.

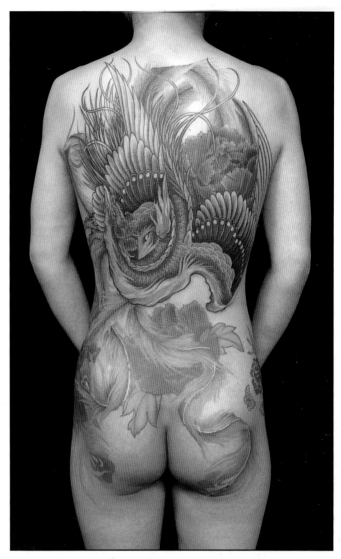

Tattoo by Shige

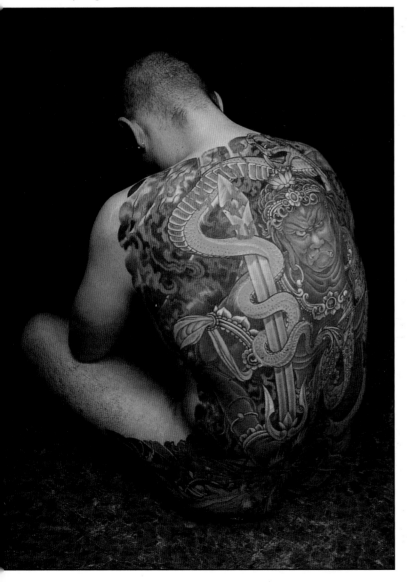

Tattoo by Shige

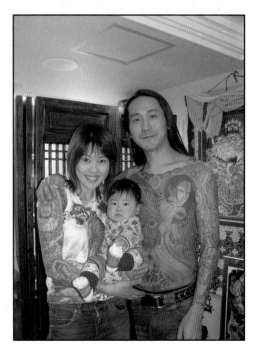

Shige with family

Artwork by Shige

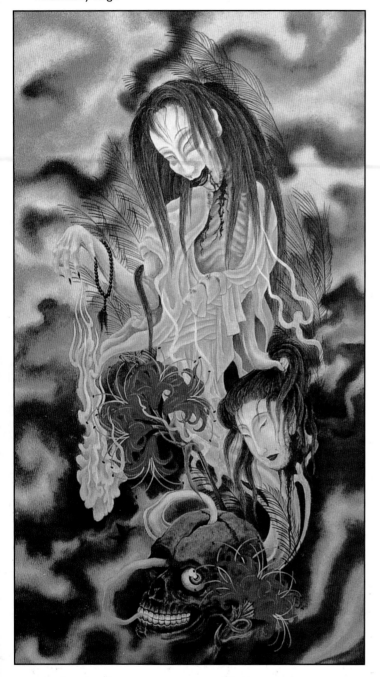

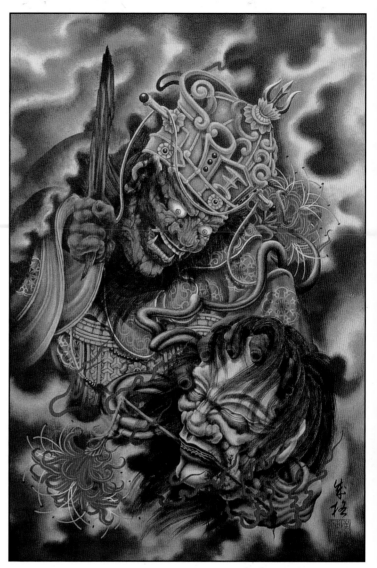

Artwork by Shige

At the time Shige did not know where to find tattooers who understood Western tattoo styles and decided to explore the style himself. He practiced with friends for five years, devoting all his time to tattooing and then opened his first Yellow Blaze studio in 1998.

Shige's life changed dramatically in 1999 when he met Filip Leu at the first Tokyo tattoo convention. Then at the second Tokyo convention Filip was working at Horiyoshi III's Yokohama studio and Shige made arrangements to get tattooed there by Filip. "It was very important for me as a tattooer and an artist to be tattooed by Filip," Shige explains. "It was the first professional tattoo work I had on my body. It was a good situation and relationship for me to be able to experience Filip and his artwork. At that point, I was being impressed by American tattoos and tattoo art. When I saw Filip's fusion style it opened my eyes and mind to the power of Japanese tattoo art. It changed my mind about things.

"For a long time," Shige continues. "I had been looking for my own style. After getting tattooed by Filip I became more interested in the Japan style. The experience helped me to create something that is more my own style. It is something I call Japanese New School Style. I decided to learn more about Japanese traditional tattoo styles."

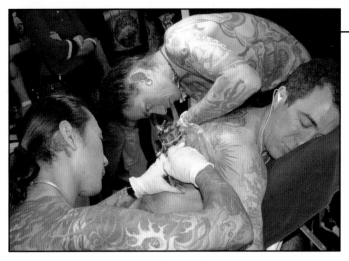

Shige and Filip Leu working on collaborative tattoo, Milan, 2004

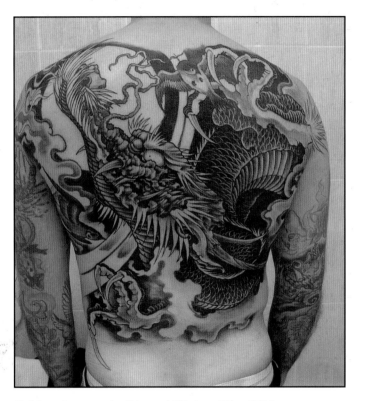

Collaborative tattoo by Shige and Filip Leu, Milan, 2004

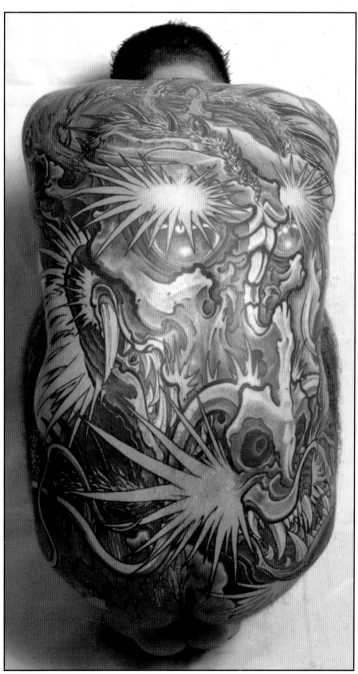

Tattoo by Filip Leu, 1998-2000, photo: Neil Labrador

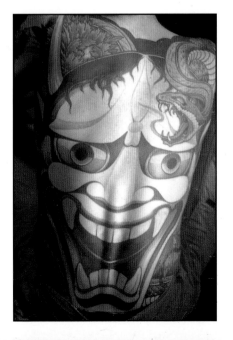

Tattoo by Filip Leu,
1997-2000, photo:
Neil Labrador

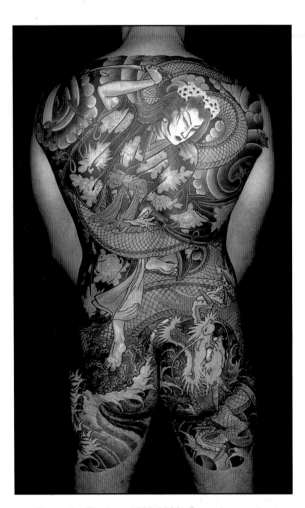

Tattoo by Filip Leu, 1998-2000, photo: Loretta Leu

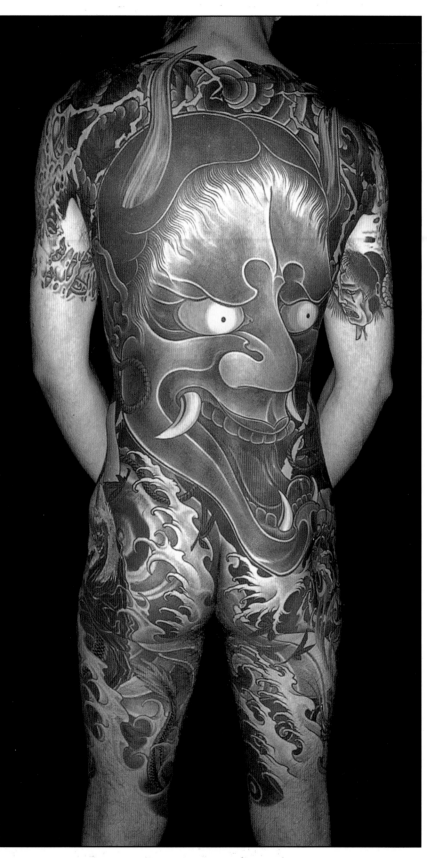

Tattoo by Filip Leu, 2000-2003, photo: Loretta Leu

Shige represents the fusion of Eastern and Western ideas and esthetics that are found today in Japanese tattooing. Like many other young Japanese tattooers, he straddles both worlds and blends the styles in an effort to form a unique artistic perspective. "I tried to visit traditional Japanese tattoo artists," Shige continues. "But it was difficult. There is a lot of politics associated with Japanese tattooing. You have to be respectful. I am now influenced by many tattooers from the West and from Japan. I am very respectful of Horiyoshi II and Horiyoshi III's work. I feel that all tattoo artists are my teachers now.

"At first I was a One Point style tattooer but now I want to work in a larger style, influenced by the Japanese style. I think that it is important to attend conventions so you can inform people about what you are doing. I made friends at the New York City convention and later I went to a Tattoo The Earth convention. This was important.

"A few years ago I went to Switzerland for three months. I stayed with Filip and learned more techniques there. I also learned more about drawing there too. I also attended some of Paul Booth's art camp and classes."

Now that tattooing has gone global, Shige feels that he wants to promote the Japanese style at the different conventions he attends. He feels that all over the world many artists are interested in the Japanese style, but they don't really understand the style. "Many of these tattoos do not look right," Shige explains. "They are fake Japanese style tattoos. I want to promote the real Japanese style. I want to maintain the authentic roots of Japanese tattooing. But also to infuse this authentic character into the Japanese New School. The authenticity is important to me. For me it is really important to know the past to bring this style into the future.

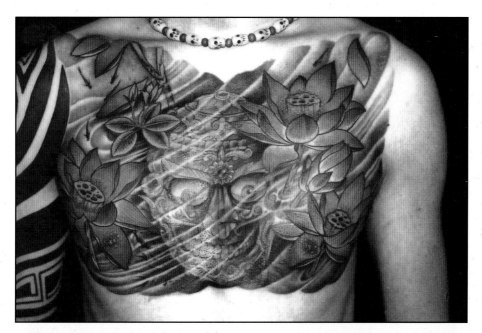

Tattoo by Shige

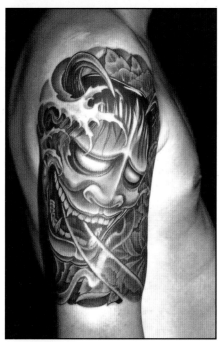

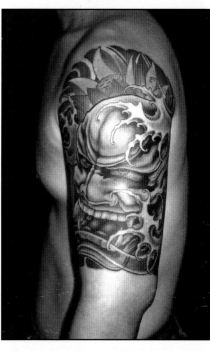

Tattoos by Shige

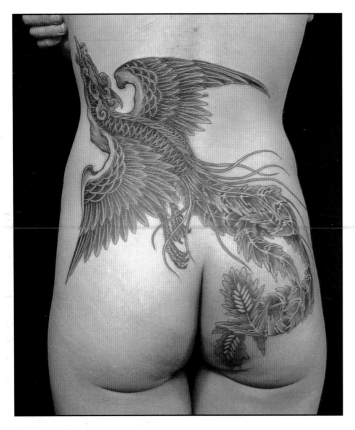

Tattoo by Shige

Tattoo by Shige

"I have a lot of respect for Japanese traditional artists. In the future, due to international influences, stylistic possibilities will change things. The look of Japanese tattooing will continue to change as it is stylistically influenced by the new possibilities."

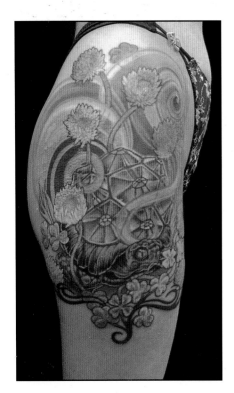

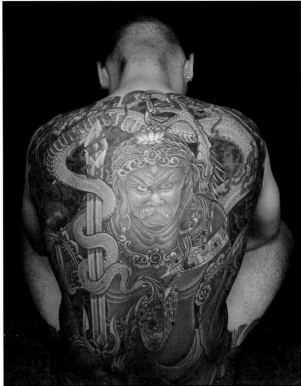

Tattoo by Shige

Tattoo by Shige

Tattoo by Shige

Chapter Two

You Should Not Tattoo Ghosts on People: Sensei Horihide of Gifu

Sensei Horihide gestures out the window of his studio towards the small tree-covered mountains that surround the city of Gifu. The land runs flat like a tabletop right up to the edge of the mountains in a curious way. "You can't see them from here," Sensei says. "But there are monkeys living in those mountains.... The hills around Gifu are full of monkeys."

Gifu is a medium-sized city located about thirty miles from Nagoya. It is famous for manufacturing paper lanterns and umbrellas as well as seasonal, cormorant fishing. The town has a modern, sprawl-like feel to it that includes a morning and afternoon rush hour of clogged secondary streets.

Sensei's new studio is located outside the city's center in a nondescript modern apartment building. There is no sign announcing his historical reputation as one of Japan's first tattooers to reach out to the West. As in many cases in Japan there is a plain business card over his studio doorbell reading, Kazuo Oguri-Horihide.

The apartment-like studio is divided into three sections, a kitchen entry room for tea, a sitting room to the left with comfortable chairs, an entertainment center, paneled walls with Asian style wall hangings. To the right is the room where Sensei works: a short-legged table surrounded with comfortable cushions, bookshelves against the wall filled with a rare collection of tattoo and art reference material. There is also a neatly organized and labeled video library of material from both the East and West. Everything in this room is about tattoos and art.

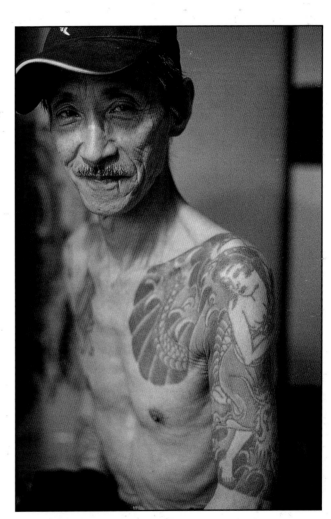

Sensei Horihide with Tamtorihime tattoo

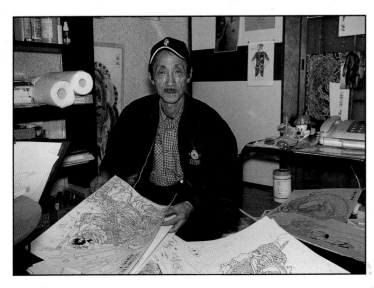

Sensei Horihide

Above the shelves along the walls, Sensei neatly displays dozens of bold, colorful, traditional Japanese designs painted on heavy watercolor board: The heroes of the Suikoden; Buddhist deities; Kannon, the Goddess of Mercy; and Tamtorihime, the female pearl diver, knife in hand who has dove to the bottom the sea to take back a jewel of unparalleled beauty from the Dragon King. In the legend, she cuts open her chest and hides the jewel from the King's army. She battles unprecedented odds but succeeds, giving the jewel to Fujiwara no Fuhito, and then dies. A classic story of bravery, servitude, and dedication. Each drawing on Sensei's wall has an equally significant story associated with it. The images and stories are the foundation of traditional Japanese tattooing that has been practiced for more than 200 years.

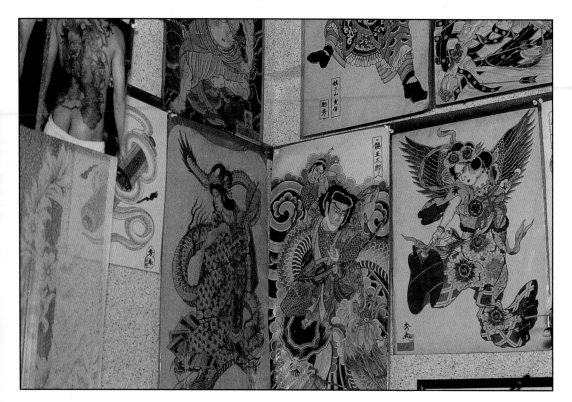

Studio art

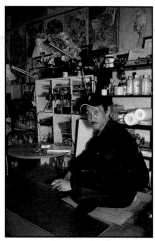

Sensei Horihide in his studio

During the early 1970s, Sensei Horihide started to reach out to the Western world. He was possibly the first Japanese tattoo artist to do so and it forever changed the flow of tattoo information between East and West. Through an associate in Tokyo, he contacted famed Honolulu tattooer, Sailor Jerry Collins, and struck up a friendship that would last for years. Through Collins, Sensei Horihide was introduced to the young American tattooers Ed Hardy and Mike Malone. Quickly, arrangements were made to visit Collins, Hardy, and Malone for an impromptu get together at Collins's home. The thrill of that early encounter was palpable to everyone involved.

He founded the Tokai Tattoo Club of Japan and produced a newsletter that was mailed on a global scale from his studio. At first the membership was limited, maybe thirteen people, but it provided a toehold for Western tattooers curious about Japanese tattoo art and tattoo history. The club grew in size exponentially, with Sensei spending long nights translating and reading a growing mountain of mail from the curious—an amazing, inspirational effort when you think about the divide of geography, language, culture, and familiarity existing at the time. The world was a bigger place in 1970—much bigger. Sensei ruffled some feathers among suspicious colleagues, embracing the West was unheard of. His impulse to look beyond was visionary in scope.

The fuzzy Xeroxed images included in the Tokai club newsletter were more than exotic for the time. They were truly rarified examples of information. Each newsletter was filled with an assortment of material including traditional Japanese designs seen only by a few outside Japan. There were references to traditional stories and myths; photos of heavily tattooed Japanese men and women; names of other Japanese tattoo sensei. It was all there in black and white and was amazing to see.

"I had a friend in Tokyo, a Mr. Kita who was friends with Sailor Jerry Collins in Honolulu," Sensei says. "He knew Jerry and thought he was the number one tattoo artist in America. Mr. Kita thought it was important for me to contact Jerry. I got Jerry's address and wrote him a letter in Honolulu. This was 1970.

"I decided, well I'll make a trip to Honolulu. Jerry told me about this young guy, Ed Hardy. Jerry said that Hardy liked the Japanese style. I called Jerry and he said Ed Hardy was going to be in Honolulu with Mike Malone. So we all stayed together at Jerry's home for one week. Everybody talk, talk, talk, you know. So I did a big outline of a dragon on Mike and I did a samurai on Ed Hardy's back.

"I did not do the tattoo Japanese style…. The floors there were very hard, no tatami. I had too much pain in my legs and knees. So I did the tattoo any ways. I outlined it all by hand. I did Mike Malone's outline in two hours. I had real pain in my legs. It was very hard to work on the hard floor. First time I tried to work with a machine Sailor Jerry said, "Kazuo, I want you to try this to make an outline. So I tried. The machine made a buzzing noise and it was very strange.

"After I went to San Francisco to visit at Ed Hardy's studio. He gave me a tattoo of a pin-up girl. Wow! That machine was a lot of pain when he make the outline! It was very painful! I was shocked to feel this new thing with the machine!"

Both sides of the Pacific were basically in the dark concerning the tools and esthetics surrounding the two unique approaches to tattooing. Rumors and myths were the foundation on which to build new relationships. People in the West wondered about the mechanics of tattooing by hand. What did it feel like? How was it done? Tattooers in Japan were intimidated with the idea of using a machine. It was loud and seemed to hit the skin too hard in a traumatic way.

"Tebori is different," Sensei describes. "There is not so much pain. The thin outline of the machine is very painful. Wow! The first time was a real shock. Wow! Too much!

"Two years later then I go to America and meet with Zeke Owen. He gave me a tattoo of a rose. Again the feeling was very strange. Zeke gave me the rose tattoo in 1971." Horihide describes these early days of contact between the different cultures. This was 1970, there was no connection between the Japan style of tattoo and the American style. The fledgling relationship required a sense of dedicated curiosity and interest.

"After I go to Honolulu and meet with Sailor Jerry, many tattoo artists from America send me a letter. Many, many questions they asked me like: How you do gray shading? Gray shading color, is what kind? They asked too many questions. I got many letters asking too many questions. Sumi stick ink and one touch of the needle inside…. Just like this make for the gray. But I got many, many letters about this."

Today Sumi gray wash is very popular, but in the 1970s nobody really knew what was involved. In a gradual process of teaching and sharing of information people learned about the technique. Sensei showed Sailor Jerry, in turn, Jerry passed the technique on to Hardy, Owen, and Malone who were impressed with the delicate shading and interested to experiment with new possibilities.

"I teach Ed Hardy about this. He come to Japan and he worked in my studio and I teach him gray shading. I re-member he said, 'Wow, this is easy!' So then many tattoo people learn about this.

"Second time I go to the United States I meet with Zeke. Ed Hardy asked me, 'Please, I would like to go to Japan.'"

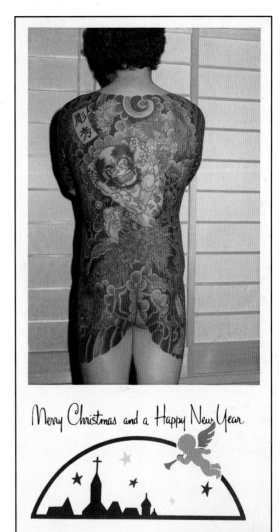

c.1974 Christmas card. *Courtesy collection of Jerry Swallow*

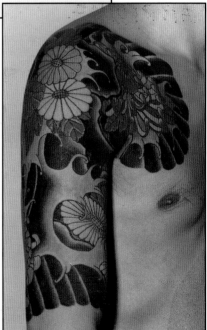

Tattoo by Sensei Horihide, 1970s. *Courtesy collection of Jerry Swallow*

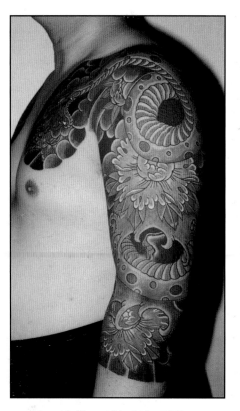

Tattoo by Sensei Horihide, 1970s.
Courtesy collection of Jerry Swallow

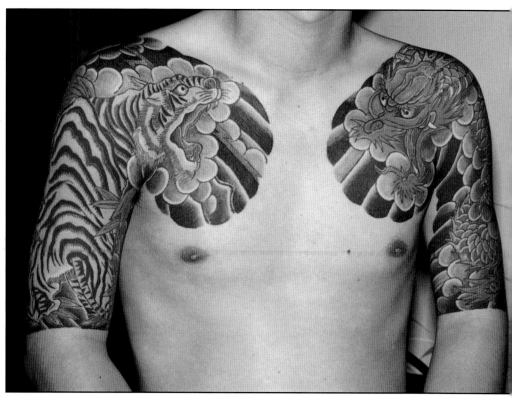

Tattoo by Sensei Horihide, 1970s. *Courtesy collection of Jerry Swallow*

Sensei Horihide, c.1970s. *Courtesy collection of Jerry Swallow*

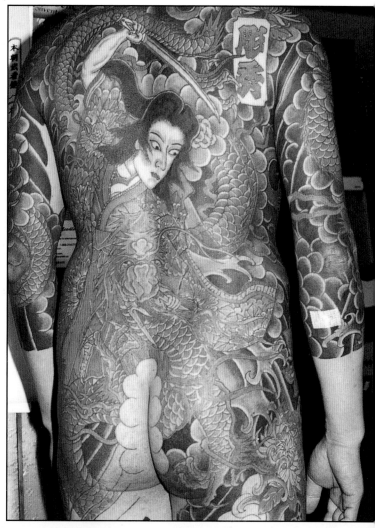

Tattoo by Sensei Horihide, 1970s.
Courtesy collection of Jerry Swallow

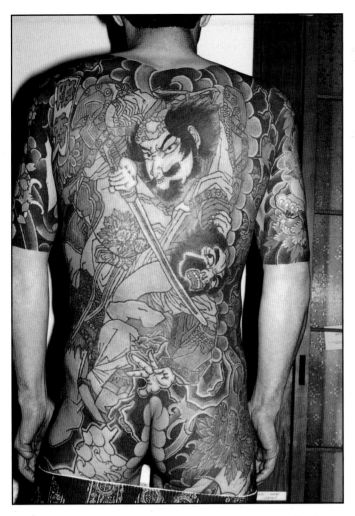

Tattoo by Sensei Horihide, 1970s. *Courtesy collection of Jerry Swallow*

Sensei Horihide. *Courtesy collection of Jerry Swallow*

Sensei Horihide. *Courtesy collection of Jerry Swallow*

Sensei Horihide, c.1980s. *Courtesy collection of Jerry Swallow*

At that point Sensei was a very special person: Other Japanese tattoo artists were not so interested in the outside world. Sensei was different, he thought this is good, it is important to make this connection. With the tremendous cultural divide that existed between Japan and America it is hard to know why Sensei felt this way. He was really going against so much of his cultural history, but there was also a practicality to Sensei's interest...

"I was very interested in the different colors that were available in America, Horihide says. "In Japan at that time there were only a few colors: orange, red.... There were very few colors. In Japan there was really only red. For me this was no good. Not enough color. In America there was yellow, blue, everything! I think I want color. I made this connection with Sailor Jerry because I wanted color. He had the first purple. He said come to Hawaii. I will tell you about these new colors. So when I went to visit, Jerry gave me many colors, Ed Hardy too. Green and blue-green. Yellow and light yellow. Mixing these colors to make a nice green. So I came back to Japan and tried these colors. Wow! It was a shock. So many colors! Old style Japanese were

black, red, brown…. That's it! I came with purple, yellow, orange. People were very surprised.

"In Japan my nickname is Purple. Everybody say my name is Horihide Purple. Purple color—Wow! Everybody was shocked! Many Japanese artists contacted me to get information. I got calls from Hong Kong…. How much, how much? Then over time in Japan there were more colors."

Later, Horihide met Pinky Yun at Ed Hardy's studio in San Diego. The information exchange between East and West continued to grow. Everyone was slowly getting answers to questions that had existed for years. Sensei Horihide had been curious about the possibility to expand his color palette. American tattooers Hardy, Owen, and Malone learned about traditional Japanese techniques from a master.

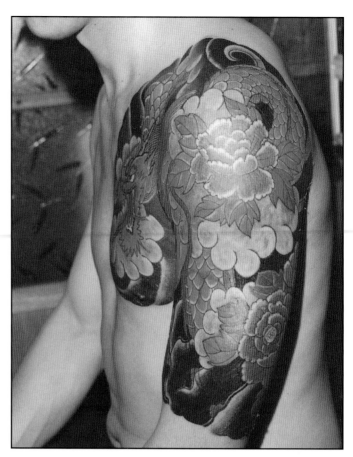

Tattoo by Sensei Horihide, c.1980s. *Courtesy collection of Jerry Swallow*

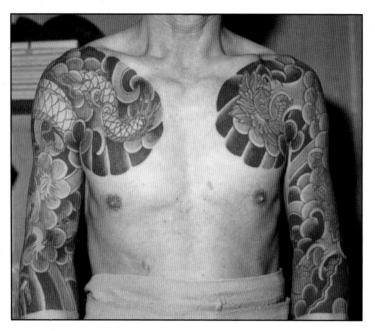

Tattoo by Sensei Horihide, c.1980s. *Courtesy collection of Jerry Swallow*

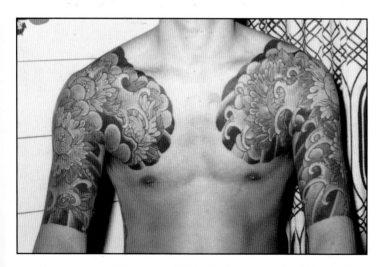

Tattoo by Sensei Horihide, c.1980s. *Courtesy collection of Jerry Swallow*

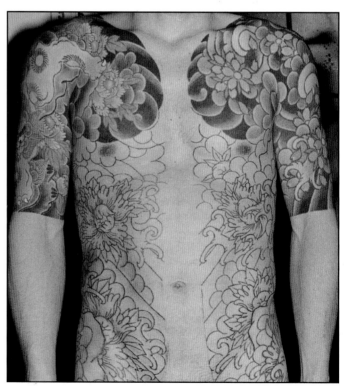

Tattoo by Sensei Horihide, c.1980s. *Courtesy collection of Jerry Swallow*

Jerry Swallow of Nova Scotia, Canada, established an early correspondence and friendship with Sensei during the early 1970s. Jerry remembers, "I became interested in Japanese tattooing way back in the early sixties when it was really unknown here. Most all old timers didn't like it and said it wasn't real, that the Japanese never had tattoos. I had found pictures from old books and I got real interested in 1969.

"Somehow I got in touch with Mitsuaki Ohwada in Yokohama. He never spoke English but sent me lots of his art to study. In 1970 I got hold of Oguri-Horihide, and we spoke for a couple years. He said he was coming over to visit Huck Spaulding, to get some colors and learn about them. I was to meet him at Huck's place and I think it was not until about 1972 when he came and it was to visit with Jerry in Honolulu and he stopped in Frisco. As I remember his first trip he was pretty young and he was at Ed Hardy's studio I think. He tattooed Zeke Owen on his chest with kanji. I never had the time or the chance to talk much with him till after he went home and we started writing again.

"I asked him first in 1970 about learning the Japanese style," Jerry continues. "He sent pictures and drawings and explained many things to me. We did exchange ideas too about needle configurations in the West and the East and the art styles too. He always told me Western is nice tattoo but traditional Japan style is the best. I thought this too. He was very good to me and said I will help you and promise what I tell you what to do is the right way. I learned his style from pictures, words, and little drawings he made to show me things. That was in 1978 before he gave me the name Horiryu, which I am still very proud of. He was a great influence on me and always will be. We are the best of friends today and he calls me Brother Jerry."

"I started my tattoo club around 1972," Sensei says. "Everybody wrote letter to me at that time. I was very busy translating all the letters and responding. It was a lot of work. Now, we call my organization Japan Tattoo Artists and Friends. We get many, many letters. First time we had only thirteen people. Now we have many." Sensei describes some of the early reactions he received from his Japanese tattoo colleagues. "It was a bit of a problem," he says. "They wondered why I was doing this. Why bother with outside world. Especially with the real traditionalists. They saw machine work from the West and did not like it that much. They were into the look of traditional tebori style.

"Many Japan tattoo artists used to make their tattoos with traditional tebori technique. Tebori outline and tebori shading. This created the real look of a Japan tattoo.

"Things have changed with many Japanese customers. I don't know why but everybody now in a hurry when they get their tattoo. Everybody hubba hubba. But I don't know why hurry up, hurry up? I don't know. I wanted to make good work. Everybody became hurry up, hurry up. I don't know why? Maybe the tattoo machine changed people.

Maybe made them want to work different. Some people work tebori style fast.

"Now in Japan the young people want it easy to make money. Machine work is OK, by hand is not easy. It takes two or three years to learn the hand technique."

Horihide started his tattoo experience in an unconventional way. As a young man he traveled from his home in Gifu to Tokyo on the run from the law....

"My teacher is Horihide of Tokyo," Sensei says. "I studied with him for two years before he let me try to make an outline. He would not teach. He would say, 'No question! No teach!' Every day I clean and clean and clean for two years. My teacher would say, 'This is how you get the guts to make tattoo.'

"Then one day I am permitted to try—only a little. Then he would teach me a little—then a little more. This went on for five years. Then one more year. Little by little he teach me.

"Every day he would beat me up. He would kick me around his studio. If he thought I was doing something wrong he would yell at me and beat me. First time he said, 'No questions—never questions!' He would punch me. He'd say, 'Get paper and keep drawing dragons!'

"One day I watch Sensei draw a dragon and he only put one horn. I say, 'Excuse me Sensei but I think dragon have two horns.' He yelled, 'Shut up!' He said, 'You look! You learn how to draw with perspective. Shut up!' He beat me every time I ask him a question."

With the kind of abusive behavior Sensei was experiencing from his teacher it is hard to imagine why he stayed. Why did he continue to endure the abuse? Something made his stick it out, a sense of drive and dedication.

"Many many young people came to him," Sensei continues. "But they could not tolerate his treatment. They leave right away. It was too hard. I stayed. Teacher said, 'Look, either you have guts or you do not have guts. You stay or you go!' I decided to stay. Teacher tell me, 'OK you have a little guts. We see how you can do this.' I stay two years. He then show me very little bit—a little and teach, teach, teach. He did not let me do anything for five or six years. Then finally a little bit. He was in his seventies. The first time I study with my teacher was in 1962.

"My teacher was known in Tokyo. I was a young punk in a street gang. Every day we would get in fights. One day we got in a bad fight with another gang. I had a knife and I took it out. I stabbed one of the rival gang members. I can remember pushing the knife into him. I think I kill him. I think I have to go away. Go to Tokyo. I thought that maybe the police would find me and catch me. I did not go outside. I stayed home. I was afraid. I didn't want to go outside, get caught, and go to jail.

"I laid low in Tokyo and learned from my Sensei. Then at one point I say to Sensei, 'OK, it is time for me to go.'

"The first time I came back to Gifu I started to work. Then different gangster families started to contact me. They wanted me to travel to their cities and tattoo their gangs. So one by one I go to other cities and work for gangsters. I tattooed them. Then I travel to the next city and tattoo gangsters—all over Japan. I tattooed for many gangster families.

"All the gangster families everywhere. In all the cities. I would go to Tokyo and tattoo gangsters there. Then I'd go to Osaka and tattoo gangsters there. These were the big gangs. They would call me. They say, 'OK, you will tattoo our whole family. You will stay one year.' I would go for one year and do the whole family.

"Then I would go on to the next city and do the same thing for the next family. Then each family would move me to other cities to tattoo their members there. The first time I came back Gifu my mother said, 'You pushed a knife into a guy but he did not die. He's not dead.' My mother paid money for hospital to make him better. So there was no problem.

"So then Gifu gangsters said, 'Oh, you tattoo artist? OK, you come and tattoo us.' I was a young man and a little afraid. These are serious people. I was a little afraid. I said this is a good opportunity to use my knowledge. I knew I could make my reputation if I worked for these people."

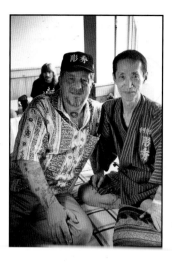

Sensei Horihide with
Jerry Swallow

Sensei Horihide is a traditionalist. He uses traditional tattoo techniques and turns to classic myths and stories for his subject matter. His artistic style follows famed Ukiyo-e woodblock master Utagawa Kuniyoshi who illustrated the 108 heroes of the historic Suikoden saga. The original fourteenth century Chinese tale titled, Shuihu Zhuan or The Water Margin was translated to Japanese in 1805 by Japanese writer Takizawa Bakin and renamed Shinpen Suikogaden. It was originally illustrated by Ukiyo-e master Hokusai Katsushika, was embraced by common urban people of Edo, and exploded into a craze.

The story describes the adventures of the 108 bandit heroes under the direction of Song Jiang who protect common peasant farmers, fighting against the injustice they experience from exploitive landowners. The bandits live in the watery, margin marsh areas near Mount Liangshan. They have their own ethical code of conduct and fairness based on comradeship and loyalty. Justice is measured out severely; opponents are first beheaded and then asked questions.

The common people of early nineteenth century Edo experienced economic prosperity but also the strict rule of the powerful Tokugawa shogunate. Social order was structured harshly into a system of inherited, hierarchical classes commanded by the Samurai and descending through a merchant, craftsman, and finally farmer classes. The common people had little chance to move up through the structure. The heroes of the Suikoden were adored by common people as symbols of social fairness, power, and mobility.

In 1827 Kuniyoshi was commissioned by publisher Kagaya Kichibei to make five designs about the 108 heroes. Kuniyoshi later published his illustrated version of the Suikoden named: *Tsuzoku Suikoden goketsu hyakuhachinin no hitori*. The book became legendary in Edo culture and Kuniyoshi was nicknamed, "Warrior Kuniyoshi". The heroic, tattooed characters of Kuniyoshi's Suikoden prints became the foundation of Japanese tattoo. Wearing tattoos became popular among common classes of Edo laborers, firemen, and prostitutes.

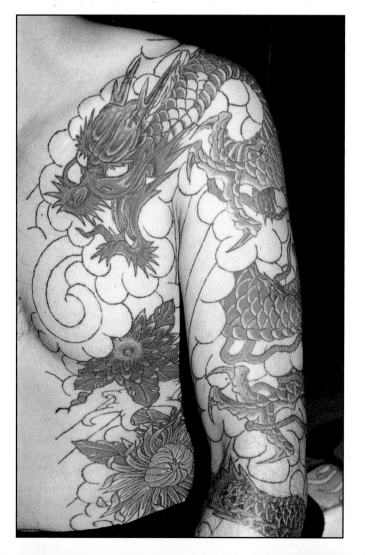

Tattoo by Sensei Horihide, c.1980s.
Courtesy collection of Jerry Swallow

"I concentrate on the pictures from the old stories," Sensei explains. "Yes, the heroes, the samurai, the dragon, the phoenix. Japanese people like the dragon. Samurai fighting style. The pictures from the Chinese samurai story, Suikoden." During his difficult apprenticeship, Sensei's teacher directed him to learn the myths and stories. He was told to become intimate with the 108 heroes of the Suikoden and their significance and meaning, to understand their different personalities and power.

"Yes, all the time my teacher concentrated on the big stories," Sensei describes. "He concentrated on the designs of Kuniyoshi. He concentrated on six of the heroes Kuniyoshi featured in his prints of the Suikoden. These are the designs he put on people's backs. My teacher did not like to feature all the heroes of the Suikoden. He felt that there were too many to feature.

"I like to feature many characters of the Suikoden. A little crazy but I like to feature many of the heroes. I like the Kuniyoshi look. For me it is not too crazy. I like Ryu O Taro image of warrior fighting dragon and holding mirror with face of woman in mirror. This is Japanese story—not Suikoden, Huncho Suikoden. Not Chinese, Go Ge Ku Suikoden. Chinese Suikoden, the warriors have tattoos. In Japan, the samurai stories, the samurai never have tattoos. The government would not allow the samurai to have tattoos. In Japan the firemen had tattoos. When Meiji government come in with Westernization, the Meiji government forbade firemen to get tattooed. Firemen during the Edo period were tattooed.

"In the Chinese Suikoden the warriors have a tattoo. In Japan, samurai were never tattooed. All the time the government said samurai and tattoos must stop. Edo firemen had a lot of tattoos.

"This was the end of the Edo period—Edo culture. Over the years there have been tattooed samurai in movies. Movie posters had samurai with tattoos. But really there were never samurai with tattoos. It was not allowed."

Sensei has taken on an apprentice who focuses on the new One Point style now gaining popularity in Japan. She is interested in learning traditional techniques and Sensei is slowly introducing her to the complexity and depth of traditional tattooing.

"I have apprentice named Shitomi," he says. "This means eye in Japanese. She has been working for three months with a machine. She wants to learn tebori style. She feels that tebori is real art. Machine, One Point is not art. It does not have same art. Tebori is real Japanese tattoo. One Point machine work is not real Japanese tattoo. That is my opinion and she feels the same way too.

"Every day I make her practice tebori on a piece of rubber. A truck tire inner tube. This has the same feel as human skin. The same. This is how she is learning how to push, the jumping of the needles. The way the skin pushes back. I think it could take two years for her to start to understand. This is not easy. Everybody here doing tebori

outline only moving up the line—going up. My style I have done going up and down. When you only go up, go up, this is very slow. I try to go up and down. It is more difficult to go up and to go down. Hard to control.

"I use special order needles. I used to use special wood for needle stick. Sometimes I use bamboo. Wood has to have strength. Bamboo has a bounce to it. In the old days tattooers used ivory. Then an Edo tattooer Horicho used bamboo. He also worked in Yokohama. An English princess came to Japan a long time ago. She wanted a tattoo. She go to Horicho.

"I do not like working with ivory. The needles do not jump. I like to work with bamboo. The needles jump. It is easier to work."

The drawings that surround sensei's studio are colored brightly in blends of yellows, reds, and oranges that balance cooler blues and greens. There is also a liberal amount of black used to create depth. The outlines are a balance of bold and narrow that create visual movement in the compositions.

"Some of these drawings are from 1972-1973," Horihide explains. "I send drawing to Sailor Jerry. Not too many hero style drawings. He liked the drawings of Japanese women.

"These traditional drawings have detail. They have a lot of lines. In the old days customers would lay there and take it. No complaint. They said nothing. Today many young people cannot take the pain. They complain about complicated designs.

"I like to model my drawing style like Kuniyoshi. I am Kuniyoshi crazy! They are strong. I do outline traditional style, tebori. Outline goes thick, medium, thin. Just like Kuniyoshi. This is how I do it. This is important. This is keeping with style. Keeping with Ukiyo-e style."

Sensei Horihide was born in the 1930s and remembers Japan before the War. The breadth of his historical experience encompasses a critical period of history in the East, before and after the rush of information and acute cultural influence from the West. His early involvement in this process with tattooer Sailor Jerry Collins opened a door.

"I was born in 1932. Today in Japan the young people do not know anything about the hardships after the War. It was very difficult for people. I was 14-15 years old. During the War and after, there was no tattooing permitted. The police would catch tattoo artists. People would have to pay money. General MacArthur saw old style tattoos and liked them. He changed law. He talked to Japanese government and said, 'This is good.'

"Now in Japan things have changed. Everything now is stencils. Now with young people there is no free hand. Everything is stencil. This is not a strong way to tattoo. Too much clean line. The outline is same line. By hand there is more of a line. By hand you go from a very small line to a medium line to a heavy line. Three kinds of outline. This

looks more strong. Machine gives you one line. It is a different look.

"I do not like small designs. American style is mostly small designs. I like the Japanese style. My heart is the Japanese style heart. American style design has no story. In Japan the tattoo designs, every tattoo design has a story.

"I see this tattoo they call the Tribal. I don't know this Tribal. Young people come; they say please, Tribal. I say, do you understand Tribal? I say why do you like that? I don't understand Tribal. They say, Oh ya? I don't know why young Japanese people like this One Point. I think they are like monkey.... They follow everything. Monkey see, monkey do They just follow.

"I think apprentice-teacher system is best system. I draw every day. I promised to my teacher that I would draw every day. I promised and I draw every day. Sometimes I get tired and sleepy but I still draw. Every day. If I don't do every day, no good.

"I worked six days a week for my teacher. I had one day off. I would go to the temple and look at designs. I would go home and draw. I would change how things looked. Make a little change from my teacher but I would never show to my teacher. He would get mad!"

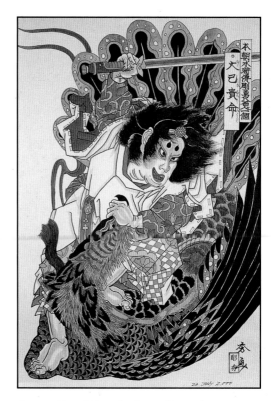

Onamuchi no Mikoto by Sensei Horihide

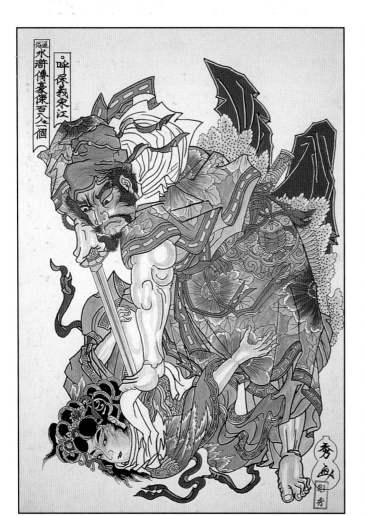

Painting by Sensei Horihide

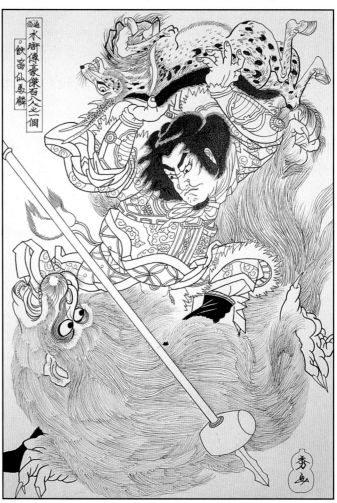

Drawing by Sensei Horihide

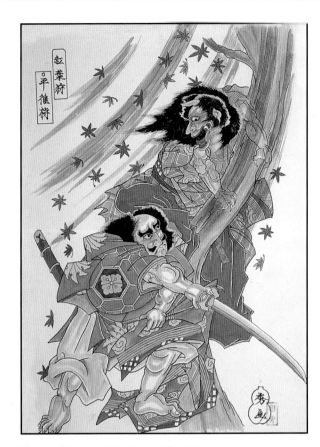

Taira no Koremochi by Sensei Horihide

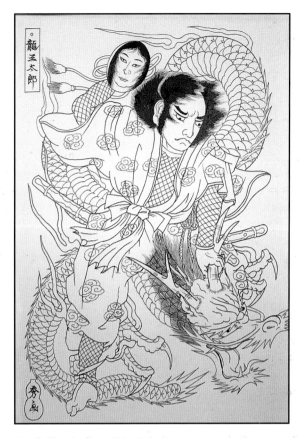

Ryu O Taro by Sensei Horihide

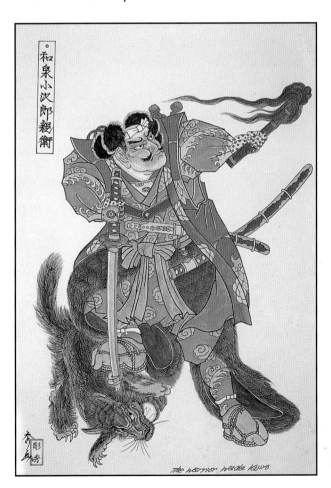

Warrior Wade Kojiro by Sensei Horihide

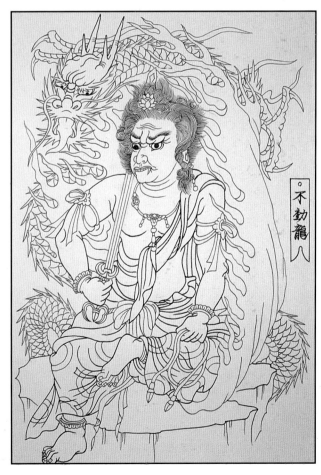

Fudomyo-o by Sensei Horihide

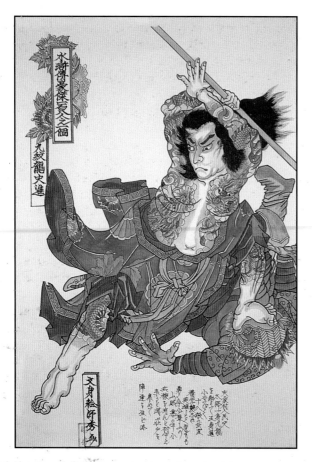

Kyumonryo Shishin

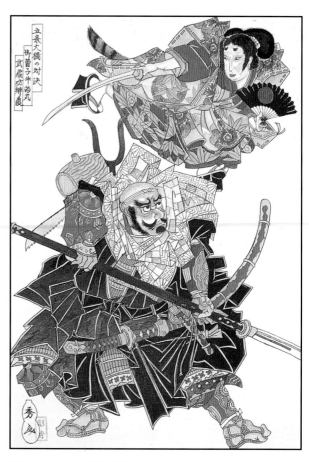

Painting by Sensei Horihide

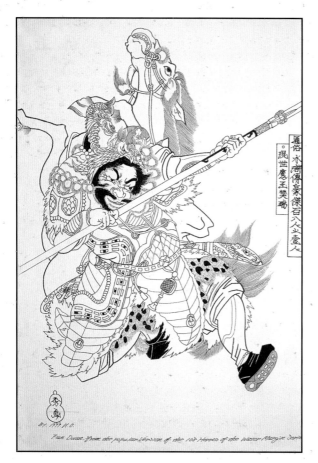

Fan Duan from 108 Heroes by Sensei Horihide

Painting by Sensei Horihide

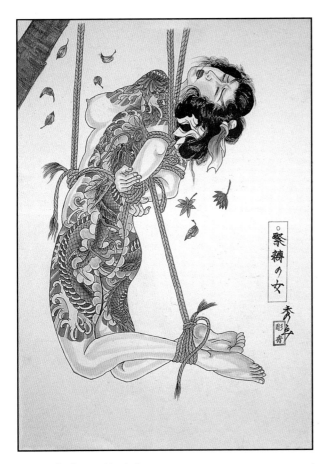

Painting by Sensei Horihide

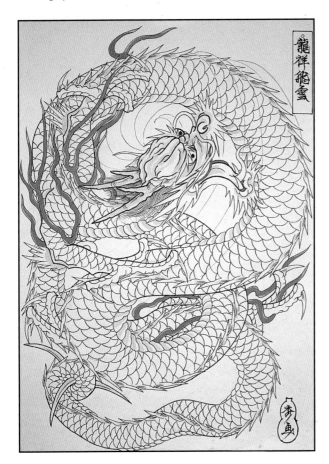

Painting by Sensei Horihide

It is said that the look of a tattoo that has been applied using traditional tebori technique lays in the skin differently. The ink is set into the skin with a different sense of authority and the traditional technique creates an opacity not seen with machine work. The pigment envelops the skin more comprehensively. The integrity of tebori style gray wash holds up over time, where a gray wash created with a machine falls apart relatively quickly.

"I think Japanese stick ink is best ink," Sensei says. "I make my ink from soot. Pure carbon. This is very expensive. Price is Wow! My teacher would tattoo me; he would add water to make the shade. He would tattoo and then change ink. Add a little water. Then tattoo.

"There is a right and wrong way to follow Japanese traditions—the stories. When you draw an image you don't have somebody wearing a summer style kimono and the design has Fall Maple leaves. This is not right.

"Old kimono styles should be accurate. Sometimes American tattoo artists change things. The way people close the kimono—Right over left. One should be outside, one should be inside.

"Today in Japan, many young people do not look for correct detail. They don't know. For me to make tattoo everything has to be correct. From beginning to end, everything has to be correct.

"Sometimes American tattoo artists exchange art with me. They try to make Japanese style and I look and I see that they make mistake. Samurai style and back style. Young people make waves on shoulder style tattoos. This is a mistake. You never have waves above.

"Ocean style is OK but back style should be correct. Shoulder should be the sky. Waves on the shoulder, this is a mistake. River is around the hips, waves should be bellow. Sky is above—water is below. This mistake might look OK but this is not correct. They make too many changes. It might look OK but this is not correct. I have designed over 600 back and arm designs. Every day I draw. I make over 600 drawings for designs. Every day I draw.

"When I make my outline, I use six needles flat. Then you turn on side. Never round. Flat. Round will hit the skin different. Too hard. Tokyo tattooer in Asakusa, Horibun, he tattoo with round needles. But it has different look. Flat needles make it look more even. You look at my tattoo, outline by hand. Looks different. It looks more strong. Outline with machine is not strong. When tattoo are done completely by hand they have a sense of heart. You don't see this with machine tattoos.

"A completely hand tattoo, they have a human quality; like the tattooer has put all of himself into the tattoo. Whether open kimono style or closed kimono style. I don't like closed kimono style. I like open style best."

The new enthusiasm in Japan about Western style tattooing does not really interest Sensei Horihide. He operates in a different world and uses a different set of criteria when he engages his art form. In Japan, these worlds are not necessarily in conflict with one another; they simply

operate on different plains. One is steeped in local tradition, the other in an internationalist preoccupation.

"I don't like this new One Point style. This tribal style. They just do this tattoo to make money. Many Japanese young people come to me. They ask me to teach them machine. This is strange. I don't care about the machine. I don't understand this at all. Tebori style puts pigment into the skin much better. Lasts longer. There is a right and a wrong way. There are rules. You must follow the rules.

"You should not tattoo ghosts on people. This could make trouble for a person. There are some designs you should not tattoo. These could be bad for a person's soul and spirit.

"Two three years ago many, many young people got One Point tattoo. Now this begin to change. These young people begin to think about what they did. Maybe One Point tattoo has no story. No good. So they think about this and they change. Maybe they think, Japanese style is best. So they get One Point covered up with Japanese style. No history, no meaning.

"They understand after first time they think any kind tattoo is OK but then after they change. Some people, they read, they learn. They do everything correct. Other people they do not learn, they do not do right. For them this is just pretty picture.

"As young artist I see strong Kuniyoshi style art. I always stay with Kuniyoshi style. It is strong. I feel I try to put my heart into every tattoo. I draw one time onto the body and then I tattoo. I use the brush to draw on body. I use tebori technique to make tattoo. People know this. This is why they come to me."

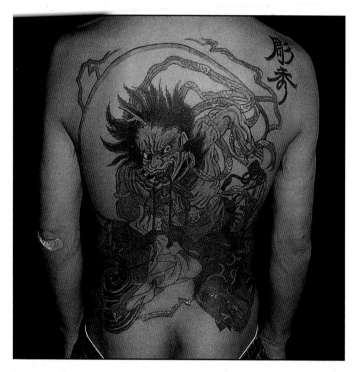

Tattoo by Sensei Horihide

Sensei Horihide

Sensei Horihide

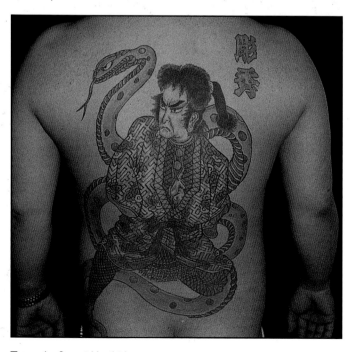

Tattoo by Sensei Horihide

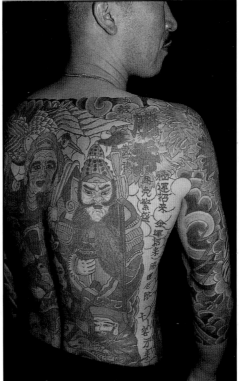

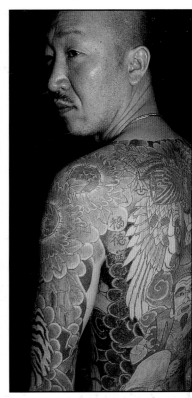

Tattoos by Sensei Horihide

Tattoos by Sensei Horihide

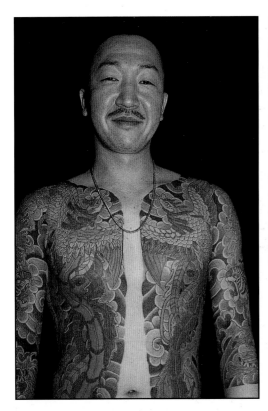

Tattoos by Sensei Horihide

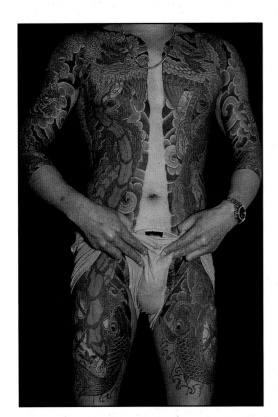

Tattoos by Sensei Horihide

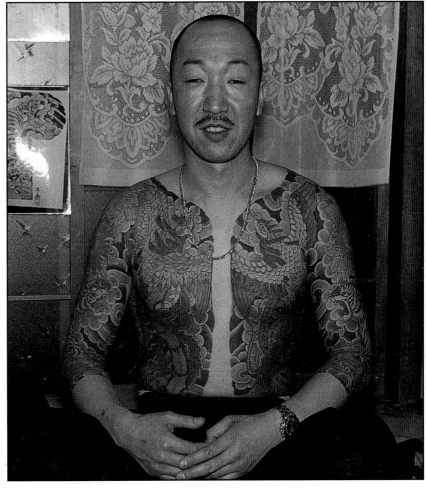

Tattoos by Sensei Horihide

Chapter Three
Sensei Horitoshi and Tattoo Soul

Sensei Horitoshi I is one of the most esteemed tattoo artists of Japan and the world. His reputation extends far from both his private studio and more open public studios located in a single building in the quiet, traditional Ikebukuro district of Tokyo. Like most private settings, Sensei's personal studio is a converted, residential apartment. There is a narrow, kitchen-like front room, a central public area with comfortable chairs and a large rear room where Sensei tattoos. His tattoo tools are neatly organized on a stainless steel, wheeled workstation. Each stainless needle stick has cotton gauze carefully wrapped around the sterile needles. A customer lies on a collapsible, padded worktable waiting for Sensei to begin. There are several middle-aged men sitting quietly in the central area smoking cigarettes and talking.

The mood throughout the studio is friendly but there is a definite undertone of seriousness and dedication. As Sensei walks through the rooms, everyone is attentive to his needs. American Country and Western music plays softly in the background as Sensei organizes the last of his ink caps. He is a huge fan of country singer Johnny Cash. The same Cash song is playing over and over again like a mantra. It is a recording of Cash's last concert before his death. Sensei is quietly singing along under his breath in a deliberate, country-style voice. He takes his music interests seriously; there is a special music room located in the building where he relaxes, practices his music, and entertains friends. He plays the electric base in a country Western band.

Sensei Horitoshi I

Sensei Horitoshi's studio

Sensei Horitoshi's business card

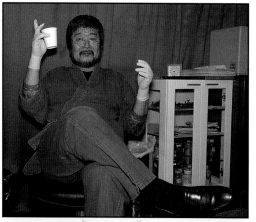

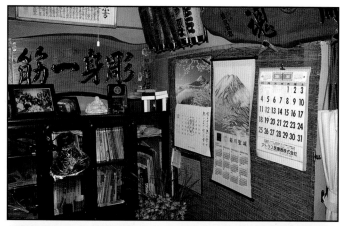

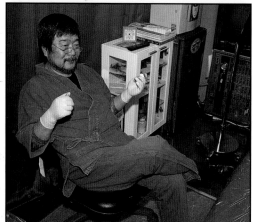

Sensei Horitoshi I

118

Sensei Horitoshi's work station

The two patrons sitting in the middle room are in the process of disrobing and revealing their large body tattoos. One patron is tattooed heavily from his collarbone to his wrists and ankles in classic donburi soushinbori—full frontal and back, nagasode long sleeve style. The insides of his armpits are fully tattooed tsubushi style with sacred bonji characters. The other patron is tattooed in the open kimono munewari style with open gobu style shorts on his calves and five-tenths gobu sleeves. The insides of this man's armpits are tattooed open katabori teardrop style. The customer who is reclining on the padded table has partial tattoo stylizations that extend from just below his elbows shichibu style, up his arms, over his shoulders, and onto his chest pectoral areas hikae style. Sensei has finished the right arm and chest and is preparing to complete the left. The size of these chest and arm styles differs depending on the region in Japan where you live. On the East Coast, the shoulder and chest design sizes are smaller. On the West Coast, these designs are larger. The thickness of the background, black bar stylization also changes according to geographic location as well. On the East Coast the bars are narrow, on the West Coast they are broader.

Sensei Horitoshi's work stands apart. There is a clarity and richness to his tebori technique that is almost shocking in its appearance. Sensei's characteristic use of solid color and rich sumi black is trademark unique. He is respected and admired for the bold and graphic look of his tattoos.

He looks towards his customer's stylizations and explains through the translation of Ryan Kunimura and Sensei's apprentice Masa. Marco Fernandez is also helping. "For some the munewari, open kimono style has a special significance," Sensei says. " Some people believe that the open chest permits the spirit to flow freely in and out of the body and the fully tattooed chest does not. Some people believe this and that is OK. It is an esthetic look also. Some people just prefer the way the open or closed style looks. It is a question of taste and this is why they get it."

Sensei pulls his workstation close to his customer and reaches for a needle stick. The needles are clustered twenty or more thick into a layered grouping. He wipes the gauze over the needles, dips them into the ink cap and settles into work, pushing the black ink into the background bars of the sleeve design. He pushes at a moderate speed for more than a minute, wipes away the excess ink, and resumes pushing. The skin is fully loaded with ink. His movement is expert and fluid. There is no wasted energy. His customer doesn't bat an eye to any of it. It's as if he is asleep, unbothered by the process.

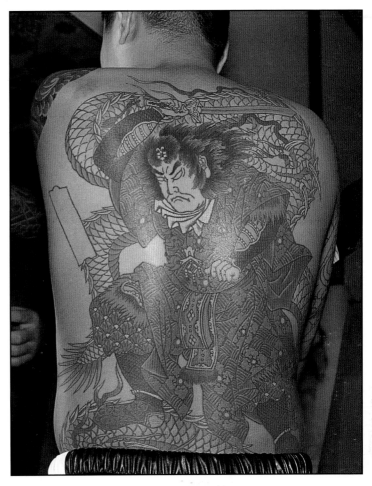

Tattoos by Sensei Horitosh

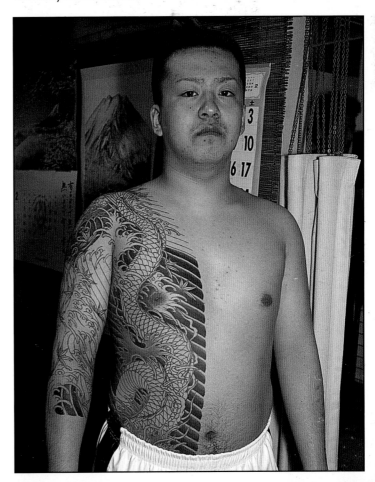

Tattoos by Sensei Horitoshi

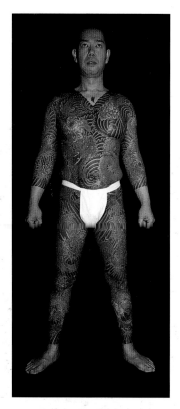

Tattoos by Sensei Horitoshi

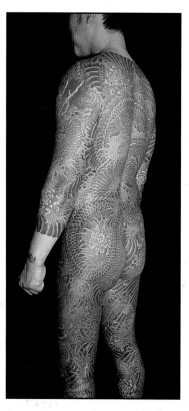

Tattoos by Sensei Horitoshi

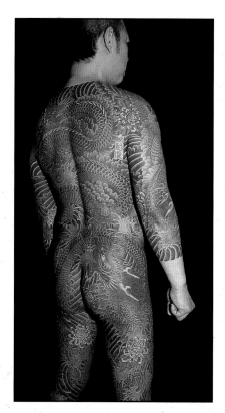

Tattoos by Sensei Horitoshi

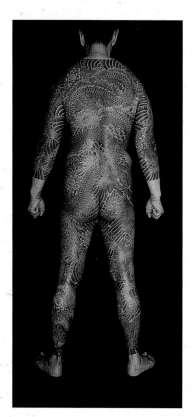

Tattoos by Sensei Horitoshi

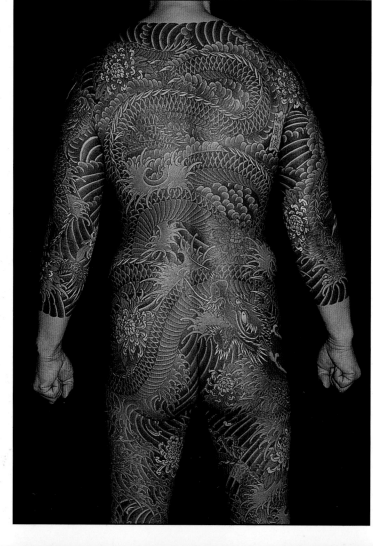

Tattoos by Sensei Horitoshi

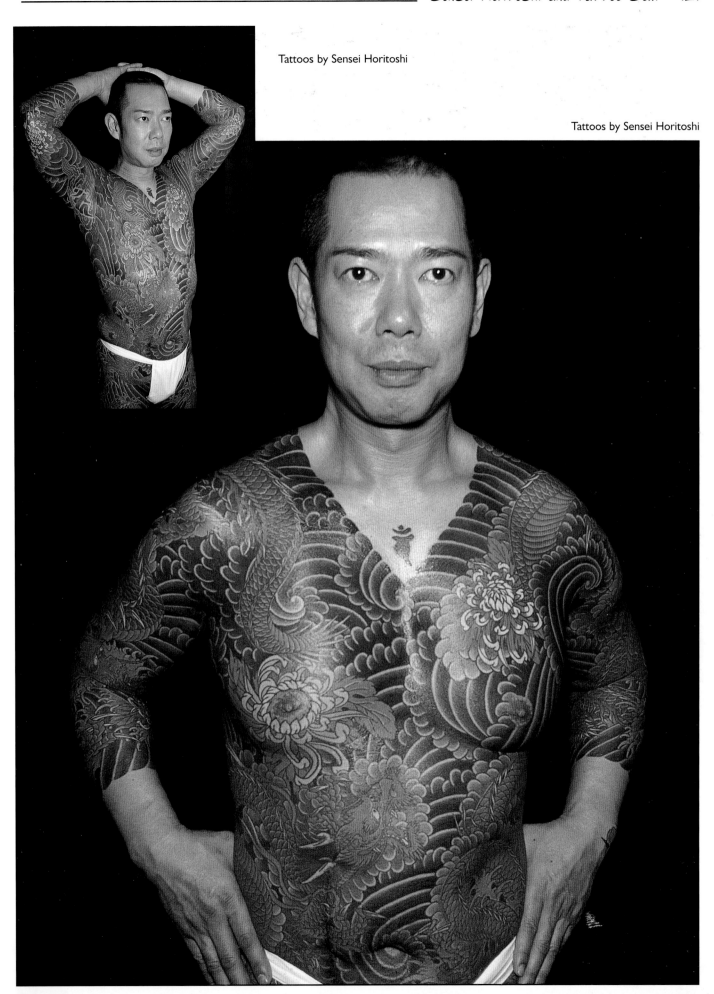

Tattoos by Sensei Horitoshi

Tattoos by Sensei Horitoshi

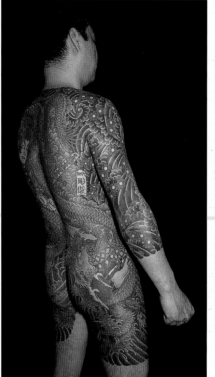

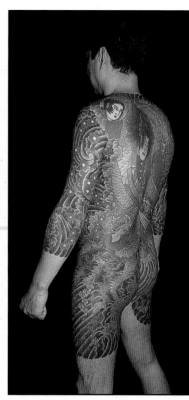

Tattoos by Sensei Horitoshi

Tattoos by Sensei Horitoshi

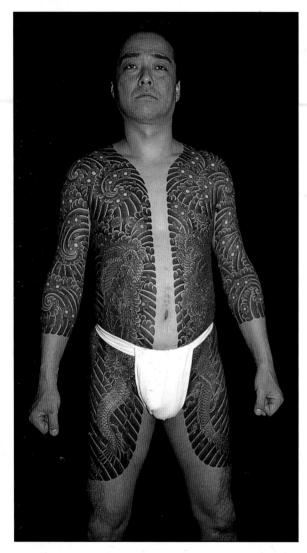

Tattoos by Sensei Horitoshi

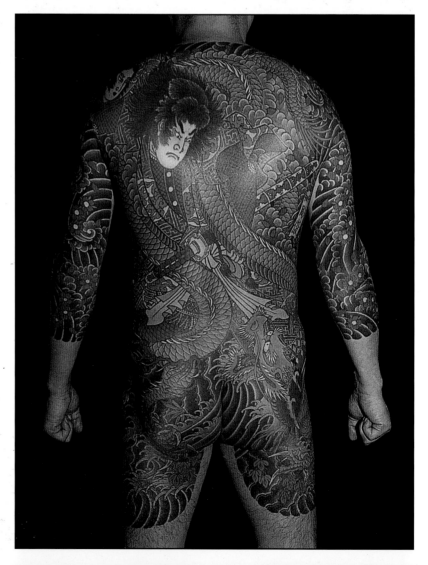

Tattoos by Sensei Horitoshi

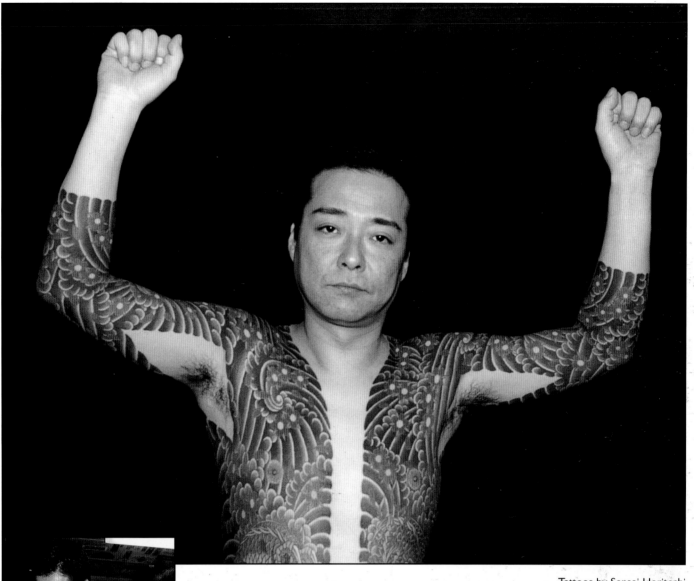

Tattoos by Sensei Horitoshi

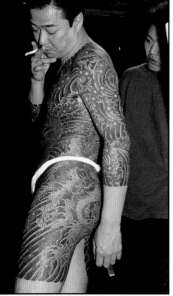

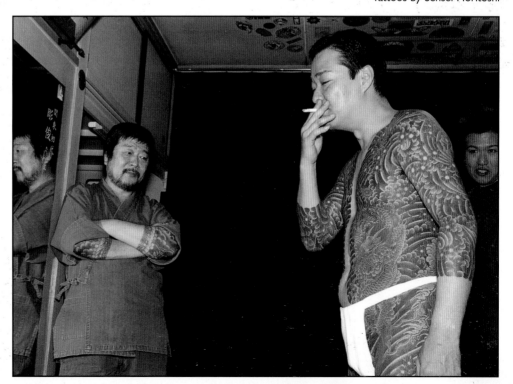

Tattoos by Sensei Horitoshi

Tattoos by Sensei Horitoshi

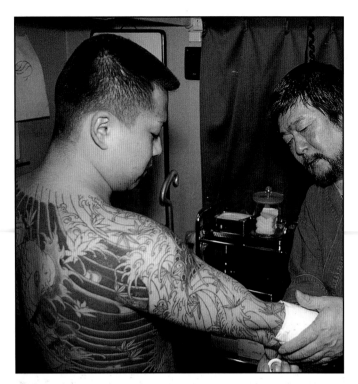

Sensei Horitoshi

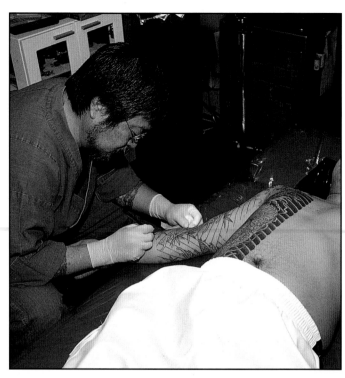

Sensei Horitoshi

"It has already been almost forty years since I started as Horitoshi the First," Sensei explains. "In the course of things, I took an apprentice about twenty years ago and became the leader of the Horitoshi the First school. The current school has approximately twenty members, both domestic and otherwise, including Horitoshi the second.

"I was born in Hakodate in Hokkaido in 1945 and from when I was very young, I lived in a place called Hidaka in Hokkaido. At that time there were many people around me who had tattoos and since I was raised in that kind of environment, I remember that it was inevitable that I would be interested in tattooing. I was impressed by its power and beauty. Though I was a child, I pretended to be a tattoo artist and when I was around twenty years old, I began training with the goal of being a real tattoo artist. At the time of the start of my training, I had the cooperation of a friend who was pursuing the same path and I dedicated myself to mastering this through independent study.

"However, the conditions for attempting to be a tattoo artist were not as favorable as they are now and a great deal of trouble and time were required for things ranging from how to create a 'chisel' (nomi) (tool needed for tebori, Japanese style tattooing) to how to select a pigment. Also, for the designs unique to Japanese style tattooing, I studied from picture collections of old art and literature over and over again to find items that could actually be used.

"At that time, there was already a celebrated tattoo artist who I respected. Horiyoshi the Second in Asabu. He's gone now but I met him in the flow of my tattoo artist life and later developed a closer relationship. He was also a painter of Japanese style paintings. I was greatly influenced by his pictures.

"In recent years more efficient, better products have been brought from overseas to Japan's tattoo world and starting from over ten years ago, I myself not only adapted pigments but also did outlines using a machine rather than solely by hand. I think this is optimal in terms of fine details and for shortening the work time. Before Japanese tattooing reached its current form, however, a variety of traditional techniques were used. One example of this is that in the era when there were few varieties of colors there was for example, a technique of making an image look more colorful by subtle use of the needle to change the density (tone) and color (gradation). This is a special feature of Japanese style tattooing and even today this is a very important technique. From this perspective as well, I believe that manual tattooing is essential."

As Sensei continues to tattoo his customer's upper arm he pauses occasionally to make a point about the design. He points at specific design elements, gesturing at the gradation of the rich black and lighter grays. He points at the main subject of the tattoo and the surrounding stylizations.

"Also, there are various rules for traditional designs for Japanese tattooing," Sensei continues. "Including things such as combinations of main subjects (motif) and how to handle the background in order to enhance what is called in Japan, the frame. By no means is it allowed to have a free combination or concept. The flow of the background (frame) and the arrangement of clouds or waves, flowers or leaves, or rocks within this flow is very difficult and these are a test of a tattoo artist's competence. There is no allowance for error.

"With Japanese traditional tattooing, trends differ according to region and the preferences of the customers. For example, there are differences in the size of the main subject and the width of the background. However, as I mentioned previously, from the perspective of having a main subject, a background that enhances this and completing a work according to set rules. I think they are the same. Other than that, the difference is the sensibility and spirit of inquiry of the tattoo artist. It is not a matter of 'this is Kanto and this is Kansai' and has nothing to do with the tattoo artist's hometown or region of activity. As long as it was possible to reference things such as Shinto shrines or Buddhist temples, art museums and other museums, kimono or fabric exhibits in Kyoto for example, I myself would make a pilgrimage anywhere to see these things.

"Furthermore, though I'm not a religious person, there are many Shinto and Buddhist images in Japanese tattoo themes and knowing the history and origin of these, observing details and believing in omens are very important elements of knowledge, I believe.

"However," Sensei continues. "This is not a matter of pushing religious sentiment onto customers. Of course, this is not just confined to Shintoism and Buddhism and it is up to the individual to tie this in with the customer's own religious sentiment, prayers or desires. Perhaps we could also say that this would of course change the personality or way of life of a person who tries to obtain the goal (of the tattoo) or a person who is able to achieve this.

"However it seems that tattooing is still subject to a great deal of prejudice in Japan. I believe that is because there is a big difference in people's attitudes toward tattoos compared to those of the West."

Sensei pauses and reflects about the connection between East and West. The process of influence between two distinct design bases. He describes the shift in seriousness and sentiment about tattoo art among many young Japanese people. He says, "It seems that recent Western style tattooing has changed a great deal in terms of the handling of compositions, perhaps due to the influence of Japanese tattooing. At the same time in Japan, due to the influence of Western tattooing, there is an increase in young people such as sportsmen or musicians who are casually getting tattoos in the sense of them as a fashion item and I feel that this has gained much more social acceptance. However, the current status is that it is still very difficult for the original Japanese traditional tattooing to become widely accepted as part of the artistic culture.

"At this point, I want to create a subject matter that I like, my desire is to pass down to future generations this traditional tattooing and I am devoting myself to cultivating successors."

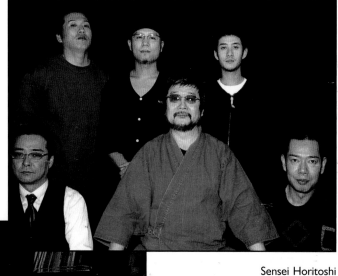

Sensei Horitoshi

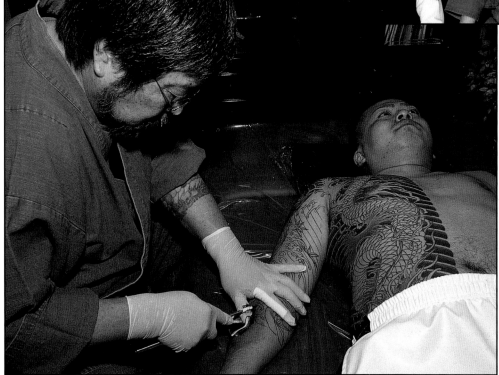

Sensei Horitoshi

Down the hall from Sensei Horitoshi's private studio is a large studio called Tattoo Soul where three of Horitoshi's apprentices work. There is a large commercial sign mounted to the side of the building that advertises the shop to people passing on the street. Tattoo Soul is mellow and has an exclusive feel to it. Soft reggae music plays in the background and the three young apprentices are either drawing or tattooing. Very little English is spoken here but one of the apprentices, named Horinosuke, has been apprenticing for six years and enjoys tattooing all the current styles. On the wall behind him there is an assortment of big drawings on tracing paper. Many of the images are large dragons and have a traditional Japanese feel to them, but several drawings are influenced by classic American tattoo iconography. Horiyamato has owned the shop for four years and is a member of the Horitoshi family. The other apprentices, Horishun and Horishunei have also been studying with Sensei Horitoshi for several years.

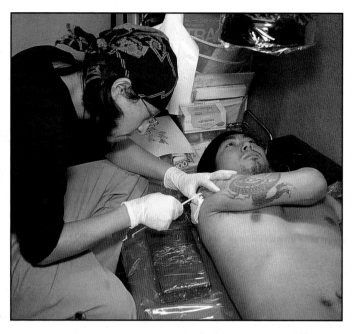

Horishun working

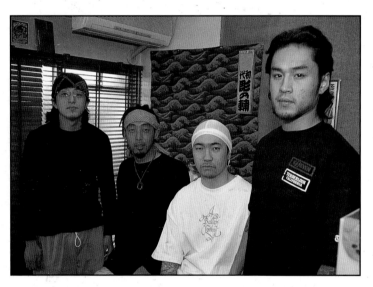

Tattoo Soul tattooers. (L-R) Horishun, Horinosuke, shop owner Horiyamato, Horishunei

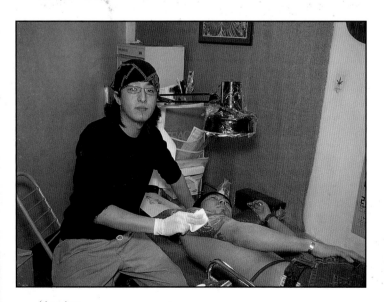

Horishun

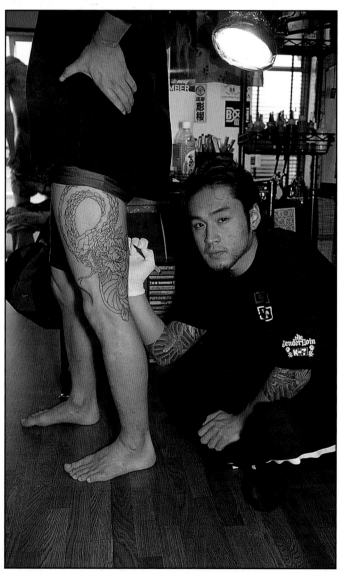

Horishunei

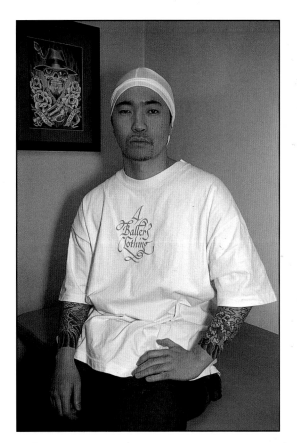

Horiyamato

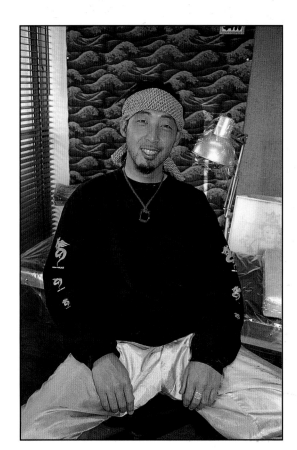

Horinosuke

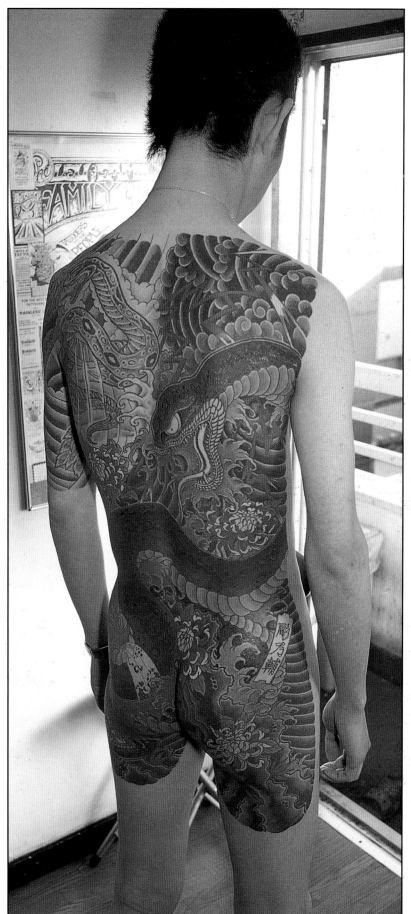

Tattoo Soul work

Horiyamato explains that the artists in his studio concentrate on both Japanese traditional images and contemporary Western style One Point images. There is not necessarily a tug of war between the traditions of Horitoshi's studio and the new demand for images from the West. There is no conflict, it is the new tattoo—the new style. Everything is a combination now, especially for people their age. The photos in the apprentice's portfolios and the drawings on the wall confirm this process of influence and combination. The images in the portfolios are weighted towards the traditional Japanese esthetic, but the West is definitely represented. This is the reality of having an open street shop in a cosmopolitan city like Tokyo, even if it is located in an undisturbed neighborhood like Ikebukuro. The influences and tastes that effect young customers are from everywhere in the world at this point.

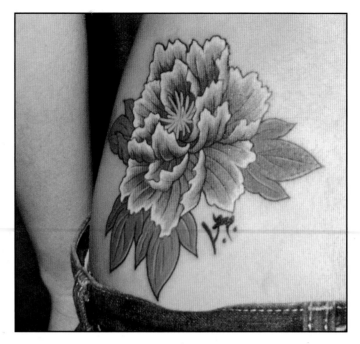

Tattoo by Horinosuke

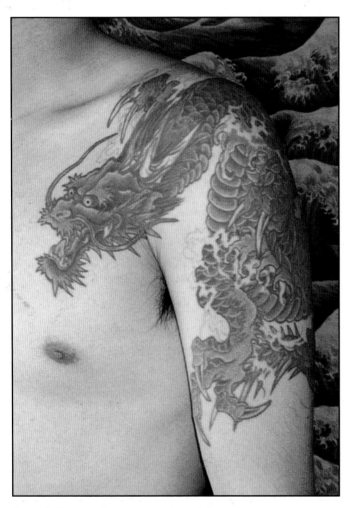

Tattoo by Horinosuke

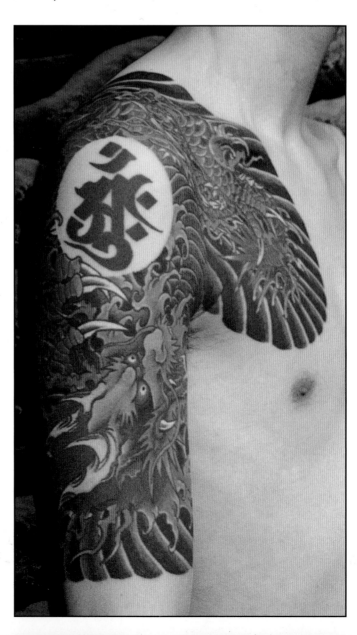

Tattoo by Horinosuke

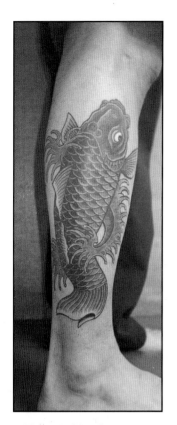

Tattoo by Horishun

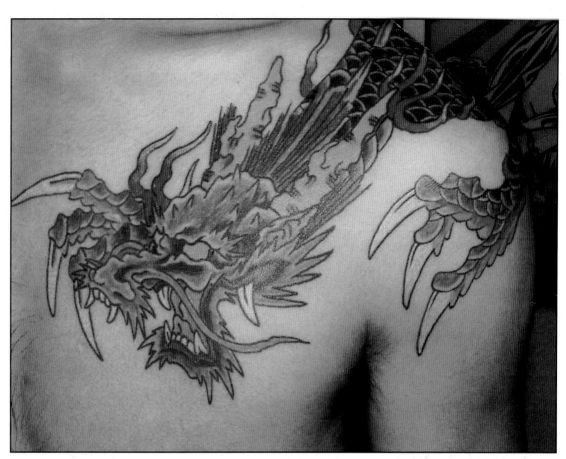

Tattoo by Horishunei

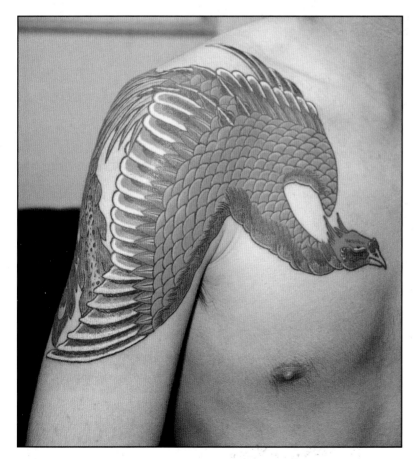

Tattoo by Horishun

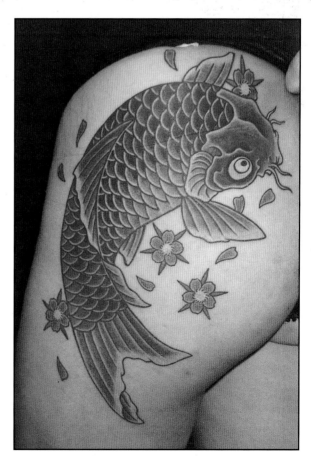

Tattoo by Horiyamato

Downstairs from Tattoo Soul is a third studio that is associated with Sensei Horitoshi. A young tattooer named Horiharu works using hand technique in a small private studio, more typical of a traditional setting. Photos of his large-scale tattoos decorate the walls in the front waiting area and are not influenced at all by the West. Horiharu feels more comfortable pursuing the traditional images and techniques. He explains that Sensei Horitoshi values the traditional style and encourages him to continue to explore this in his work. It is an honor to be a part of the respected Horitoshi family and he works very hard to continue to learn the history and skills from Sensei Horitoshi.

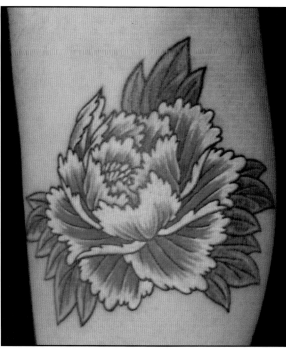

Horiharu

Horiharu business card

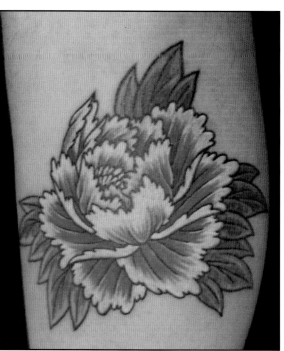

Tattoo by Horiharu

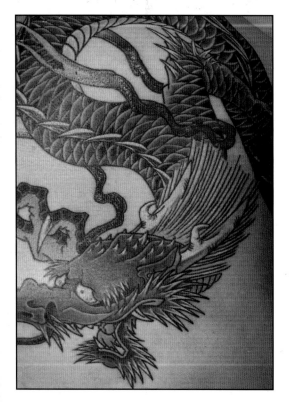

Tattoo by Horiharu

Tattoo by Horiharu

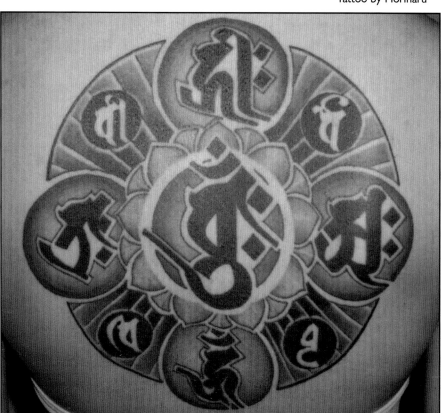

Chapter Four
Sensei Horikoi–A Sense of Tradition and Respect

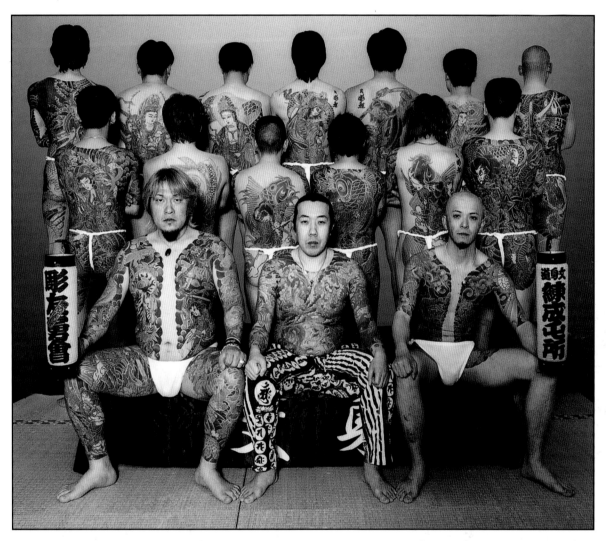

Sensei Horikoi and associates

As Horikoi's hand pushes the bundle of needles through the ink they make a distinctive sound when they hit the skin. It's not quite a *thud* but more a gentle, repetitive, squishing, *pap*. He pauses momentarily and wipes away the excess ink that has pooled onto his client's back. The skin is fully loaded with rich, black pigment. The needles Horikoi prefers are designed for sewing kimonos and are slightly larger in diameter than tattoo needles used in the West. He dips them quickly into the pigment cap, rests the needle stick onto the fulcrum between his left index finger and thumb and resumes.

It is quiet in Horikoi's studio; just the squishing sound of the needles and the rustling of the paper he uses to wipe the ink from the dramatic image of Ryu O Taro he is tattooing onto his customer. There is a complicated traditional fairy tale associated with this image. In the tattoo, Ryu O Taro holds a hand mirror pointed at the face of a wild dragon he rides and battles but the reflection of a woman, not the dragon, is in the mirror. Ryu O Taro is fighting with the angry spirit of his mother, not the dragon. Her face is reflected in the mirror. Ryu O Taro is saying, "Mother it is me your son, please calm down. I have come to help you.

Sensei Horikoi calling card Sensei Horikoi calling card

and Buddhist sculptures. Kannon the Goddess of Compassion looks down onto the studio from above.

In a second room at the back of the apartment Horikoi is kneeling over his client, tattooing. He looks up briefly, nods, and smiles. He is forty-one years old and has been tattooing for more than a decade. He pats his customer's shoulder to say it is time to take a break and smoke a cigarette. As he lights up, Horikoi asks about his tattoo machines. They are a mystery to him but he feels they need to be tuned. He now uses a machine for his outlines but shades his tattoos exclusively by hand. He feels the machine produces a more exact and detailed line, which contributes to a better-looking tattoo.

"I am a traditionalist," he says through Masa's translation. "When I first start many years ago, I tried with a chop stick and needles. Slowly I taught myself hand technique. I only understand traditional tebori style. It is the opposite of the Western approach which is all machine.

"I saw an advertisement for tattoo equipment made by Bon Tem Taro who was a famous Japanese traditional tattooer who made rotary machines too. I saw in a magazine and wondered about using machines. I saw other magazines from the West."

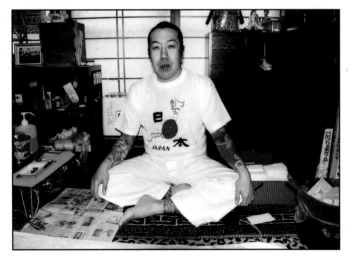

Sensei Horikoi

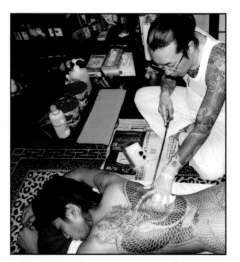

Sensei Horikoi working

"People who wear this tattoo have the power to calm the dangerous dragon," Horikoi says. "That it is a popular design. There are traditional folk stories associated with all the images and personalities of large Japanese tattoos. I am a traditionalist. It is important to know all the stories that bring these tattoos to life."

Horikoi tattoos in the medium-sized city of Toyohashi, located in the Aichi prefecture. He does not speak English and Masa Sakamoto of Three Tides Tattoo in Osaka has generously offered to translate between the languages.

Horikoi's apartment studio is organized similarly to many private tattoo settings. There is a front room with tattoo theme posters on the wall and shelves with books

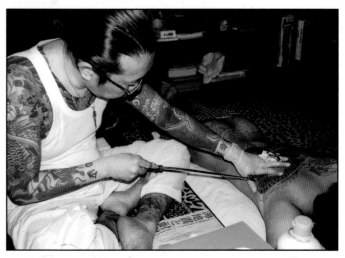

Sensei Horikoi working

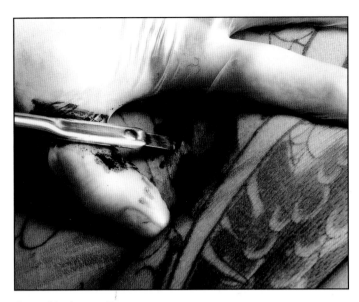

Sensei Horikoi working

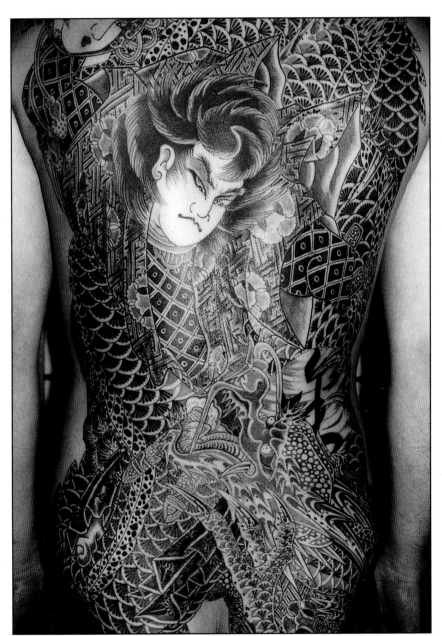

Horikoi represents a new middle ground that is developing around tattooing in Japan today. The old traditional hand techniques continue to exist along with new influences from the West. The old techniques are becoming symbolic of Japan's tattoo heritage and artists who continue to use them do so almost as a neo-traditional statement. They feel it is important to maintain these connections to the past for cultural as well as technical purposes.

"I use hand technique out of a sense of cultural respect," Horikoi says. "But also because I feel that the hand techniques introduce pigment in unique ways that look better.", He wipes his client's back and bends close for a good look. The richness of the black ink is more intense compared to the black in many Western tattoos. The ink is really IN the skin. The combination of the ink, the hit of the needles on skin, and the large cluster of possibly up to twenty or thirty needles produces some kind of efficient and unique situation. There is a rare quality to the look of hand done tattoos that is deep and amazing.

"Tattoos that are done completely by hand are 100% Japanese tattoos," he says. "By using the machine for outline, the tattoo look is more controlled and tighter. There is also the question of time. Most clients do not want to prolong the tattoo and pain. Machines work more quickly and customers like a tattoo made faster."

Horikoi knows and respects traditional techniques but also sees the progress of using machines and how it advances tattooing. He understands why the Japanese separate traditional horimono techniques and machine work but feels it might be a mistake. It is all tattoo.

"Many times traditional techniques and styles are associated with the Yakuza," he says. "This is incorrect and unfair. Over the years I have had trouble with landlords. Many have a problem with tattooing. Especially the style of tattooing I do. Traditional tattoo styles attract Yakuza customers. It can create problems. I have moved a lot over the years from location to location but I have been here for six years.

"As a young man from 1970 to 1980 I saw many Japanese gangster films," Horikoi says. "Many public bathhouses had gangster Yakuza tattoo posters on the wall. I was impressed with the tattoos and became very curious about tattooing.

Ryu O Taro

"I had a natural ability to draw. I found reference books. I found a book of paintings by Kaname Ozuma and looked at it for references. I went to Horiyoshi III's book release party and met Horiyoshi. He gave me a lot of inspiration and encouragement. He gave me a painting name. Horiyoshi did not teach me tebori technique but he does not teach about tebori or pigment technology."

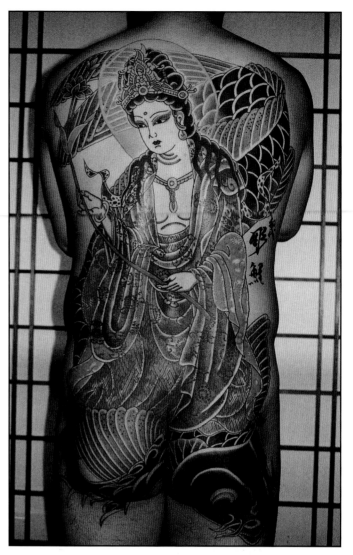

Tattoo by Sensei Horikoi

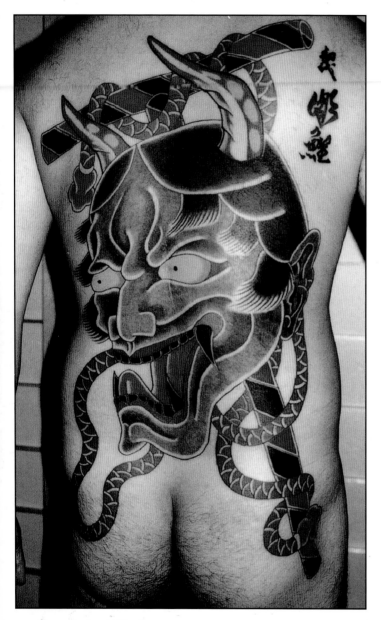

Tattoo by Sensei Horikoi

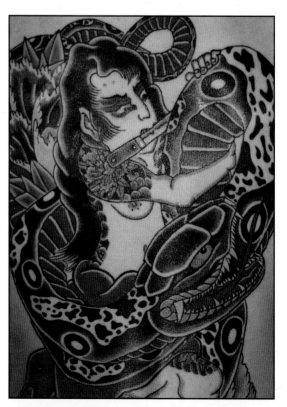

Tattoo by Sensei Horikoi

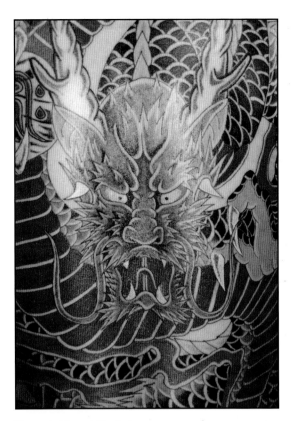

Tattoo by Sensei Horikoi

Unlike many people in Japan who are becoming enthusiastic about Western style tattooing, Horikoi is drawn to the roots of the art form in his country. "One reason I think many young Japanese are interested in Western style tattoo designs," he says, "they do not demand too much from people. There is little depth to the modern Western designs. Traditional Japanese designs demand a lot from people. They must have knowledge and respect of the complicated nuances associated with the myths and stories. Most young Japanese simply find this too demanding and difficult. It is the responsibility of the tattooer to know all the stories. It will take time and dedication but someday I want to know as much as Horiyoshi III. It will take time."

Recently, the Japanese government has maintained a neutral position about the legal status of tattooing. With all the new enthusiasm among young people focused on the art form, Horikoi wonders if this could change. He says, "Now, the Japanese government does not like Japanese traditional tattooing. It is associated with the underworld. There are many young people tattooing today in Japan. Maybe too many. They should be very responsible about issues of health. I make an effort to teach the young proper sterilization techniques. This is very important.

"Most people in Japan are not too interested in tattoos," Horikoi says. "Tattoos contradict things that Japanese people think. It is looked at like a dirty thing. Old people look at tattoos and they turn away. It is too much for them. I think they think it is a crazy thing or gangster thing. Sometimes I see old people looking at young people with tattoos. They seem confused about the whole thing."

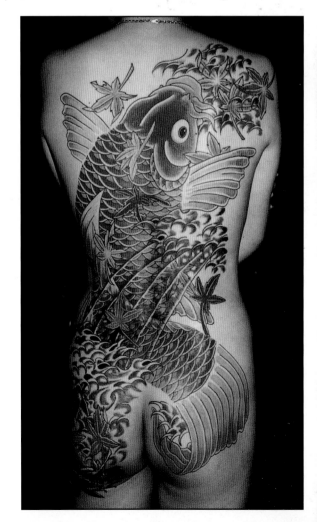

Tattoo by Sensei Horikoi

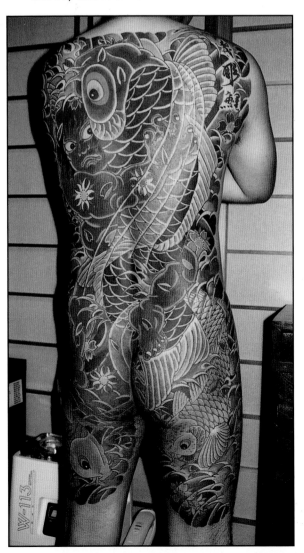

Tattoo by Sensei Horikoi

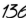

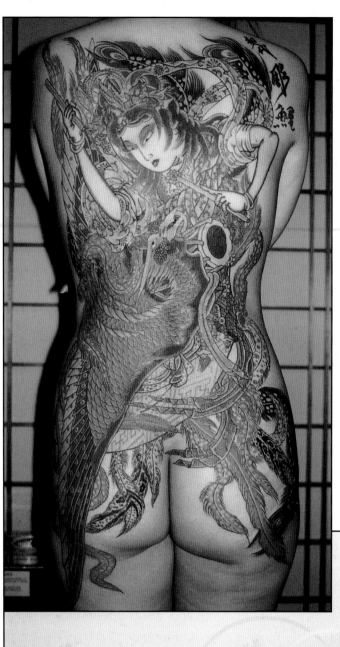

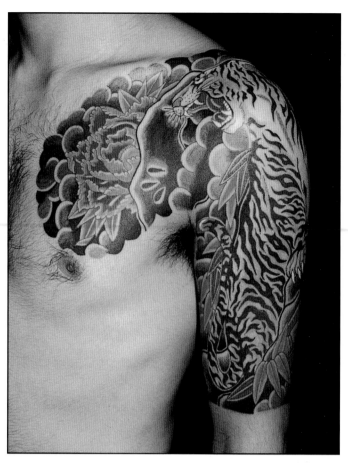

Tattoo by Sensei Horikoi

Left and below:
Tattoo by Sensei Horikoi

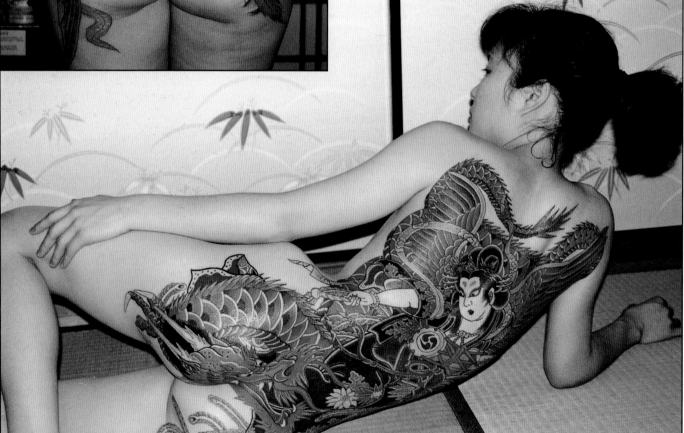

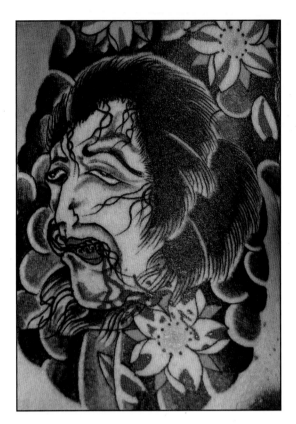

Tattoo by Sensei Horikoi

As a traditionalist, Horikoi sees the youthful enthusiasm for Western style tattooing as the part of a process. He does not pass judgment on the impulses of the young but sees their interests as possibly the byproduct of a momentary fascination with new cultural forms from the West.

"I see that young people are interested in One Point style tattooing. I think eventually they will come to realize that they have made a misjudgment. These young people will return to old style Japanese tattoos. For kids, One Point is OK now but when they get old it might look strange. They will realize this.

"They should be getting smaller versions of Japanese style; they should be getting smaller One Point Japanese style. Not Western style. When they get old, I will have a lot of work bringing these kids back to Japanese style."

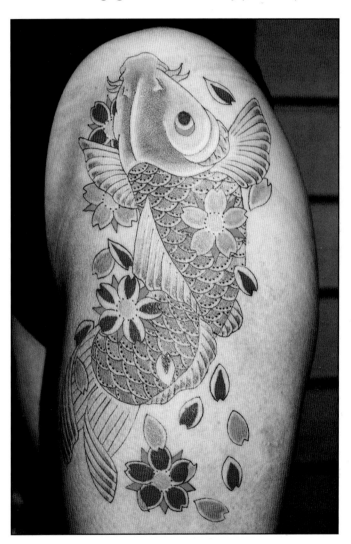

Tattoo by Sensei Horikoi

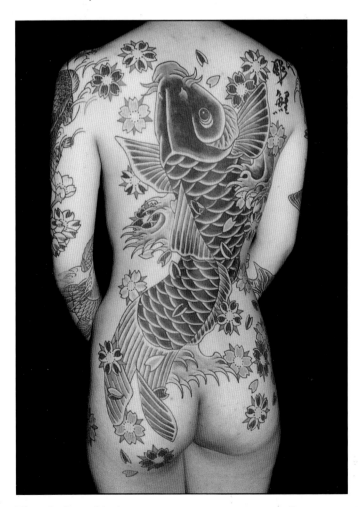

Tattoo by Sensei Horikoi

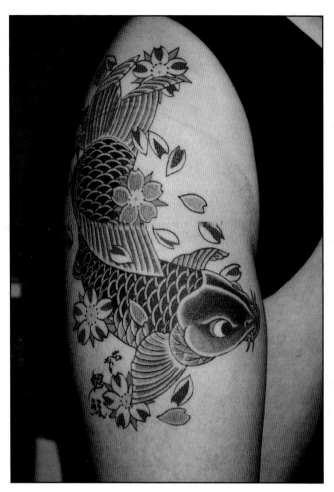

Tattoo by Sensei Horikoi

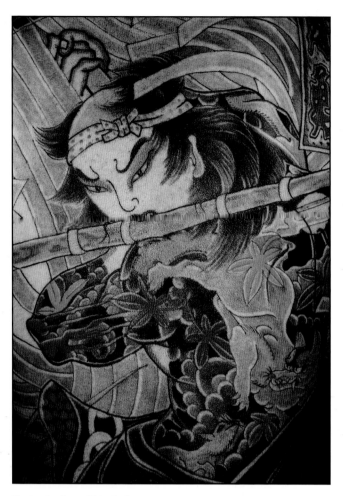

Tattoo by Sensei Horikoi

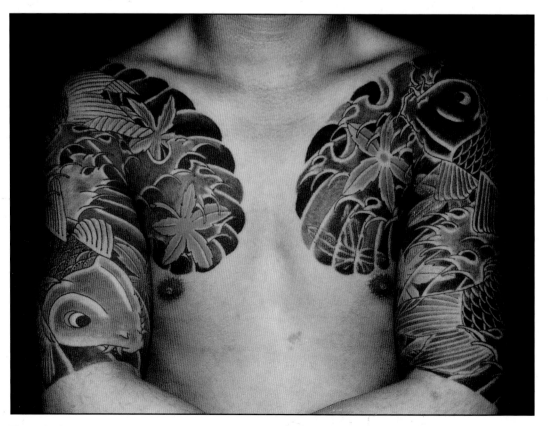

Tattoo by Sensei Horikoi

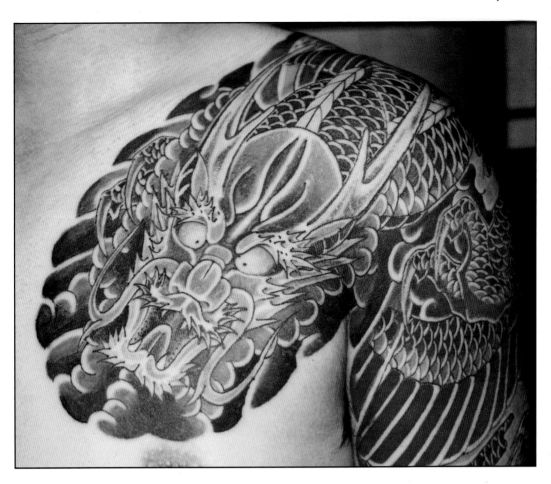

Tattoo by Sensei Horikoi

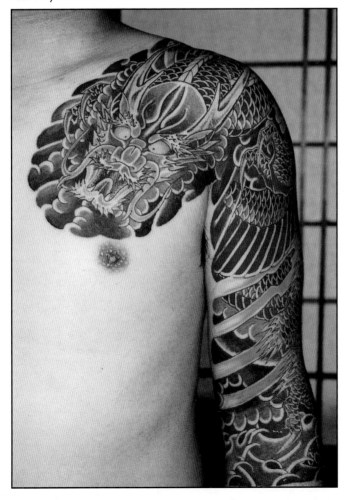

Tattoo by Sensei Horikoi

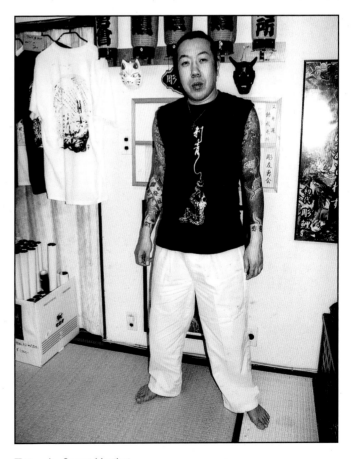

Tattoo by Sensei Horikoi

Chapter Five
Tokyo Shita-machi Culture and the Tattoos of Asakusa Horiyasu

Like many private studio settings in Tokyo, Sensei Horiyasu works from a modest-sized apartment located deep in a typical, contemporary, featureless building. The elevator glides to an upper floor and opens onto a hallway of identical, generic doors. There is no sign, just an apartment number.

Horiyasu's studio is bright, well organized, and clean. He tattoos in a rear room that has thick curtains drawn across the back wall. A nearly naked middle aged customer lies across some pillows while Horiyasu tattoos his side and lower back. There is a veiled wince of occasional discomfort in the man's eyes. Sensei's hand moves quickly, his tattoo machine snaps seriously as he outlines the large, dramatic traditional image of a koi and finger waves. Horiyasu's customer is quiet and respectful. There are few words exchanged. Sensei pats the man's shoulder to signal that it is time to take a short break and smoke a cigarette. Horiyasu cleans away the excess ink and inspects the bold, black lines that flow across the man's pale skin. His customer rises slowly, gives Sensei a cigarette and lights it, then lights his own.

Horiyasu intentionally projects an air of accommodation. He smiles at his customer warmly and asks if he is feeling all right. Sensei understands that this is a sensitive spot to be tattooed. The customer laughs shyly, acknowledging the sensitivity, and takes a long, exaggerated puff of his cigarette. Sensei is genuinely concerned about his client, who looks to be a modest person, someone who works for a living.

There is an atmosphere of openness, not exclusivity, in Horiyasu's studio. He is a man of subdued ego and populist intent. Everyones' jackets are hung next to each other on plain pegs without attention to status or ceremony. Sensei chats openly with two customers who are sitting comfortably on a couch in the front room, watching TV. On the paneled wall behind them, there is an impressive backdrop of color photographs of Sensei's work. The images of the large, full body tattoos focus on the traditional vocabulary of Japanese tattoo. Buddhist deities, dragons, tigers, historical protective personalities, water, and floral motifs are popular and respected images tattooed hundreds of thousands of times since the days of Edo and the Floating World.

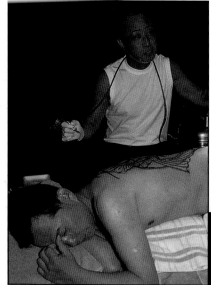

Sensei Horiyasu

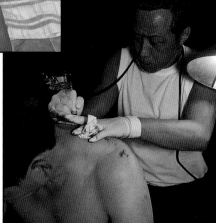

Sensei Horiyasu

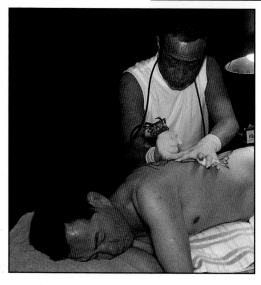

Sensei Horiyasu

140

Sensei Horiyasu's business card

〒111-0035
Mansions Nishi-Asakusa 502.
Nishi-Asakusa 2-14-13
Taitou-ku Tokyo Japan.
Phone:03-3843-3444
URL http://www.horiyasu.com
MAIL info@horiyasu.com

Sensei Horiyasu's business card

浅草
彫やす

安田 森次

〒111-0035
東京都台東区西浅草二丁目十四の十三
マンション西浅草五〇二
電話 〇三―三八四三―三四四四
携帯 〇九〇―一八八四―二八七八五八

URL ▶ http://www.horiyasu.com
MAIL ▶ info@horiyasu.com

Sensei Horiyasu's business card

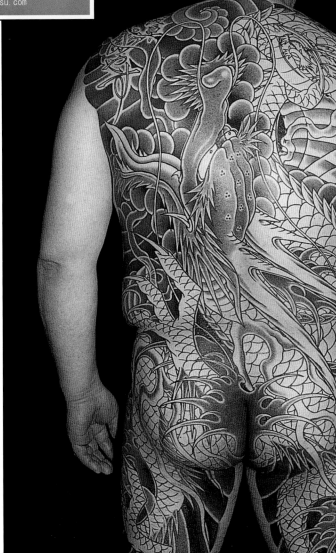

Tattoo by Sensei Horiyasu

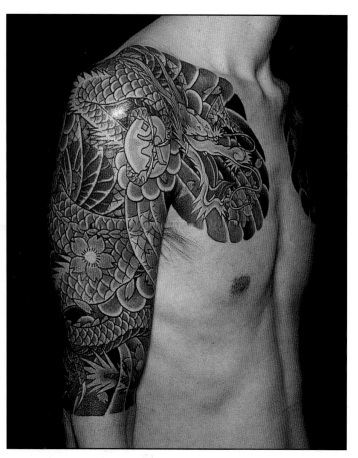

Tattoo by Sensei Horiyasu

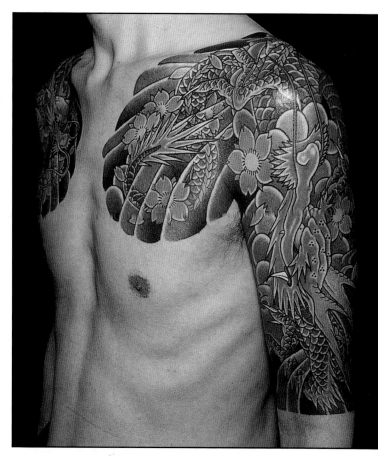

Tattoo by Sensei Horiyasu

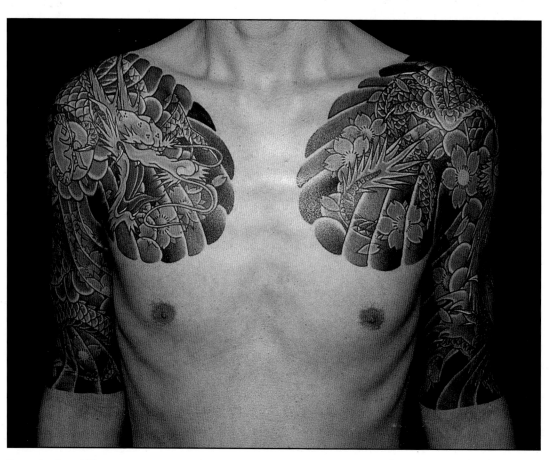

Tattoo by Sensei Horiyasu

To fully appreciate Asakusa Horiyasu's perspective about his art and client base, it is necessary to understand the section of Tokyo called Asakusa where he works. The two are intimately linked. Asakusa is the heart of the city's populist Shita-machi culture that first took shape when the city was called Edo in the late seventeenth century and the working people who lived there were referred to as Edokko. Narrow, crowded streets and Shoten-gai shopping arcade commerce characterizes the area. The sidewalks overflow with shuffling people, smoking food stalls, and neighborhood-style shops selling the necessities of daily life.

Asakusa's large temple called Senso-ji was originally built in 630 AD to mark the spot where two brothers, Hamanari and Takenari Hikonuma, found an ancient statue of the Buddhist deity of compassion, Kannon. What is now the area of Asakusa was located along the route people took to the temple and over the centuries coalesced and gained in reputation.

Ieyasu, the first Tokugawa Shogun, combined several existing fiefdoms into an efficient bureaucracy beginning in 1590 that was seated in Edo. Within time, the capital of Japan was moved by Ieyasu from Kyoto to Edo, which created growth and a form of urban sprawl. The city divided into two distinct societies. The lords, samurai, and people of the court who lived on estates in the high ground known as the uptown "Bluff" or Yamanote and the supportive workers, entertainers, and artisans who lived downtown beneath the castle in a crowded area of crafts, entertainment, and distraction called Shita-machi. By the year 1680 there were more than a million people living in the jo-ka-machi castle town beneath Edo-jo castle. In 1841 the popular Kabuki theatre moved to this downtown Asakusa district of narrow streets and alleys and the area was secured as the center of Edo's Floating World.

A lifestyle and culture emerged among the middle class people of Tokugawa Edo. Merchants, artisans, and lordless, low ranking samurai blended together to create a novel way of life. Styles of art, literature, drama, and music that massaged the tastes and values of this coalition of people gelled into what would be called the "Floating World". Characterized by elegance, stylishness, pleasure, and gratification, the blurry Floating World rooted in populist areas like Asakusa.

The 1661 novel, *Tales of the Floating World* by Asai Ryoi, described a unique, urban setting where people lived for the moment, appreciating the subtleties of nature, emotion, a particular line of poetry, beautiful women, and dandy men: A world of carefree leisure, adrift in effortless delight. The pictures, or Ukiyo-e, of this Floating World and the artists who produced them created the foundation of images that became Japanese tattoo. This unique artistic stylization is echoed in the work of Sensei Horiyasu and other Japanese traditionalist tattooers who continually reestablish the Ukiyo-e esthetic in their work.

The heart of this Ukiyo-e image base rests in the woodblock print images of Utagawa Kuniyoshi, who illus-trated the 108 heroes of the historic Suikoden saga. The original fourteenth century Chinese tale was titled *Shuihu Zhuan,* or *The Water Margin,* and was translated to Japanese in 1805 by Japanese writer Takizawa Bakin. It was originally illustrated by Ukiyo-e master Hokusai Katsushika and was embraced by common urban Edokko of Asakusa. The illustrated book exploded into a craze.

The people of early Edo who lived in areas like Asakusa experienced economic prosperity but also the strict rule of the powerful Tokugawa shogunate. The heroic, tattooed characters of Kuniyoshi's Suikoden prints became the foundation of Japanese tattoo.

The cultural revolution of the Meiji Restoration that started in 1868 changed the ground rules and opened the previously isolated Japanese society to the West. Asakusa was the section of the city that first interacted with Western influence. Photo studios and shops selling imported goods appeared. The first drinking establishment called a "bar" opened in 1880, the first movie theater in 1903. Later in the twentieth century, the elitist Yamanote evolved into the Tokyo of finance and skyscrapers. Tokyo's Asakusa, the vibrant downtown area of the common person remained connected to the soul of Edo Shita-machi.

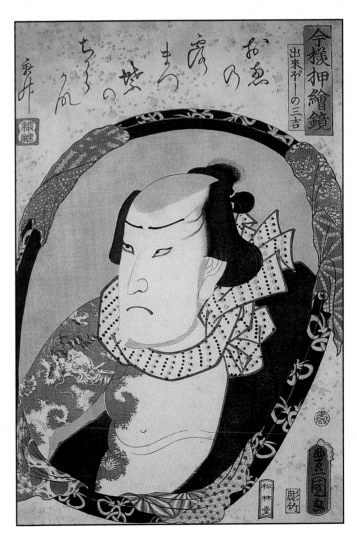

Ukiyo-e woodblock print by Toyokuni c.1840. *Collection of author*

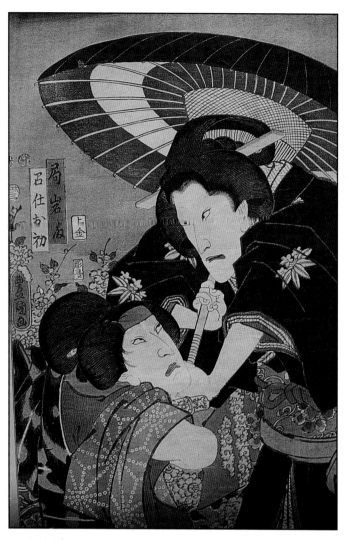

Ukiyo-e woodblock print of Kabuki by
Kunisada c.1870. *Collection of author*

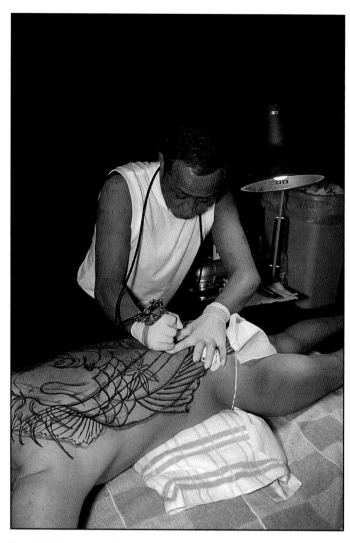

Sensei Horiyasu tattooing

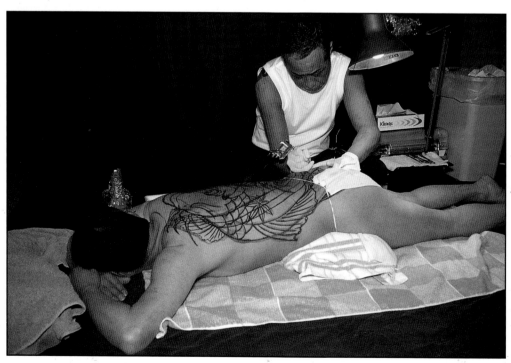

Sensei Horiyasu tattooing

Sensei Horiyasu's portfolio books feature photos of his customers who are tattooed heavily with his unique style. He works with contemporary tattoo machines but the personal technique he has developed lays the ink into the skin more comprehensively—he pushes the colors to the darker end of the spectrum, which creates a heavy opacity. His tattoos have the appearance of more traditional tebori hand style work and his customers appreciate the look.

"I started tattooing several years ago when I was thirty-six years old," Horiyasu says through Mr. Kunihiro Shimada of Keibunsha Publishing, who is translating. "I came to tattooing at a later age. I started working tebori hand style. I use machine technique now for a mixture of reasons.

"As a young man I was a grinder. I had skill to grind the edge of sword and sharpen sword. I work as grinder for sixteen years. As a child I always like to draw picture. I draw all the time as a young person. I remember when I saw my first tattoo. I see man with big body tattoo. I remember this tattoo very well. I was very impressed with this.

"I did not have a Sensei when I first learn about tattooing. I learned by myself, I teach myself about tattoo. When I started to tattoo, Tokoi Horihiro of Gifu taught me a lot. He did not only teach me about tattoo. He told me about tattoo machines, the good posture a tattoo artist should have. He was not my Sensei; this was more like friendship. Tokai Horihiro and I studied about tattoo machine together. We learned about tattoo machine a lot. I make my tattoos look rich and deep in style—tebori style."

Sensei Horiyasu appreciates his hard working Asakusa customers and feels that tattooing by machine works for him as a tattoo artist. "The process of getting a tattoo is important," he says. "Japanese tradition is important. But end product of tattoo and how it looks is important too. This is most important. I work to make my tattoos look the best in the end product. Tattoo quality should be good, they should be done quickly and for me machine helps me to do that. My customers work hard for their money, I respect this. Little pain is important, customer should be happy. This is what tattoo artist should strive to do. Keep customer happy."

Like many traditional Japanese tattoo artists, Sensei Horiyasu limits his working sessions. He dedicates no more than two hours to each customer and then stops. If needed, he feels it is OK to limit the session even more to accommodate the customer.

"I only work eight hours in one day," Sensei explains. "I work no more than two hour for each customer. That means I tattoo only four customers in one day. That is all I do. No more than four customers. I work six days a week. That add up to a lot of work. I am tired by end of day and end of week. I enjoy good food and good talk. I work hard and I like to enjoy life too. I feel that life is for hard work but also for enjoyment too." Sentiments of Asakusa's Floating World ethos reverberate in Sensei Horiyasu's description of his lifestyle.

Historically in Japan, there has always been a mixed reaction about tattooing from governmental authorities. At times cultural or legal institutions turned a blind eye, other times tattooing was scrutinized, prohibited, and seen as a national embarrassment—particularly during the early periods of Western contact. The Meiji government wanted to project an air of sophistication and international integration, not nativist, idiosyncratic behavior.

Early after the Second World War, when Japan was reconstructing, U.S. General MacArthur surprised local authorities that had banned the practice of tattooing as a national embarrassment. Through the post-war GHQ laws, MacArthur expressed interest in tattooing as a beautiful cultural artifact, reversed the ban and re-legalized the practice. This gesture promoted a mid-twentieth century revitalization of tattooing.

Organized crime families of Japan's Yakuza turned to tattooing as a symbol of bold nationalistic, cultural solidarity. The beautiful tattoo images of the Floating World represented an idealized period in Japanese history before Western influence and what some viewed as the subordination of historical integrity. Family members were heavily tattooed with traditional images and stylizations, which promoted familial pride and honor. In recent history, a reputation developed about these associations that curbed public enthusiasm for the art form.

Today however, youth trends that are embracing Western tattoo styles have again shifted the social significance of tattoos. What was once a distinguishing characteristic of hardened Yakuza soldiers is being redefined by young urban adults who are getting tattooed in Japanese and Western styles in an effort to plug into an international trend. The softening of the tattoo reputation in Japan has also softened the significance that was once worn like a badge by the Yakuza.

"The percentage of Yakuza members who get tattooed might be changing," Sensei Horiyasu explains. "The meaning might be changing for some. Sometimes the family boss will pay for members to be tattooed. He wants members of his family to be tattooed. If they go to jail they show off for the family. Now, so many people have tattoos the significance has changed.

"Now with One Point style, tattooing appeals to a different group of people," Sensei Horiyasu continues. "Young people get tattoos for different reason. Traditional tattooing is different. Maybe there is a different motivation. You have to get to know the artist, you develop a relationship. This is old tattoo way. It takes time and dedication. Horiyoshi II (Tamotsu Kuronuma) used to say, 'I teach by the needle.' He would spend time and talk, give instructions. In the old days people did not have good education, they received education from their tattooer. This is traditional way. Tattoo artists communicated complicated message: 'Don't show off tattoos in this area. Pay attention, be polite.' These things were communicated by the tattooer to his customers. The customers spent a long time with the tattooers. It was a teaching experience for the customers.

"I do same thing with my customers. I instruct my customers about my style. I tell them about the traditions and experience and cultural knowledge. If customer does not like my style this is OK, then I ask that they go elsewhere. Instead of changing for the customer, I ask they go to other tattoo artist. This is OK, no problem."

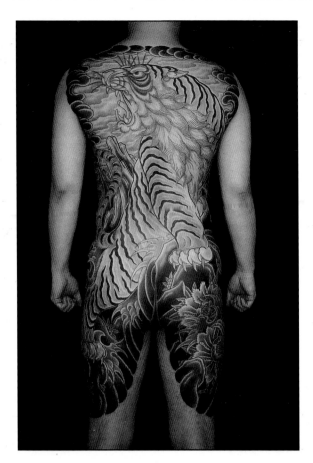

Tattoo by Sensei Horiyasu

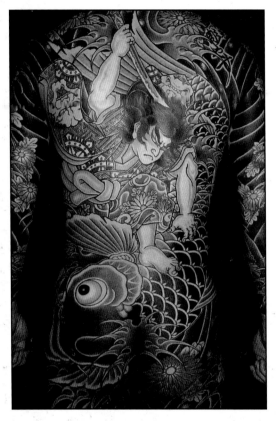

Tattoo by Sensei Horiyasu

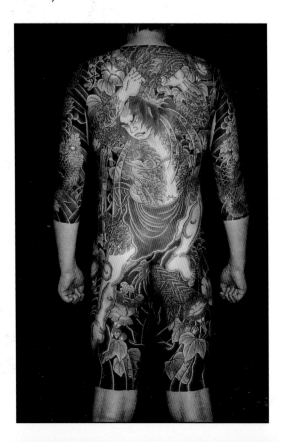

Tattoo by
Sensei Horiyasu

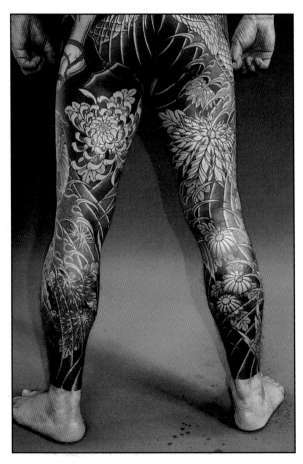

Tattoo by Sensei Horiyasu

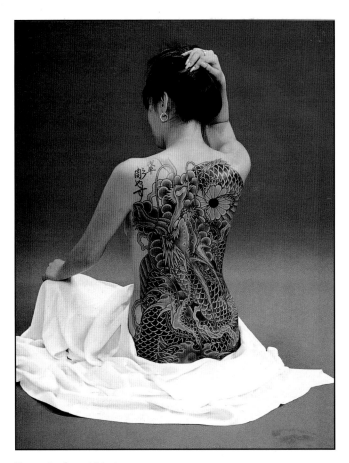

Tattoo by Sensei Horiyasu

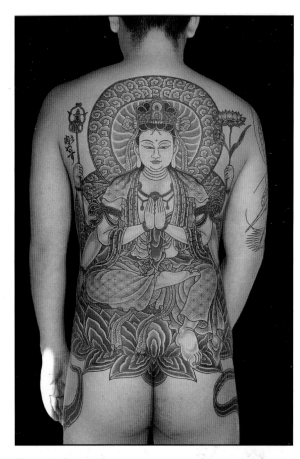

Tattoo by Sensei Horiyasu

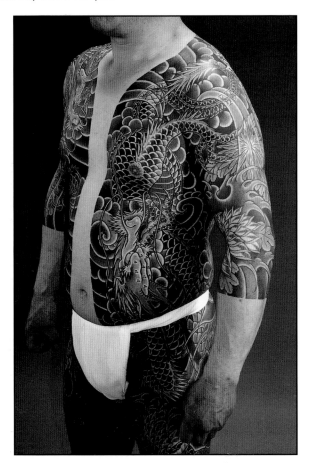

Tattoo by Sensei Horiyasu

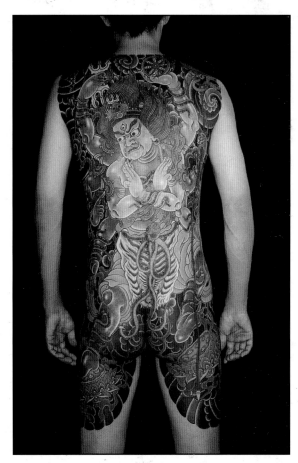

Tattoo by Sensei Horiyasu

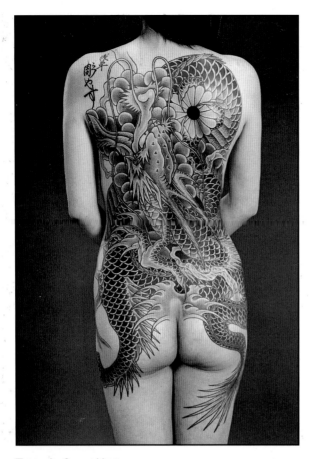

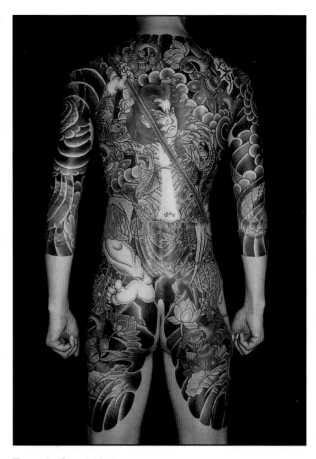

Tattoo by Sensei Horiyasu

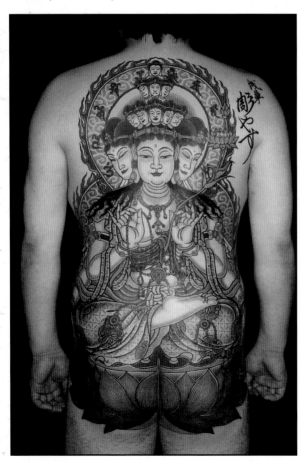

Tattoo by Sensei Horiyasu

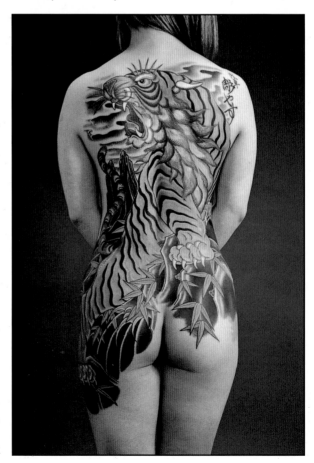

Tattoo by Sensei Horiyasu

Tattoo by Sensei Horiyasu

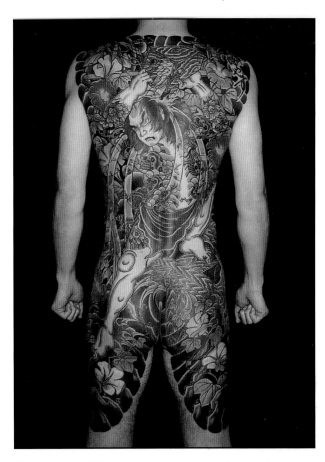

Tattoo by Sensei Horiyasu

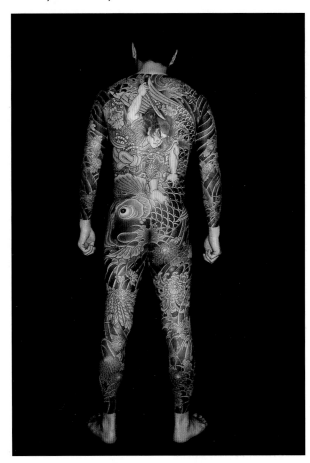

Tattoo by Sensei Horiyasu

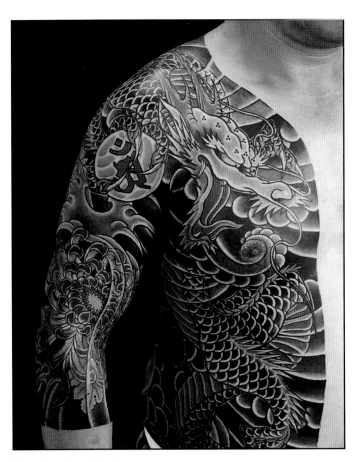

Tattoo by Sensei Horiyasu

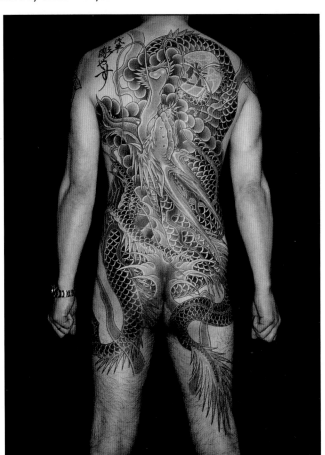

Tattoo by Sensei Horiyasu

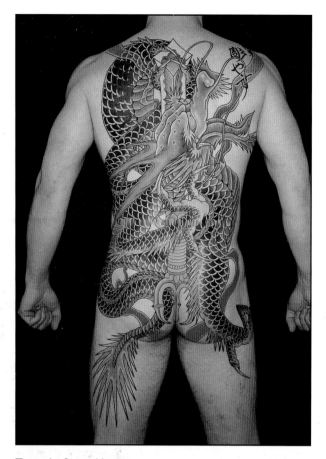

Tattoo by Sensei Horiyasu

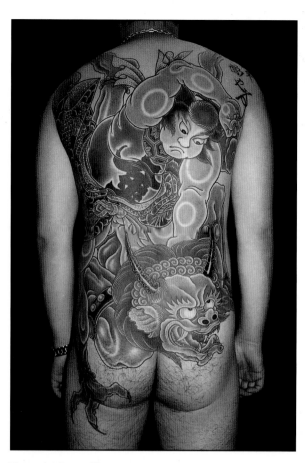

Tattoo by Sensei Horiyasu

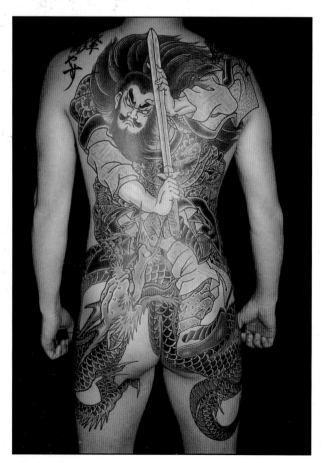

Tattoo by Sensei Horiyasu

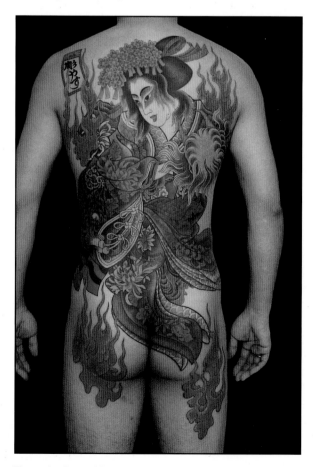

Tattoo by Sensei Horiyasu

Looking Back, Looking Forward: The Tattoos of Hori-Sho

After he tattooed for five years in the crazy Shibuya district of Tokyo, Hori-Sho decided to move back to his hometown of Okazaki. It is a small city of 100,000 characterized by a gentle, even suburban pace. Life in Tokyo became too much for him; the noisy, agitated flow seemed wasteful and unnecessary. His apprenticeship with Tokyo tattooer Horiwaka prepared him to strike out on his own.

Hori-Sho was first exposed to Western style tattooing as a musician playing the stand-up base in Rock-A-Billy bands. He noticed that many Rock-A-Billy musicians in America were heavily tattooed and became curious about the whole thing. In 1992 he traveled to San Francisco with Horiwaka and studied tattooing with Bill Salmon at his Diamond Club shop. "I walked the city, exploring the quality tattoo work that was available there," he says. "There are many talented people tattooing in this place. Tattoo City and Primal Urge had such good quality tattoos. When I came back from San Francisco I was still in Horiwaka family. I spent four years with this family. Then I came back to my hometown and opened a shop. At my studio, I tattoo a mix of traditional and One Point style."

The middle ground Hori-Sho inhabits between the traditional and One Point tattoo styles is a part of an ongoing process of change in Japanese tattooing. The young customers in his stylish shop sit quietly, perusing his portfolios looking for ideas. Young people here are following the global trend to get tattooed and their tastes are being shaped by potent influences from the West.

Life for a young person in Japan is very different from what their American counterpart might experience. Mythical perceptions of life in the USA are idealized by the urban youth. Notions of limitless opportunity and cultural freedom impress young people in Japan, where codes of behavior are strict and unyielding. Getting Western style tattoos unlocks deep, psychological restraints and in some way liberates the young people wearing the tattoos.

"When I tattoo at Horiwaka's studio," Hori-Sho continues. "I make all Japanese traditional style tattoos. He teach me the design techniques necessary to understand the old style. Now young people here get influenced by new One Point style. They see pictures in tattoo magazines and they think this is new and improved tattoo. For a while I do a lot of One Point style, now I think things are changing again. Many young people are coming to my studio and asking about traditional style again. This is OK for me. I find traditional style again too. Now I like to tattoo the old designs. I have become more interested in this style."

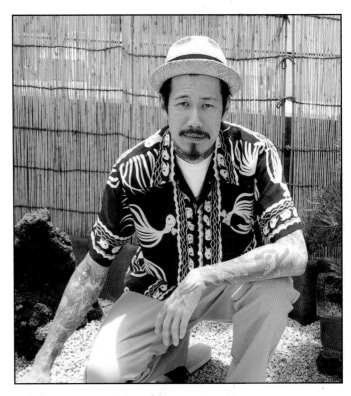

Hori-Sho. *Hori-Sho photos courtesy Masa Sakamoto*

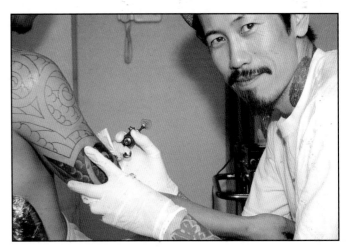

Hori-Sho

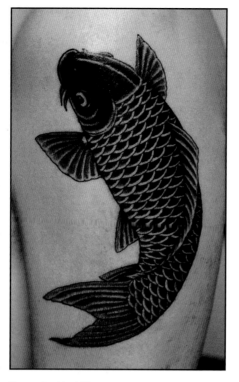

Tattoo by Hori-Sho

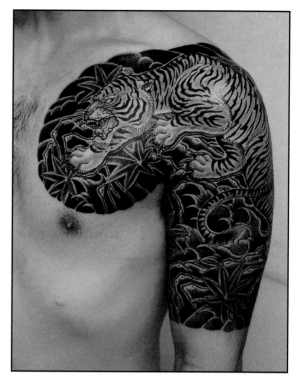

Tattoo by Hori-Sho

Hori-Sho card

MIND SCAPE TATTOO

彫　鐘
HORI SHO

TEL : 0564 — 28 — 6095
205 EAST GARDEN POPLARKAN
22-6 MITADA, KITADORI, KAKEMACHI
OKAZAKI, AICHI, JAPAN 〒 444-0011

Hori-Sho card

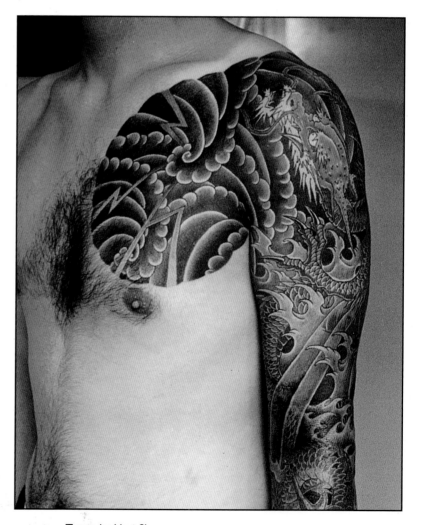

Tattoo by Hori-Sho

Young people who patronize Hori-Sho and others directly challenge the mainstream fabric of their culture. Getting tattooed in Japan is still considered risky business and shameful behavior. The courage young tattoo customers must rally should not be trivialized.

"I work in an isolated area. This is not Tokyo," Hori-Sho explains. "My customers look at my portfolio books and their faces have both excitement and shame. They want to look but something in them is also saying. 'Don't look!' I can see it. I understand their faces too; I am Japanese. This is interesting.

"When I first open my studio here, my customers were unaware of the options available to them. They had no exposure to it," Hori-Sho says. "Gradually as tattoo magazines like *Tattoo Burst* and *Tattoo Tribal* develop, young people see what the options are. Now they see tattoo as a part of big global thing. Young people feel connected to young people in other places. They do not want to be left out or behind I think. This is just starting here, especially in my area.

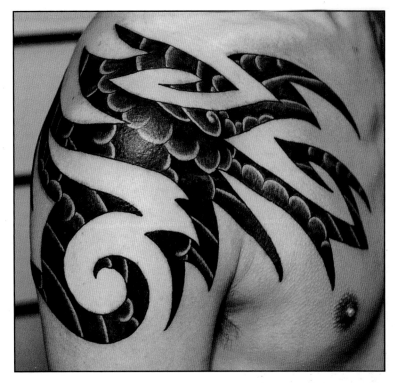

Tattoo by Hori-Sho

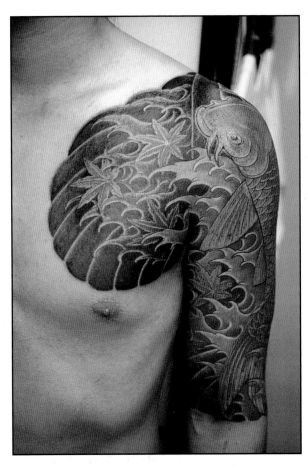

Tattoo by Hori-Sho

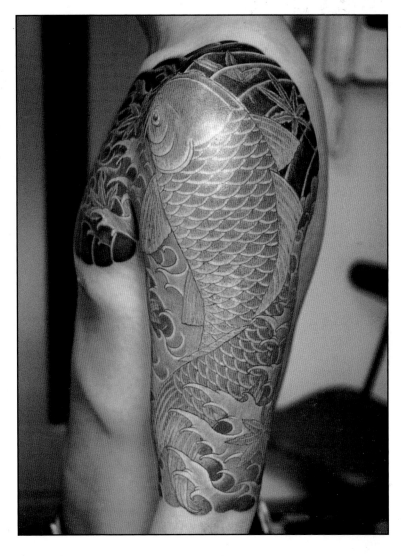

Tattoo by Hori-Sho

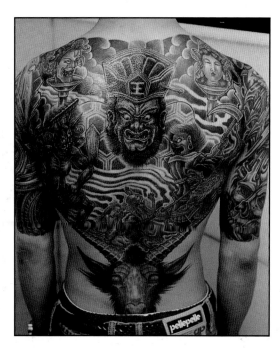

Tattoo by Hori-Sho

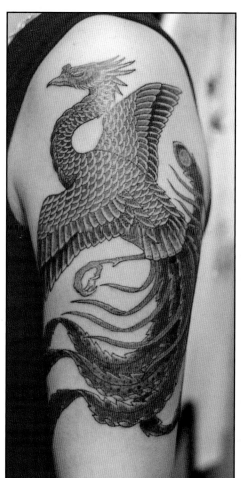

Tattoo by Hori-Sho

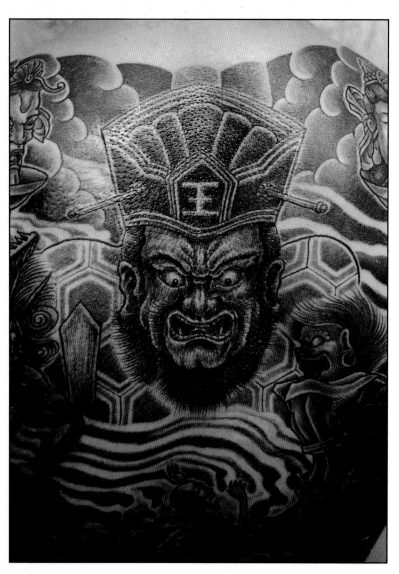

Tattoo by Hori-Sho

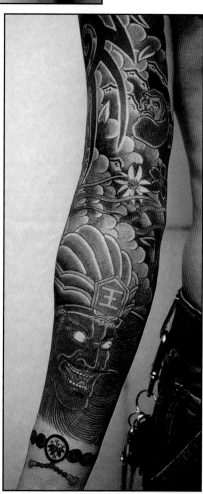

Tattoo by Hori-Sho

"I come from small family. I have one sister. My father manages a pachinko parlor. He became very suspicious when I get interested in tattoo. He think his son is becoming a gangster and bad person. My mother cried when she see my tattoos. 'Look what you did to yourself' she said. She think I had damaged my body. For older person, this is completely unheard of. You should never damage your body. It was a problem. My parents thought I had been corrupted during my trip to America."

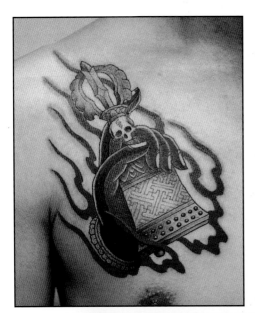

Tattoo by Hori-Sho

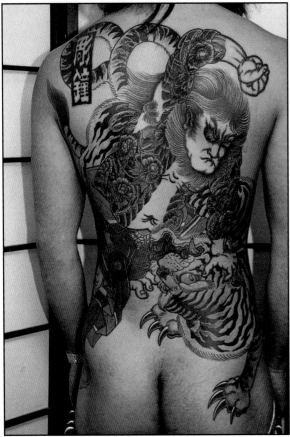

Tattoo by Hori-Sho

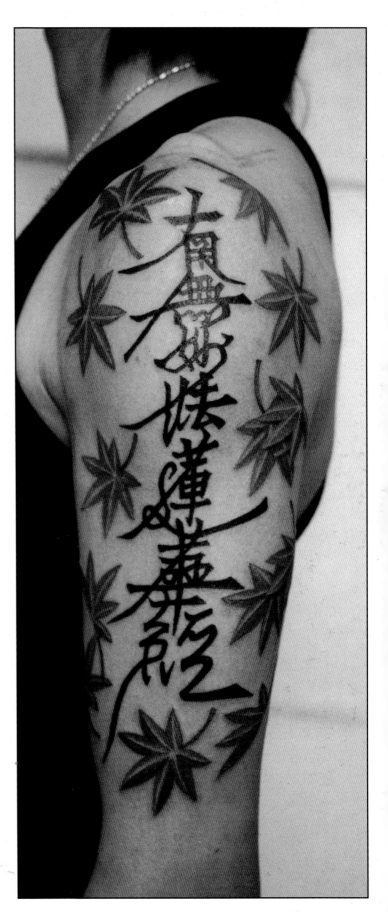

Tattoo by Hori-Sho

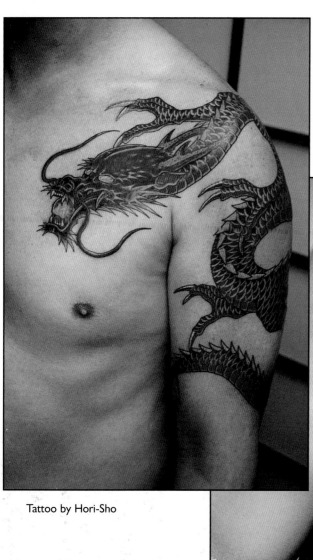

Tattoo by Hori-Sho

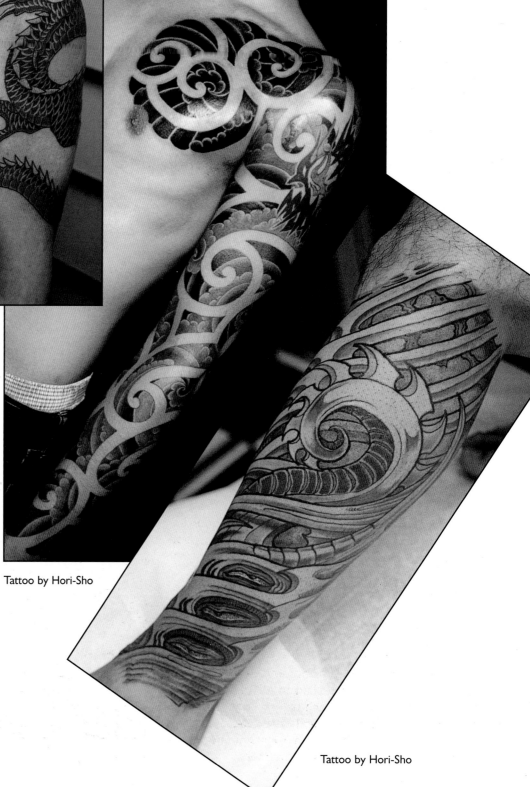

Tattoo by Hori-Sho

Tattoo by Hori-Sho

Hori-Sho's shop is more like an exclusive studio. Located in an upscale, modern apartment building; there are no outside signs. Like other semi-private Japanese tattooers, there's just his business card sitting quietly over the bell. Inside, he has put together a really stylish place using modern lighting fixtures and interesting room dividers. The music is low and moody and the shop really projects an evolved sensibility. There is a small area for customers to sit and look through portfolios, a few special task side rooms for drawing and photographing, the central tattooing area and a quiet roof deck garden. The garden is closed in with bamboo screens and is complete with evergreen plants, a gravel floor, and meditative stones.

The young men and women sitting in Hori-Sho's waiting area are dressed stylishly. They all wear a hat of some kind whether it is a wooly pullover or a brimmed snap down cap and the hair that sticks out has been colored, bleached or faded away from the natural black. Everyone's neck and wrist is accessorized with a chain of some kind and all the t-shirts have hip logos. For many young Japanese, life and style are one in the same. Without one, the other simply does not exist. Tattoos and particularly One Point style tattoos are seen as a risky new style to engage.

As in other cities around the world, faddishness and group-think are stereotypical of the urban young but it seems more poignant in Japan where the society is predominantly mono-cultural and mono-racial. The solidarity of the culture is both comforting and suffocating to many young people here who increasingly get their marching orders from an internationalized, fast paced electronic media. Kids in Japan see the same images and trends unfold on their TV screens as kids in New York, Paris, London or Berlin, but there is a perception of removal and isolation. Japan is a small island country and many young people very possibly have a subconscious insecurity about being out of the global, youth loop. Tattoos have become an increasingly important stylistic element for many young Japanese, who use them to combat and neutralize this sense of disconnect.

One Point tattoos provide an opportunity for Hori-Sho to establish himself as a tattooer. "Young people in my area see the tattoos in my portfolios," he says. "I have done a lot of One Point designs and these pictures open a door for people. This is important because some people get tattooed with One Point and then they take it to the next level. They leave One Point behind and explore large-scale work.

"One Point customers always have the same motivation," he continues. "Trendiness! There is a risk for young people in Japan. There is the social stigma. In the countryside this really exists. My town is a little different. There are many tattoo artists here.

"I get my customers only from word of mouth. I did not attend art school but always had an artistic ability. I tattoo two or three customers each day and my clients are about 70% male and 30% female. I have noticed a steady increase of business over the past few years but not an increase in the percentage of female customers.

"In this area if a girl and boy are dating and the boy gets tattooed the girl may break up with him. This might be the same for men too. A boy may break up with a girl if she gets a tattoo. These Shinto themes of purity run very deep in an area like this. It is difficult to change these traditional feelings."

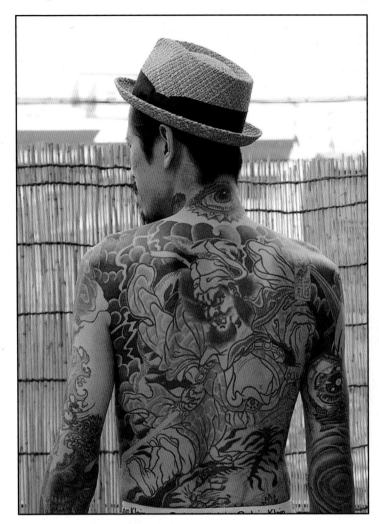

Hori-Sho

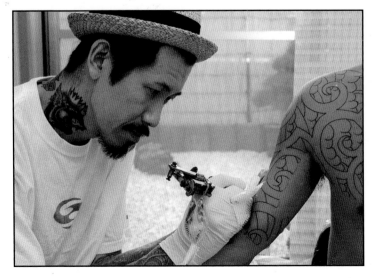

Hori-Sho

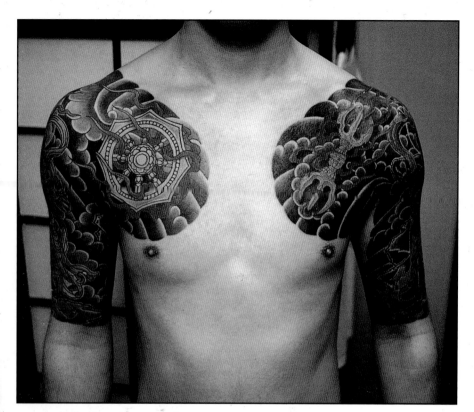

Tattoo by Hori-Sho

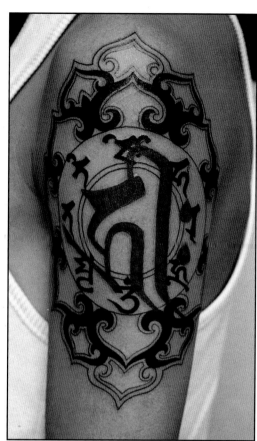

Tattoo by Hori-Sho

Issues of responsibility are critical to Hori-Sho. There is always a gentle tug of war in his head concerning the marking of the body. He was brought up in a culture which shuns the unnecessary marking of the body at the same time that he does so to earn a living. He negotiates his way through this conflict with a sense of concern towards his customers. He only tattoos positive images and refuses to work on the neck or hands.

"When I first started," he says. "I felt such a responsibility to my customers. I was marking their bodies. This was in direct opposition to very old Shinto values about the body. I paid attention to this and my customers definitely appreciated my concern. My customers are very loyal and this may have had something to do with this. There is a sense of trust.

"Recently, I have been getting many customers who want big back piece tattoos. These people are exploring old cultural images and themes. This is interesting to me. I feel that many people who start with Western One Point style might change. Many might eventually change to big tattoos.

"I remember over last couple years, young customers did not like traditional shading style. It looks like tattoos of Yakuza. Then young people see work by Western tattooers like Ed Hardy and Filip Leu, who do traditional Japanese style. They see in American tattoo magazines and are influenced to think the Japanese traditional style must be good. So they think about getting a traditional style tattoo. This is interesting…. Young people in Japan have their opinions changed only because they see traditional Japanese tattoo made by Western tattoo artists in American magazine. This says something about how young people in Japan get influenced."

Hori-Sho is thirty-eight years old and finds himself in the middle of the flow of tattoo information between East and West. He watches his customers reacting to local, national, and global trends that influence what they want to have as tattoos. The process reveals connections between history, culture, young people, and their sense of self.

"Today with the global influence of tattooing, young people are effected by this," Hori-Sho says. "Interest in One Point has to do with being impressed with Western culture. Then at some point I start to see young people say, 'Wait, I am Japanese. I should explore Japanese style.' So there is a mix. This year when there was a tattoo summit held in this area, over 2000 people showed up. This is very impressive. At this point, young people in Japan are really thinking about this whole thing. They are in the middle and it is interesting to see which way they go."

Tattoo by Hori-Sho

Chapter Seven
Hori-Show Tattoos Tokyo

There is a touch of humor in the way Hori-Show has decided to spell his name. The choice describes something about him as a contemporary tattoo artist in Japan. He is sensitive to the changing profile of his art form.

"I take the name Hori-Show," he says. "I think this is what a tattoo artist can do. He can show you something. Something about himself and something about his customer."

Hori-Show traveled from Tokyo to San Francisco in 1991 to visit his friend Yoshi who was apprenticing with tattoo legend Bill Salmon. He was tattooed by Bill and then decided to ask if he could also apprentice with him. In short order an apprenticeship was established and Hori-Show traveled several times to San Francisco to complete his work with Bill. "I work any type of job to make money for my travel to America," he says. "I work a lot of difficult construction jobs in Tokyo. I saved my money and traveled to study with Bill. I was impressed with tattooing. I became very dedicated to it. Bill helped me to learn about this."

American Rock-A-Billy music had always interested Hori-Show and he wanted to get tattooed with the types of images worn by Rock-A-Billy musicians he idolized. It looked cool. For many young Japanese, the allure of American Pop Culture is exotic and captivating. Kids in urban centers like Tokyo and Osaka keep an eye on what goes on in the USA. They focus on new clothing styles, music styles, and attitudes about life. The issue of self-presentation is acute among Japanese youth. How you dress and hold yourself are at the center of life. It effects everything you do and think.

People live in tiny apartments in places like Tokyo and Osaka. During the warmer months life unfolds on the street. Shopping is viewed as a lifestyle; the Shibuya and Harajuku districts in Tokyo and the American Village area in Osaka are mobbed on the weekend with thousands of young people. In very recent times, open tattoo shops have sprung up in these areas. They cater to the growing number of young people becoming curious about tattooing as a new form of style and self-presentation.

The second time Hori-Show visited Bill Salmon's Diamond Club studio, Filip Leu was working there. He did not know Filip but was introduced to his unique Japanese hybrid style that combines sophisticated Eastern and Western sensibilities.

"I had never seen this before," Hori-Show says. "I was at Bill's studio to get Western, One Point style tattoos but then I see what Filip is doing. It is such a good blend of these styles. It makes me want to work hard to become a tattoo artist. I was impressed seeing these connections between the styles. I worked crazy jobs in Tokyo and spend money to go to the USA to learn from Bill.

"After I see Filip's style I get more interested in Japanese style. I decide I should go to Switzerland to visit with Filip Leu. I want to learn this technique. I think it is good to mix Japanese and Western styles. I think this mix is the best. I like to combine the bold graphics of these styles."

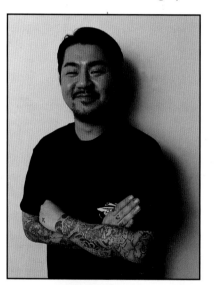

Hori-Show

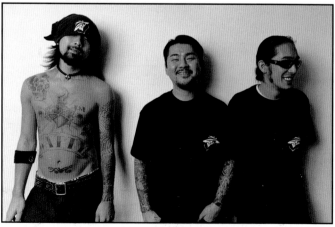

Hori-Show with crew

Hori-Show in studio

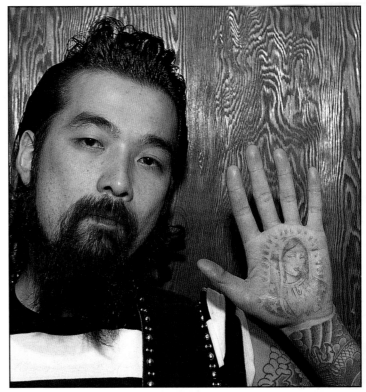

Wataru of Core Fighter—palm tattoo by Cory Miller

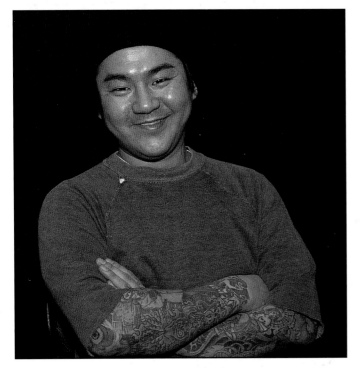

Hori-Show

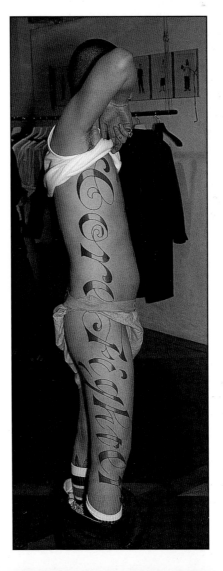

The art form of tattoo has become completely internationalized at this point. Hori-Show's personal experience is symbolic of a process of influence and exchange between artists from very different parts of the world. He became inspired to investigate and learn about Japanese tattooing, not by someone in his own country, but by a talented artist from Switzerland. A European, Filip Leu was influenced by Japanese traditions and developed a new style that in turn influenced a Japanese artist. This fluid process of artistic cross-pollination speaks volumes about the growth of tattooing and the nature of our globalized lives.

Core Fighter tattoo by Hori-Show

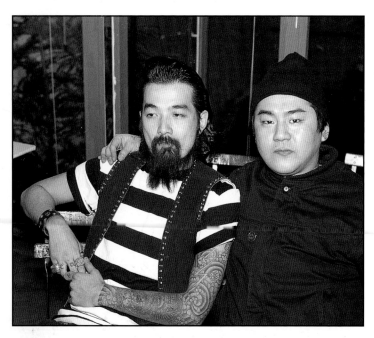

Hori-Show and Wataru of Core Fighter

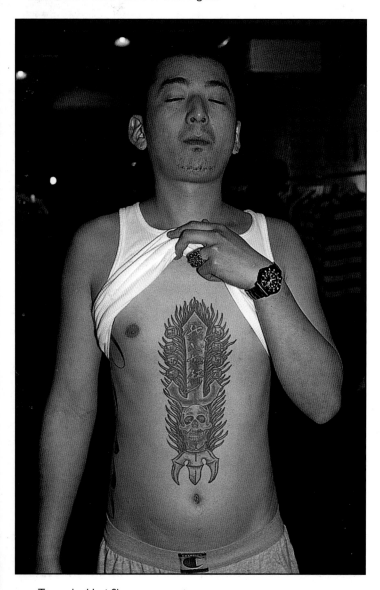

Tattoo by Hori-Show

"I think 1995 was the year that tattoo begin to be popular in Japan among young people," Hori-Show says. "I think this new popularity is good but maybe also a little dangerous too. I think about the old techniques…. This new Free Style is not a problem; it is a part of a process of influence. Of course I like Free Style tattooing. It lets people do what they want to do. However I wonder if this new process will take over Japanese style. Will this new technique push out old, traditional tebori hand technique? Westernizing process might do this. At some point I would like to learn traditional tebori technique. It is a part of the traditions from my culture.

"When I make my needles, I like to use needles used in Japan to sew kimonos. They are slightly larger than needles used in the West to make tattoo. I think they work better. They are traditional Japanese tattoo needles. This is important to me. As I get older, I realize the strength of my culture and I enjoy connecting to the traditions. I value these traditions.

"I understand a little about the American mind-set and a lot about the Japanese mind-set. I like being in the middle at times. I like choosing images from different cultures and mixing them to create powerful tattoos."

Hori-Show is thirty-two years old and his perspective about life is becoming more focused. Tokyo is Japan's largest city and a major economic dynamo but life there is overbearing. The energy of the city is frantic and exhausting. Hori-Show realizes that Tokyo provides him with the economic opportunity to pursue his artistic ambitions but he also realizes that there is a price to be paid. He feels overwhelmed at times and looks forward to living a simpler life some day.

"Tokyo is best for business," he says. "Eventually I would like to live a simpler, creative life. I am not fixated on fame, just fulfillment and happiness. I have been studying art recently. I want to create a gallery that will feature work from all the arts. I would like to go back to my hometown in the Toyama prefecture. It is five hours from Tokyo. It would be nice to settle down and live with my wife and my mother. I would like to spend more time drawing."

Overloaded bookshelves hold a mixture of Western Hot Rod art books and Japanese reference material. Hori-Show's studio is a very well organized converted apartment similar to many private tattoo settings in Japan. Impressive, large drawings of tattoos in progress are tacked above his desk that feature images of traditional Buddhist deities juxtaposed with Americana. There is no sign outside advertising his services.

"There are too many people tattooing in Tokyo now but this is where the business is. Life is too crazy here; I look forward to a simpler life someday. Maybe after ten years of working in Tokyo I will be able to go back home to live the simple life.

"I look at Old School American style tattoos and I really respect the old artists. Many young tattooers in Japan feel

this way too about American Old School. It is similar to the Japanese way. The old creates the possibility of the new. This is very Japanese way of thinking. One generation creates for the next. I feel like I am a part of this process. We are all a little piece of a big picture.

"I feel that in Japan, the old have a sense of feeling and commitment about everything they do in life. We may differ a little from the West about this. Japanese look back and they look forward. There is a philosophy of respect for the past."

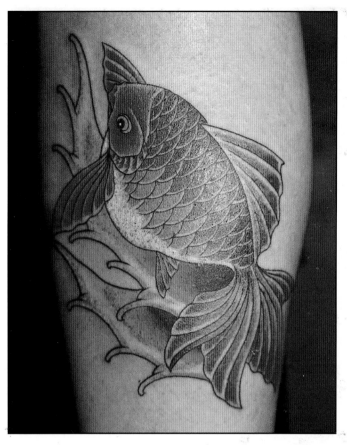

Tattoo by Hori-Show

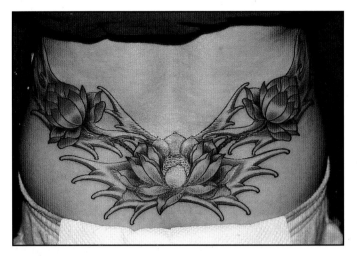

Tattoo by Hori-Show

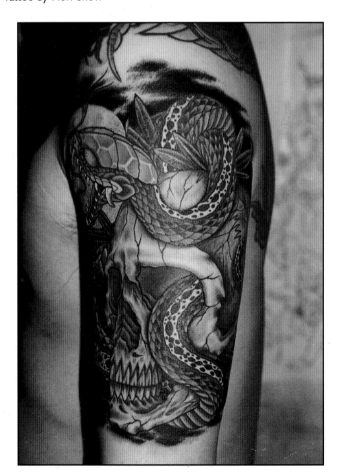

Tattoo by Hori-Show

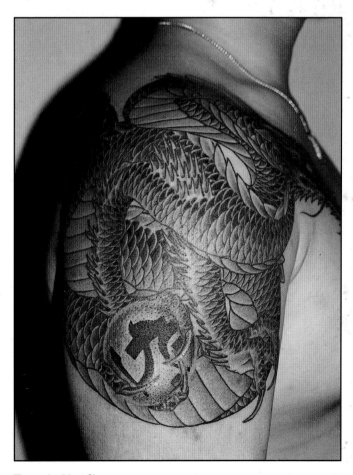

Tattoo by Hori-Show

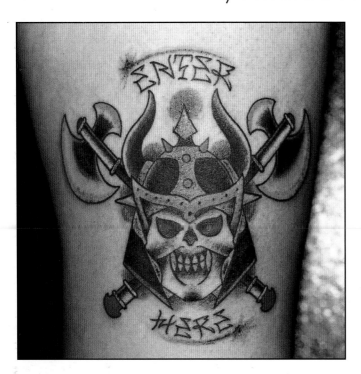

Tattoo by Hori-Show

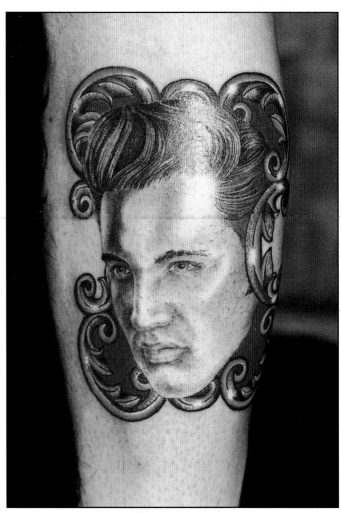

Tattoo by Hori-Show

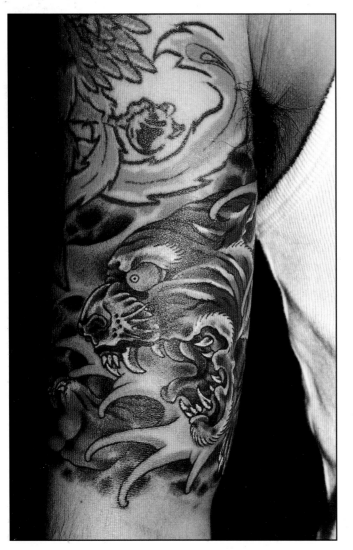

Tattoo by Hori-Show

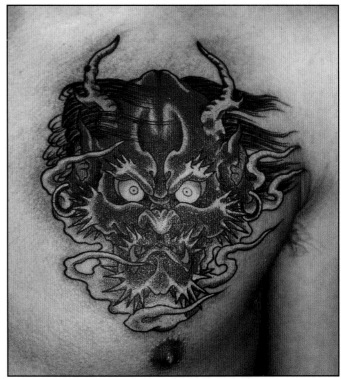

Tattoo by Hori-Show

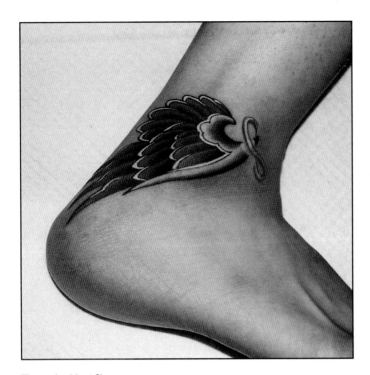

Tattoo by Hori-Show

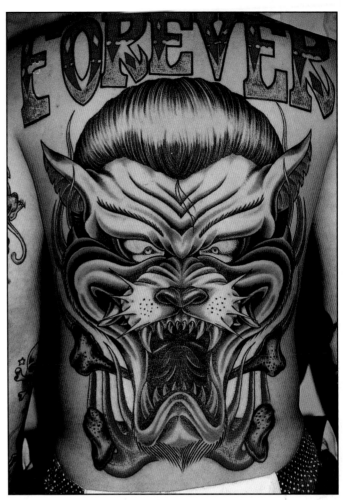

Tattoo by Hori-Show

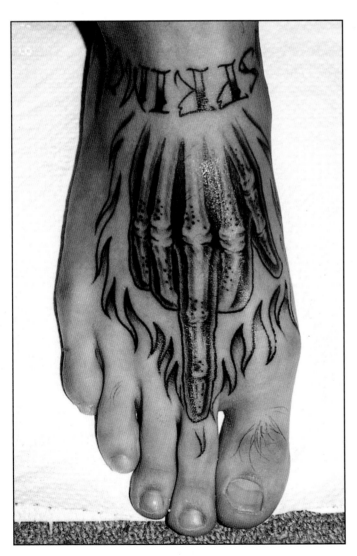

Tattoo by Hori-Show

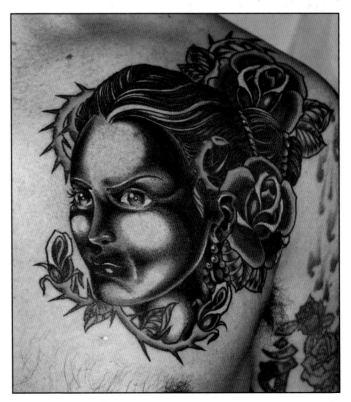

Tattoo by Hori-Show

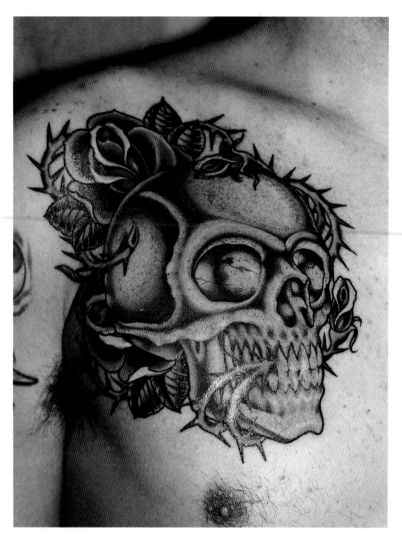

Tattoo by Hori-Show

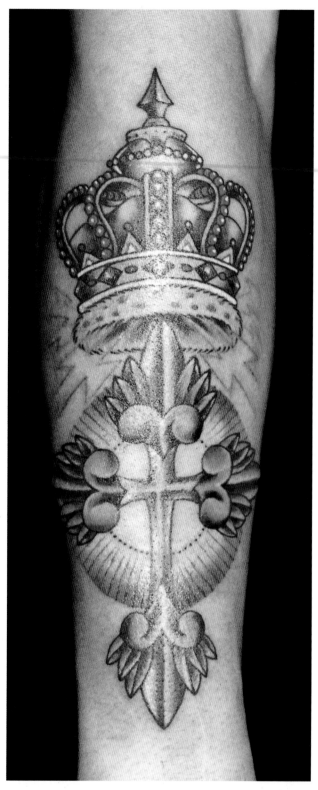

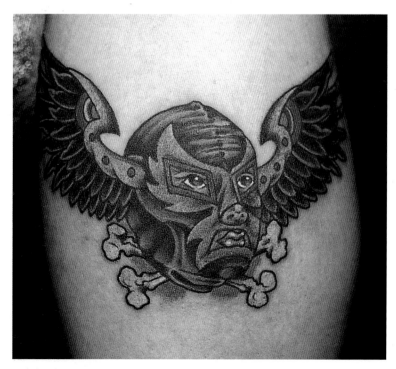

Tattoo by Hori-Show

Tattoo by Hori-Show

Chapter Eight

Sabado and Eccentric Super Tattoo

"When I was nineteen years old I worked for the Sony Corporation as a technical draftsman," Sabado explains about his early professional life. "There was a sense of dissatisfaction and I decided to travel. I was interested in other countries outside of Japan." Sabado was one of the first to open a street tattoo shop location in Japan in 1993. At that time most people, both young and old, thought him foolhardy. His parents became very upset, his interests in tattooing completely contradicted strong cultural beliefs about the human body. There were associations between tattooing and organized crime. People asked Sabado if he knew what he was doing.

"I came to tattooing differently than most people in Japan," he says. "I decided to go to the United States and travel around. I bought a Honda 500cc motorcycle in Los Angeles and I decided to look for Route 66. I wanted to find the old traveling routes in America. That was 1987, I was twenty-two years old—now I am thirty-nine. I rode that motorcycle from LA to Chicago, New York, Jacksonville, Houston, the ocean.... I did meet other Japanese guys doing some similar things.

"There is a power from the American culture that I had always seen: Skateboarding, art, beautiful stores, large houses... everything... a power. I was very interested to see the space in America... there is a lot of space. Riding across Route 66 I was impressed with the amount of room America has... it's incredible. I sold my motorcycle in Houston, Texas, and took a bus to Mexico. I traveled down the coast of the Gulf of Mexico through the Yucatan to Guatemala, Nicaragua, El Salvador..."

Like many young people in Japan, Sabado's fascination with the United States was strong and attracting. The myths of freedom and self-determination that are associated with American life were alluring. For many young Japanese, traveling to the West is a powerful right of passage. An exotic journey of exploration and validation.

"In Guatemala," he continues, "I met some guys who wanted to travel down the Amazon River. It was the rainy season, so we decided to wait for the dry season. I went back to Japan and spent three months in Yokohama working for Nissan Motors on the assembly line. I made my money and then went back to Peru to meet up with the guys. We had an appointment in July to start our raft trip down the Amazon.

"We planned to do a lot of the Amazon on the raft but it got to be too much. Every day it was the same thing—sitting on the raft, going along, fishing. It got boring; we lived only on the raft. I quit the raft and decided to travel by myself again. I ended up in Brazil.

"When I was on the borders of Argentina, Paraguay, and Brazil, I met a guy who had some beautiful tattoos, so I asked him who did them. He said some guy in Rio de Janeiro had done them. I said to myself, I want to meet this guy. I tried to tattoo myself by hand. I made a few simple tattoo machines—like jailhouse machines.

"I ended up in Rio and decided to look for the tattoo artist. His name was Russo; he was maybe ten years older than me. I told him that I was interested in learning how to tattoo and he said that would be OK. So I visited him almost every day at his home and we talked about tattooing. He was not working a lot, so we decided to put together a mobile tattoo shop. We would drive around and park our tattoo shop in areas where young people would hang out. We did a lot of tattoos!"

Sabado returned to Japan in the early 1990s and opened his Eccentric tattoo shop. He lives in the city of Nagoya and has recently opened a second shop he calls Eccentric Super Tattoo. All of the shop's stylish furniture is constructed of wood and was made by Sabado and his assistants. He has very personal ideas about the look of his shops and the mood that they project. Like many, Sabado used to be wrapped up in the New World of digital information and the Internet. He has recently rethought these impulses and concluded that he feels more comfortable in a tactile world of conventional communication. He no longer has an e-mail account and thinks seriously about shutting down his Web site. Instead, he has published a brochure about Eccentric Super Tattoo that is full of text and images. He designed it to be easily held in the hand and kept in a pocket. It is analogue format information that travels at an analogue pace.

Sabado's early tattoo shop and work was very influential among young people in Japan who were just becoming curious about tattooing. He worked on his own terms outside preexisting Japanese historical influences. His tattoo imagery centered on Western themes: American traditional tattoo motifs and "Hot Rod Kulture." He still enjoys the process of talking with his customers about

their interests and does not feel comfortable telling his customers what to do. The dialogue about the images is important.

This perspective is very different from the tattoo traditions of Japan where everything is predetermined. The images are centuries old; the supporting mythology is even older. Tattoo stylizations are predetermined; placement is formalized and conventional. Some people take solace in an arrangement like this. Others, particularly urban young people in Japan, find this consciously or subconsciously suffocating. They flirt with the possibility to be different, outstanding, and novel. Sabado enjoys contributing to this new brand of cultural charisma.

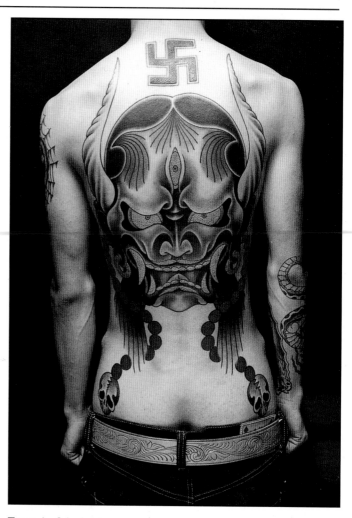

Tattoo by Sabado

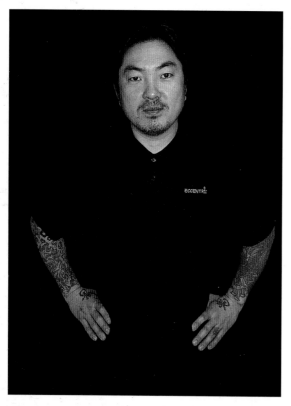

Sabado

Eccentric Super Tattoo

Sabado

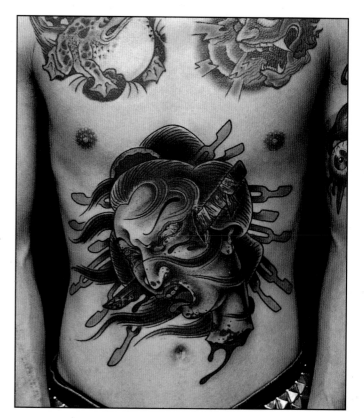

Tattoo by Sabado

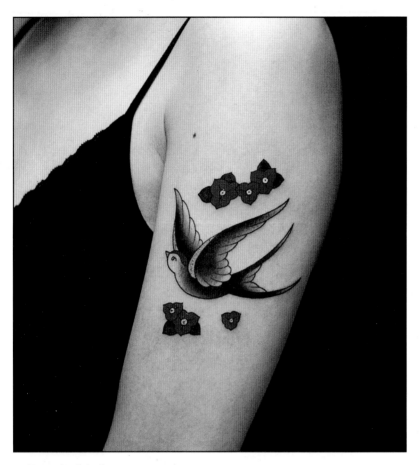

Tattoo by Sabado

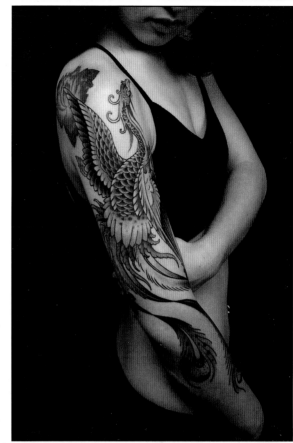

Tattoo by Genkoo

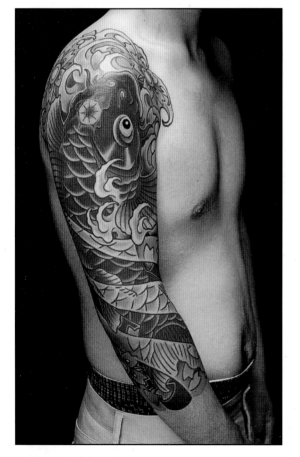

Tattoo by Sabado

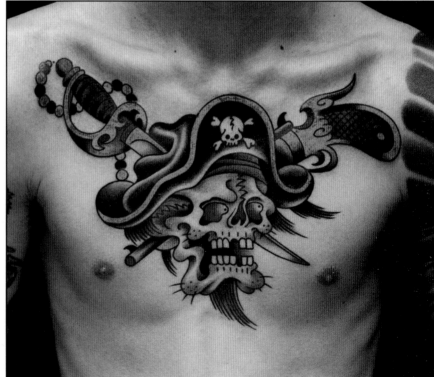

Tattoo by Genkoo

"I like traditional Japanese tattooing," he says. "I just feel that it is the traditional Japanese style. It's nice but it is only one style in the entire scheme of things. It's good to learn more and to be able to accept many kinds of art and tattoos... to learn more. I need to learn them—it's more fun! Sometimes a customer comes in and says, 'I want Hawaiian Style Tribal.' If I don't know what they are talking about, then I can't do it and that is not good. If I know what they are referring to, then I can do it. Maybe they come in and want Japanese style or American style. If they know that I can do all these styles then it's good. That makes me a better tattoo artist and keeps me more interested.

"I think that someone just doing one thing, exploring the one style, that's cool too. That is very good but the world has changed. There are many styles and people can choose for themselves. They can choose Horiyoshi, they can choose Horihide, they can choose Sabado. I thought, I will create a new setting, a new style. Top quality, top art, top presentation.

"A person comes in with an American Hot Rod magazine and says, 'I want something like this... this is cool.' I might not come up with these ideas if I were not exposed to the ideas of the customers. I love the continuous stream of fresh ideas that the customers bring in. My customers push me to do things that I might not do on my own. I like 50% idea from the customer and 50% idea from me. It is a creative partnership."

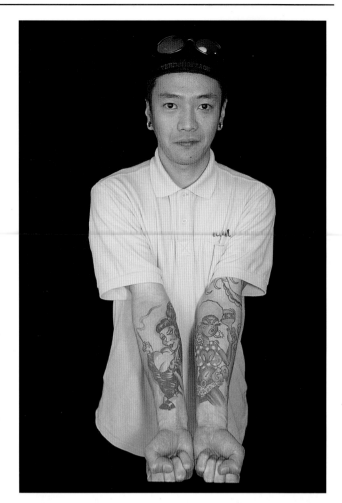

Genkoo

Eccentric Super Tattoo crew. (L-R) Sabado, Genkoo, Shin-ten

Shin-ten

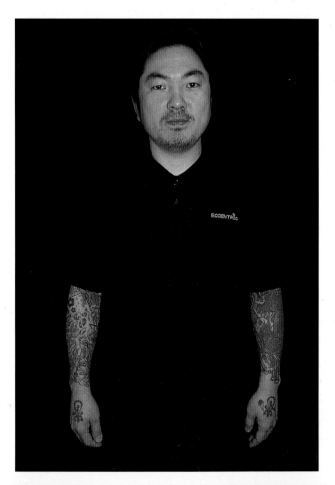

Sabado

In many ways Sabado has a contradictory perspective. He enjoys being different and looking for truly unique ideas and inspirational material. This is in direct opposition to the average Japanese person who feels comfortable interacting with preordained forms. Globalization is eroding Japan's orthodoxy but young urban people continue to articulate difference through the use of constructed, stylized forms. They dress and act as representations: the '50s rebel, the punk, the Fruit, the Ganguro girl, the hip-hop gangster. It is creative and fun but it is all photocopied, temporal fashion. This does not really interest Sabado. He encourages customers to experiment with new things. He asks people to take risks and challenge themselves.

"I always thought about my likes and dislikes. I have always liked something new and different. I have always looked for new things, never at existing tattoo things. I look for new ways to present tattooing. Presentation is so important. This concept of presenting yourself goes way back in Japan.

"Esthetic life is so much a part of Japanese life. From the urban extreme to the countryside. Life is an esthetic journey. I wonder what type of style to create. I follow my customer's lead. The customer's originality and personality. They will tell me about what they want. Their idea, but they can not make a tattoo. I can make a tattoo and I follow my customer's lead. When the customer comes to me and tells me their idea, then together we create a tattoo. The tattoo is not mine, it is the customer's. My customers completely trust me but I always ask they must tell me something. They must give me a tip. The customer's personality is so important. I am an amplifier for my customer's ideas.

"I am drawing constantly. I spend many hours drawing designs for customers. We go back and forth several times preparing a tattoo design. Finally, a design is created that we both agree on for the tattoo. The drawing process is very important. It is the union of customer and tattoo artist. I enjoy this process very much because I grow with each tattoo.

"I have expression that I put on my brochures, it reads 'Many experiences support your lifestyle' I really believe this and I think that many young Japanese people begin to think like this too in recent time. This is difficult but also good."

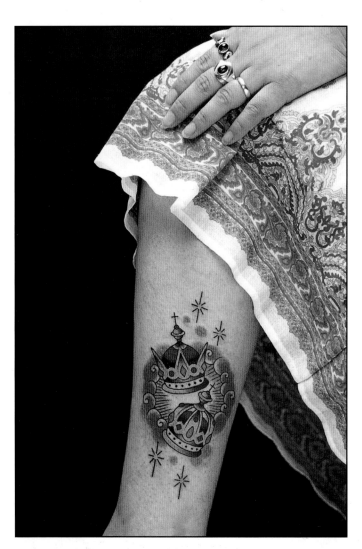

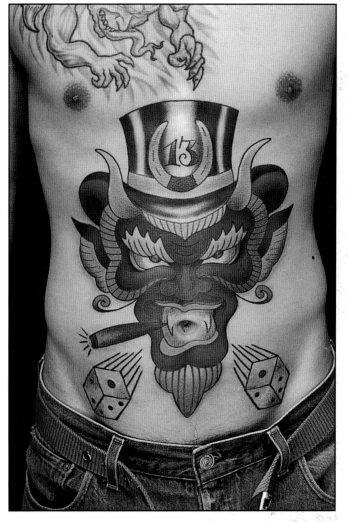

Tattoo by Sabado

Tattoo by Sabado

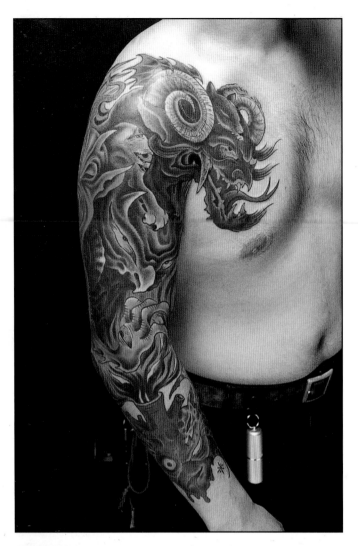

Tattoo by Sabado

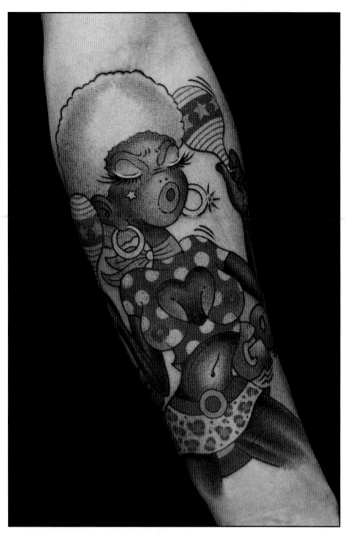

Tattoo by Sabado

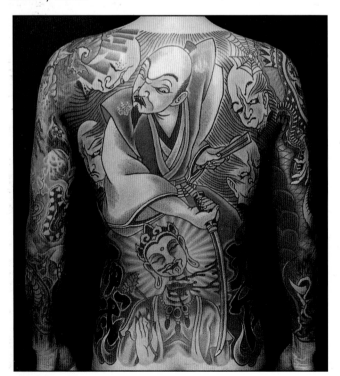

Tattoo by Sabado

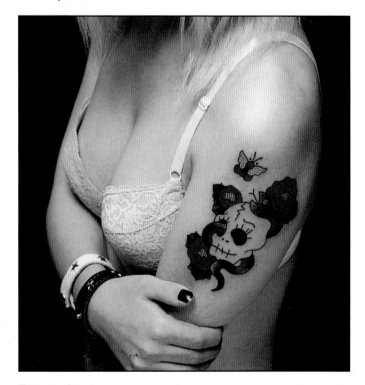

Tattoo by Sabado

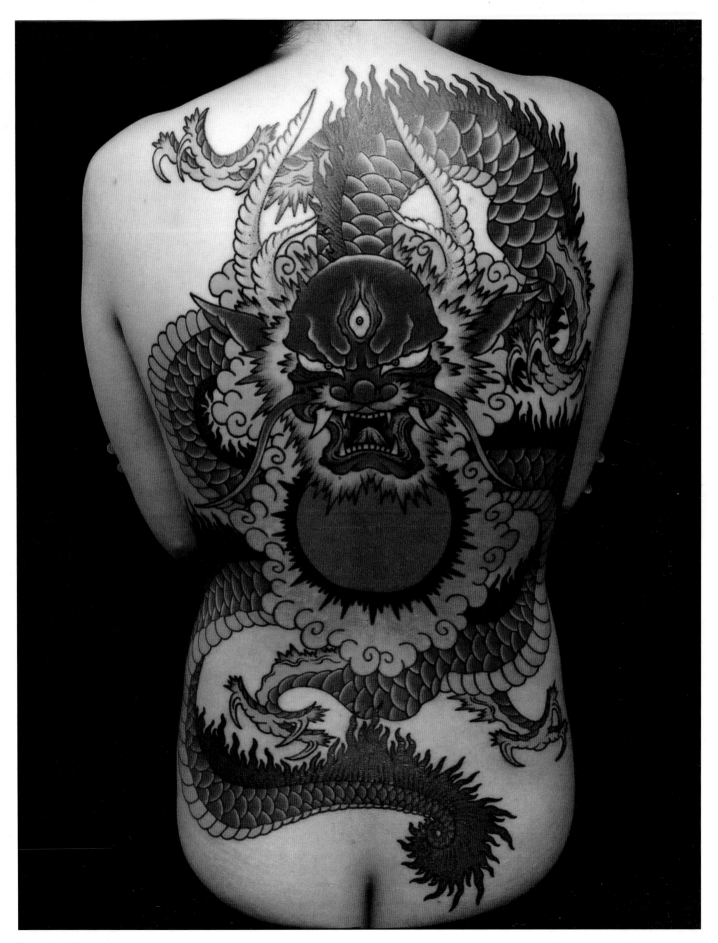

Tattoo by Sabado

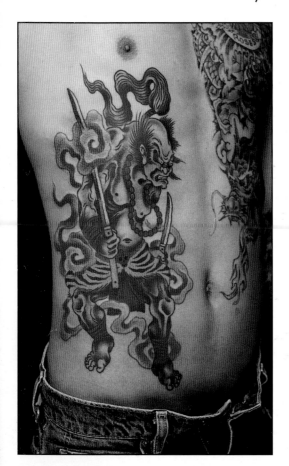

Tattoo by Sabado

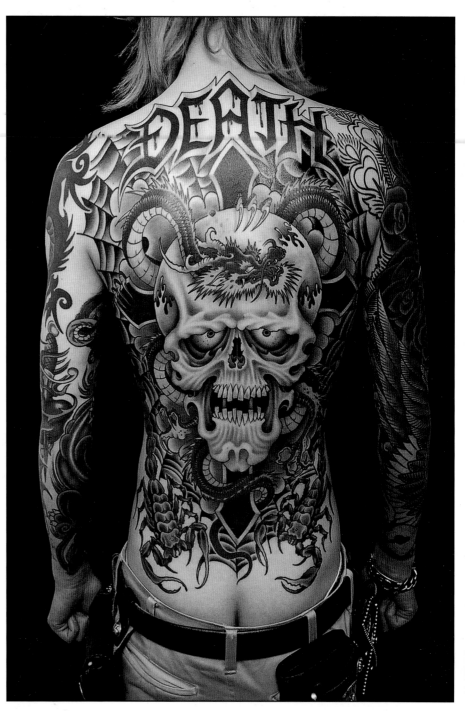

Tattoo by Genkoo

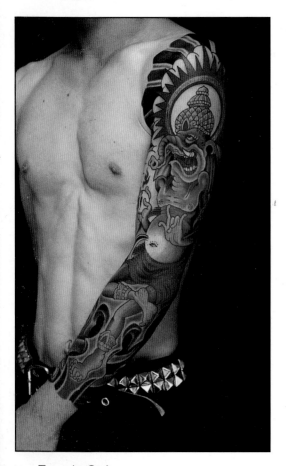

Tattoo by Genkoo

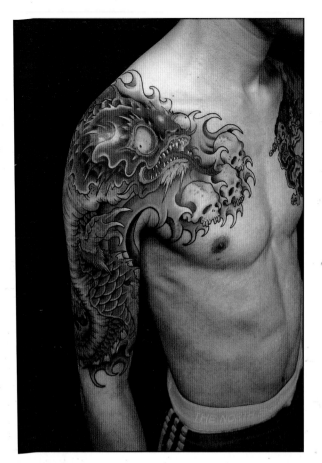

Tattoo by Genkoo

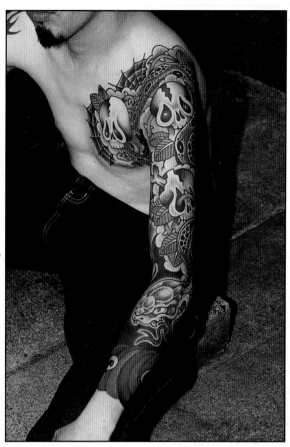

Tattoo by Genkoo

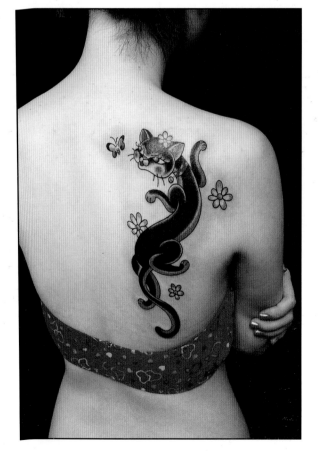

Tattoo by Genkoo

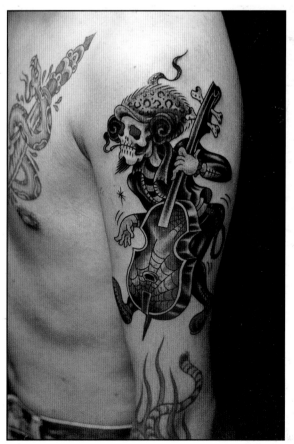

Tattoo by Genkoo

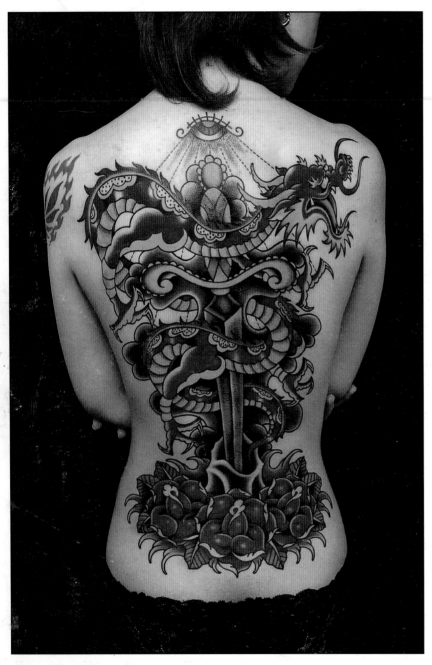

Tattoo by Genkoo

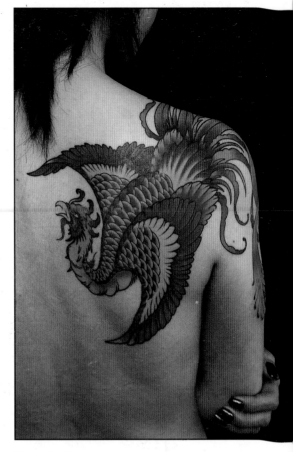

Tattoo by Genkoo

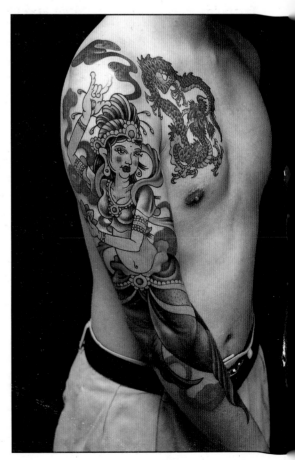

Tattoo by Genkoo